# *The*
# WANDERERS

## *Masters of 19th-Century Russian Painting*

### An Exhibition from the Soviet Union

Edited by

ELIZABETH KRIDL VALKENIER

Organized by

INTERCULTURA, FORT WORTH

THE DALLAS MUSEUM OF ART

in cooperation with the

MINISTRY OF CULTURE OF THE USSR

This exhibition is made possible by a generous contribution from NCNB.

THE WANDERERS *Masters of 19th-Century Russian Painting* was organized by InterCultura of Fort Worth and the Dallas Museum of Art in association with the Ministry of Culture of the USSR.

*Exhibition Itinerary*
Dallas Museum of Art
Dallas, Texas
October 28, 1990 – January 6, 1991

Joslyn Art Museum
Omaha, Nebraska
February 2, 1991 – March 24, 1991

*Edited by* Elizabeth K. Valkenier, Robert V. Rozelle, Susan J. Barnes, Gordon Dee Smith and Linda D. Ledford

*Photography by* Valerii Mikhailovich Yevstigneev and Aleksandr Mikhailovich Galkin of The Ye. V. Vuchetich All-Union Art Production Association, and Vladimir Alekseevich Voronov, Igor Mikhailovich Kozlov, and Igor Sergeevich Khliustov of the State Tretiakov Gallery

*Translations by* Aline Isdebsky-Pritchard, Donald Lineburgh, Ada Rotkiewicz and Marcus Sloan

*Co-designed by* Greg Dittmar and Becky Wade
*Color separations by* Webb & Sons, Inc.
*Printed by* Hurst Printing Company in the United States

*Front Cover*
M.V. Nesterov, *The Hermit*, 1888
*Frontispiece*
Group photograph of The Wanderers in 1881.

*Library of Congress Cataloging-in-Publication Data*
The Wanderers: masters of 19th-century Russian painting /edited by Elizabeth Kridl Valkenier; organized by InterCultura of Fort Worth, the Dallas Museum of Art, and the Ministry of Culture of the USSR.

p. cm.

Includes bibliographical references and index.
1. Peredvizhniki (Society) – Exhibitions.
2. Realism in art – Russian S.F.S.R. – Exhibitions.
3. Painting, Modern – 19th century – Russian S.F.S.R. terature – Exhibitions. I. Valkenier Elizabeth Kridl. II. InterCultura of Fort Worth. III. Dallas Museum of Art. IV. Soviet Union. Ministerstvo kul'tury. V. National Center for Nonprofit Boards (U.S.) VI. Joslyn Art Museum.

ND687.5.R4W36 1990
759.7'074'7642812 – dc20

90-46001
CIP
0-936227-08-7
ISBN

*Distributed by* University of Texas Press

# CONTENTS

This volume is published on the occasion of the first exhibition in the United States devoted to the art of the Itinerant Society for Circulating Art Exhibitions. Turning their backs on the financial and professional security offered by an official career under the control of the Russian Imperial Academy of Art, these "Itinerants" or "Wanderers" banded together to assert their right to artistic independence and self-determination, to depict the life of the Russian people and their land and history, and to exhibit their paintings in group exhibitions throughout Russia.

The twentieth century has been an age of great transformations, changes which have not yet ended. Although it often seems that the ideas and events of today are completely of our own time, they are in fact the living legacy of the past. Nowhere is this more true than in Russia, which still forms the central political, social, and cultural force in the Soviet Union. Nineteenth-century Russian culture, in particular, continues to inform in the cultural, intellectual and social debates ongoing in the Soviet Union, of which the current national reforms are the latest chapter. Numerous movements which came to the fore in that period–including Slavophile revivalism, to name one relevant to the Wanderers–are re-emerging today as increasingly powerful forces in the Soviet Union. Moreover, Russian culture of the last half of the last century, and of the period immediately following, has had a wide-ranging influence on the development of Western culture in the twentieth century.

As the authors of the present volume note, we in the United States know the literature and music of the period almost as our own, but how many know the names Repin, Levitan, or Arkhipov? Yet the movement these artists represent not only produced works of great aesthetic importance, but raised social questions which still remain unanswered in Russia. They also set the stage for the artistic movements which followed, the *Mir Iskuskva* (Diagalev's "World of Art" movement) and the Russian Avant-garde. Both of these movements have been enormously influential, and the latter has

been of critical importance, in the West. Without the work of the Wanderers, these later developments in Russian art would be unthinkable.

The importance of the Wanderers to Russian art can scarcely be exaggerated. The purpose of the present exhibition and volume is to examine closely this movement, from its beginnings to its decline, to engender an understanding of its importance and accomplishments, and to relate the work of these artists, who are relatively unknown in the West, to the culture of their time. The essays included herein, by major scholars in both the Soviet Union and the United States, address important topics related to the work and place of the Wanderers. Selections from critical texts of the day, most published here for the first time in English, allow us to see how the paintings were received by the contemporaries of that period. Finally, each work is interpreted through a substantive object entry that puts it into cultural context. These entries, prepared by scholars in the Soviet Union, would doubtless please the painters, who voiced concern that the viewer understand the message and meaning of their paintings.

One of the most unfortunate tendencies in art history (and indeed in history in general) is to view historical movements, ideas, and figures as unified, consistent, and logical. It has been the goal of the collaborators of this project to reject such a canonical view. This book proposes to look at the Wanderers not as a monolithic force (they have often been seen in this light in Russia as well as in the West), but to reassess the movement and reveal the tensions and inconsistencies within it as well to concentrate on the claims made for the movement by certain contemporary critics, sometimes by artists themselves, and by many later historians. These tensions can be seen in the history of the movement (the initial rejection of the Academy vs. the subsequent *rapproachment*), in the treatment of themes (e.g., the invocation of the Orthodox monk as a symbol of spiritual purity and nature mysticism in Nesterov's *The Hermit* vs. the rejection of the Orthodox church as corrupt, self-indulgent, and a pawn of

the political establishment in *The Refectory* by Perov), and in the development of style (from innovators at the beginning to conservatives at the end). Yet despite these inconsistencies, there does emerge an overall sense and significance to the movement which, for several decades, remained true to its intentions.

This exhibition has been made possible by the vision of NCNB and its leaders in providing a generous contribution to sponsor the project. Special thanks must go to Kenneth D. Lewis, President, NCNB General Bank; Robert B. Lane, President, NCNB Texas; and Timothy P. Hartman, Chairman of the Board, NCNB Texas for their dedication to the realization of this exhibition. In our rapidly shrinking world, the issues which the Wanderers addressed–freedom of individual artistic expression, national cultural identity, and social concerns–are very timely. NCNB's commitment to a cultural project of such international scope and relevance symbolizes the growing influence of global exchange in enhancing the flow of ideas, diplomacy and commerce, and enriching the experience of our lives.

The work of many individuals in the Soviet Union and the United States has been crucial to the planning and implementation of this project. First and foremost, great thanks must go to the exhibition's two co-curators, Marina Ursina, art historian of the All Union Artistic Production Company named after Ye.V. Vuchetich (a branch of the Ministry of Culture of the Soviet Union, Soviet co-organizer of the exhibition), and Susan Barnes, Senior Curator of Western Art at the Dallas Museum of Art (InterCultura's American co-organizer in the project). The exhibition would have been impossible without the patience, vision, and unflagging work of these two scholars. Their collaboration provided the perfect balance between the deep Russian understanding of the Wanderers' work and a point of view embracing European and American art of the same period.

Genrikh P. Popov, Chief of Fine Arts of the Ministry of Culture of the USSR, played an equally crucial role in the realization of the project, providing essential support, enthusiasm,

and vision during its long development. Richard Brettell, Director of the Dallas Museum of Art, who originated the exhibition conceptually, was a guiding force for the project from beginning to end and contributed an essay to the catalogue. The exhibition would have been impossible without the tireless and unceasing work of Roderick Grierson, Vice-President of InterCultura, in providing an essential diplomatic, administrative, and logistical link between Texas and Moscow from InterCultura's office in London, England. Elizabeth Valkenier, professor at the Harriman Institute, Columbia University, provided unique expertise, enormous support and was both author of the lead essay and scholarly editor of this volume.

Also on the Soviet side, Valentin L. Rivkind, Deputy Director, Aleksandr Z. Olinov, General Director, Svetlana Dzaforova, Chief of Art History, and Alexander Kuzmin, Chief Exhibitions Coordinator, of the Ye. V. Vuchetich provided vital support and assistance to the project on a continuing basis, as did Andrei L. Anikeev, Chief of the Department of International and Soviet Exhibitions at the Ministry, and Tatiana Abalova, formerly Chief Exhibitions Coordinator at the Vuchetich.

Without the generous cooperation and contributions of colleagues in Soviet museums the project would never have been realized. The organizers are especially grateful to Yurii Korolev, Director, Lidia Romashkova, Curator, and Lidia Yovleva, Deputy Director of Academic Affairs, from the Tretiakov Gallery; and Vladimir A. Gusev, Director, Yevgenia Petrova, Deputy Director of Academic Affairs, and Ivan Karlov, Curator, at the Russian Museum in Leningrad, for their support and encouragement. Zoya Skopintseva, Director, Marina Kuzina, Deputy Director of Academic Affairs, and Larisa Cherba, Head Curator, at the Tula Art Museum in Tula, and Tatiana Kuyukina, Director, Olga Piotrovskaya, Deputy Director of Academic Affairs, and Margarita Zheleznova, Head Curator, at the Tver' Regional Picture Gallery in Tver', provided great hospitality and help.

We are honored to bring to our public the scholarly contributions by Dimitrii Sarabianov, Chairman of the Department

of Art History at the University of Moscow; Galina Churak, noted Russian author from the State Tretiakov Gallery; and Irina Shuvalova, candidate of Fine Arts, State Russian Museum, and authors of the object entries: Marina Ursina, Galina Churak, and Irina Shuvalova.

On the InterCultura staff, Nicole Holland, Executive Vice-President, oversaw administrative functions thoughout the project and, with James Bradburne, formerly Manager of Design and Planning, created the concept for the accompanying educational outreach program. She also managed its implementation along with Andrew Harris, Chairman of the Theater Department at Texas Christian University, and from the Dallas Museum of Art, Nancy Berry, Director of Public Programs, and Melissa Berry, Special Programs Coordinator.

Ann Hefner, Exhibitions Coordinator for InterCultura, and Kim Bush, Registrar, at the Dallas Museum of Art, managed many details of exhibition implementation, and essential services were also provided by Anna McFarland, DMA Administrator, Collections and Exhibitions.

Robert Rozelle, Director of Publications at the Dallas Museum of Art, helped to edit *The Wanderers* and oversaw the production of this book, the manuscript of which was carefully processed by Linda Ledford. The book was co-designed by Greg Dittmar, Graphic Designer of the DMA, and Becky Wade of Dallas. Judy Nix, Director of Development, and Melanie Wright, Public Relations Manager, and Pam Wendland, Marketing Manager, all of the museum, were instrumental in informing the public of this project.

Finally, InterCultura is especially grateful to Jack Matlock, American Ambassador to Moscow, and his wife, Rebecca, for their on-going support and interest in InterCultura's long-term exhibition exchange program between the United States and the Soviet Union, of which *The Wanderers* is the second exhibition.

Gordon Dee Smith
*President*
*InterCultura*

Russian artists have made a profound contribution to their country's heritage, particularly during the late 19th and early 20th centuries. However, many of these wonderful works, including genre paintings, landscapes, portraits and scenes from Russian history, have never been seen outside the Soviet Union.

Now, as barriers tumble and two societies try to better understand each other, NCNB is proud to sponsor this historic exhibition. *The Wanderers* is a concrete manifestation of expanding cultural relations and illustrates the growing interest of the American and Soviet people toward each other's history and culture. The fact that these beautiful paintings can now be shared gives prominence and focus to the exhibition. Known and honored in their homeland, these Russian artists may now be admired by a wide audience.

We are grateful to the leaders of the Soviet government, including the Ministry of Culture, and the directors and staffs of the lending museums. We also extend our thanks to the Dallas Museum of Art and InterCultura of Fort Worth for their cooperation and assistance in mounting such a significant exhibition for the public to enjoy. We look forward to the continuing cultural awareness and mutual understanding that are derived from efforts such as these.

Kenneth D. Lewis
*President*
*NCNB General Bank*

# ACKNOWLEDGMENTS

*We are grateful to the following for works displayed:*

STATE TRETIAKOV GALLERY
Yurii Konstantinovich Korolev
   *General Director*
Lidia Ivanovna Yovleva
   *Deputy Director of Academic Affairs*
Lidia Ivanovna Romashkova
   *Head Curator*

STATE RUSSIAN MUSEUM
Vladimir Aleksandrovich Gusev
   *Director*
Yevgenia Nikolaevna Petrova
   *Deputy Director of Academic Affairs*
Ivan Ivanovich Karlov
   *Head Curator*

TVER' REGIONAL PICTURE
GALLERY *
Tatiana Savvateevna Kuyukina
   *Director*
Olga Viacheslavovna Piotrovskaya
   *Deputy Director of Academic Affairs*
Margarita Mikhailovna Zheleznova
   *Head Curator*

KIEV MUSEUM OF RUSSIAN ART
Tamara Nikolaevna Soldatova
   *Director*
Emma Arkadevna Babaeva
   *Deputy Director of Academic Affairs*
Alla Anatolyeva Gaiduk
   *Chief Custodian*

TULA ART MUSEUM
Zoya Nikolaevna Skopintseva
   *Director*
Marina Nikolaevna Kuzina
   *Deputy Director of Academic Affairs*
Larisa Valerianovna Cherba
   *Head Curator*

STATE MUSEUM OF UZBEK SSR
Damir Salidzhanovich Ruzybaev
   *Director*

PHOTOGRAPHS
Valerii Mikhailovich Yevstigneev, Aleksandr
Mikhailovich Galkin
   *The Ye.V. Vuchetich All-Union Art Production Association*
Vladimir Alekseevich Voronov, Igor Mikhailovich
Kozlov, and Igor Sergeevich Khliustov
   *State Tretiakov Gallery*

* *Prior to publication of* The Wanderers, *the historic name of
Tver' was restored to the Russian city of Kalinin. Works of art
listed in this publication as catalogue numbers 4, 11, 31, 37
and 44 are on loan to this exhibition from the Tver' Regional
Picture Gallery.*

# Essays

Volkov, *October*, 1883 (*see* Cat. No. 94)

# The Art of the Wanderers in the Culture of Their Time

BY ELIZABETH KRIDL VALKENIER

In the history of Russian culture, the art of the Wanderers occupied a place of honor parallel to the novels of such great writers as Tolstoy, Turgenev and Dostoevsky. These Realist painters were revered during their lifetime and later recognized as the creators of a national school of art, much like the distinctive Russian music created by the composers Tchaikovsky, Mussorgsky or Rimsky-Korsakov.

Although the art of the Wanderers passed through different phases during the more than three decades of the group's preeminence, all along it displayed one overarching characteristic: an intense commitment to Russian subjects and scenes. This distinguishing quality was grounded in the conviction that art should serve a public, social function – conveying civic, moral, or national values – rather than focus on aesthetic expression and stylistic refinement. Their paintings, like the literature of the day, recorded and commented on the vast changes that Russian society experienced during the second half of the nineteenth century.

Admittedly, the art of the Wanderers remains little known or appreciated in the West, but it holds a place of distinction on its own merit and for having played such a crucial role in the development of Russian art. The Wanderers transformed Russian art from a formal exercise patterned on foreign models into a popular and potent cultural force richly rooted in the national heritage. Their successors, Serge Diaghilev's World of Art group and the twentieth-century Modernists, elevated that heritage to more sophisticated artistic levels. But it was the Wanderers who first introduced the revivifying vision and themes and colors into Russia's artistic vocabulary. They gave Russian art its modern, national idiom.

## ORIGINS

Russian Realism was born during a time of reform and renovation that swept the country in the 1860s. In that decade the Tsarist government liberalized the autocratic institutions of the Empire: millions of serfs were emancipated in 1861, and in some western areas they constituted as much as 80 percent of the population. Two years later the first, rudimentary forms of representative government were introduced on the local level. Nor did Russian society remain passive. It, too, sought liberation: state employees from the straitjacket of bureaucracy, wives from tyrannical husbands, children from overbearing parents. It was a short era of great change and great hopes, of ferment and national renovation, which launched Russia into a period of rapid economic and social change.

Every sphere of the nation's life was affected, including art. In 1859 the government tried to reform the Imperial Academy of Arts, but the new statute did not loosen the official stranglehold on the nation's artistic life or the careers of artists. The Academy retained its near-monopoly over training, exhibiting, employment, and commissions. And it remained dedicated to the perpetuation of the Neoclassical style, patterned on High Renaissance art. Creative individuality and artistic plurality were simply not countenanced.

Opposed to the official views of what constituted the art appropriate to the times was the intelligentsia – that

quintessential Russian class composed of well-educated, critically inclined, high-minded individuals, who by some unspoken consent acted as a conscience for the nation. They were composed of three divergent groups – the radicals, the liberals, and the nationalist aesthetes – each with a different vision of the kind of art that would best answer to the needs of the country. Their opinions are worth noting, for each view, generally speaking, was manifested (though with varying intensity) during the Wanderers' ascendancy, first as a creative force and eventually as a moribund tradition. Each of the three stances repudiated international Neoclassicism and advocated an art responsive to contemporary issues. But what message was the new art supposed to convey? And by what means? Here their opinions differed markedly.

The radicals equated Neoclassicism with the aesthetic detachment that was consciously perpetuated by the authorities to preserve undemocratic institutions. They urged painters to reject the antiquated style and subject matter and to become actively involved in the political problems of the day – that is, to paint "denunciatory" canvases on contemporary themes that would "curse" the oppressive institutions and hasten the demise of autocracy. This course was most openly advocated by political exiles, notably by Aleksander Herzen in his journal *Kolokol (The Bell)*, which was published abroad and smuggled into Russia. In more guarded ways, because of censorship, similar arguments were advanced by radical writers at home.

A more moderate view was expressed by the best-known of the "radical" critics, Nikolai Chernyshevsky (1828-89), who argued in his philosophical tract *The Aesthetic Relations of Art to Reality* (1855) that the mission of art was not merely to reflect reality, but also to pass judgment on it. His hot-headed followers, however, called on painters to "evoke energetic protest and dissatisfaction" or "to transmit ideas and decide problems." When Vasilii Perov's *Easter Procession in the Countryside* (1861) was removed by authorities from an exhibition (it showed drunken clergy – an offense to the state religion),

Chernyshevsky's followers interpreted it to mean that art had indeed become involved in political agitation.

The "liberals" had a less one-sided program. They did not necessarily reject the official style or biblical subjects, but they did want art to provide viewers with a moral uplift. Literary figures were prominent in this grouping, of whom Mikhail Saltykov-Shchedrin, a satirical writer of note, was fairly typical. His review of Nikolai Ge's *Last Supper*, shown at the Academy's exhibit in 1863, commended its confrontation between Christ and Judas for reminding viewers that there were higher goals in life than ordinary pursuits or time-worn traditions. Saltykov-Shchedrin did not demand that paintings specifically call for the removal of political and social inequities, but that they arouse critical perceptions in the public so that, instead of blindly accepting the existing system, the public would think about changing it for the better. In short, the liberals saw painters as teachers, not as political activists.

While most of the intelligentsia in the 1860s assumed that subject matter alone would render Russian art of contemporary significance, some were concerned with style as well. This view cropped up among persons more involved with art than with literature or politics. Fyodor Buslaev (1818-97), a historian of architecture, suggested that a style purveying a sense of the common national identity, reaching back to the Middle Ages, would make Russian art truly meaningful and popular. His advice to young painters was not to ape the newest trends abroad but to study Russia's legacy, especially the naive, patriarchal simplicity exemplified in medieval icons and church ornamentation.

Although art criticism as a profession was still in its infancy, Buslaev's view was shared by the few art critics of the time, especially after the dismissive reception of Russian art at the 1862 International Exhibition in London, where it was derided for being devoid of any originality. This western assessment reinforced the critics' arguments that Russian art should shed its "cosmopolitan garb" and become reinvigorated with native themes.

Artists also spoke up for themselves. In 1863, two years after the emancipation of the serfs, thirteen graduating painters and one sculptor, led by Ivan Kramskoy, staged a secession from the Academy of Arts, declining to participate in the final Gold Medal competition; the artists refused to respond to a prescribed mythological subject and its obligatory handling, which they thought of as confining and humiliating to creative artists. Walking out in protest, they set up a cooperative workshop, an Artel (the St. Petersburg Artists' Cooperative), to work as independent professionals outside the official system of civil-service ranks for artists and government commissions. (By coincidence, the early Impressionists staged a similar protest against the French Academy in 1863, when they formed their own exhibition and called it the *Salon des Refusés*.)

At first glance the 1863 secession looks like a direct response to the radicals' call for bold protest. But when one examines the paintings and other activities of the Artel members, the first-generation Realists, it is impossible to classify them as militant activists. They clearly did not represent the narrow concerns of a small vocal circle of revolutionary-minded democrats, but rather a much more broadly based liberal trend among the intelligentsia. This was in keeping with their own strivings for personal and professional emancipation, and for a life based on the principles of justice and dedicated to a moral renovation of society.

The Artel embodied that new life. During the 1860s, cooperative living was very much in vogue among young people, and Chernyshevsky's novel, *What Is to Be Done?* (1863), well expresses that earnest spirit. The entire group of fourteen painters lived in a large common apartment and shared their earnings. They discussed the role of art and listened to Kramskoy, their mentor, argue that pictures should be "wise" and "educational" as well as "beautiful." They tried to buttress their creative work by extensively reading contemporary literature, philosophy and history. Despite the positivist spirit of the age, these painters still felt unprepared in light of their own

I.N. Kramskoy

humble education to speak out as artists on the issues that engrossed Russian society without a firm grounding in "knowledge."

The group strove to function outside the established system by popularizing their art and their life-style. The Artel held private shows in its apartment and, to reach the new middle-class public, organized in 1865 the first independent traveling art exhibit for the annual trade fair in Nizhni Novgorod. They also held "open" Thursday evenings at which friends and supporters would sketch and listen to readings of topical publications that ranged from Chernyshevsky to his western counterpart, the French socialist critic, Proudhon.

As for their art, the Artel members for the most part painted and exhibited social genre that depicted the lower classes or dealt with some social injustices. They gave their pictures explanatory titles, such as *The Hungry Ones or Drowned Man in the Countryside*. That spirit of a nascent Realist art is well represented by one canvas in this exhibition, Grigorii Miasoedov's *Congratulating the Young at the Landowner's House* (1861; cat. no. 49). Although the figures are idealized, the scene still draws attention to the socio-economic gulf between landowners and their serfs. In a similar vein, Nikolai Nevrev's pensive *Moscow Caretaker* (1880s; cat. no. 52) dwells on the servant's isolation, and shows how that ethos of alienation persisted into subsequent decades. Two other pictures make an even bolder and more pointed statement related to the political situation and atmosphere of the 1860s. By placing peasants against a gloomy sky, Andrei Popov's *Pilgrims* (1861, the year of the Emancipation; cat. no. 64) conveys the widespread disappointment with the terms of the decree, which left the peasantry shackled with heavy financial burdens and serious legal restrictions. Vasilii Perov's *The Refectory* (1865-76; cat. no. 57), on the other hand, is an acid commentary on the wealth and indifference of the clergy – and by extension the callousness of the whole system, for the Russian Orthodox Church as the state's established religion was a pillar of autocracy.

In general, the extra-painterly concerns of artists in the 1860s paralleled those of the liberal intelligentsia. None responded to Aleksander Herzen's call that they portray the "civil execution" of Nikolai Chernyshevsky, which stripped him of his civil rights in a public ceremony. They preferred, instead, to paint the far less dramatic, though poignant episodes from the life of the underprivileged as symbolic of Russia's problems. In this the painters' endeavors matched the exposé literature of that decade, as typified by the poems of Nikolai Nekrasov (1821-78) and the satirical writings of Mikhail Saltykov-Shchedrin (1826-89). The Russian term for this type of literature and art is *oblichitel'nyi*, and is often translated in English as "denunciatory." But the term "moral indignation" expresses far better the artists intentions of this genre. Its thrust is well described in Ilya Repin's reminiscences in which he wrote that "the pictures of those days made the viewer blush, to shiver and carefully look into oneself...They upset the public and directed it onto the path of humaneness." The depiction of peasant misfortunes was one means by which painters and the liberal intelligentsia could stir passions and contribute to the reform movement.

THE ASSOCIATION OF TRAVELING ART EXHIBITS
The 1860s, then, served as an incubation period, for the next two decades were marked by a creative burst in Russian Realism. That efflorescence is closely linked with the activities of the Association of Traveling Art Exhibits, formed in 1870 by fifteen painters. Although artists residing in Moscow took the lead in founding the Association, the venture was patterned on Artel's earlier quest for professional autonomy, and Kramskoy continued to be regarded as the new group's key figure.

The Association acted more vigorously than its predecessor Artel in bringing art to the public by means of regular annual exhibits that went to several provincial cities after opening in St. Petersburg and in Moscow. Even more importantly, the works exhibited made more serious artistic and public statements than did the anecdotal pictures of the 1860s. Inspired

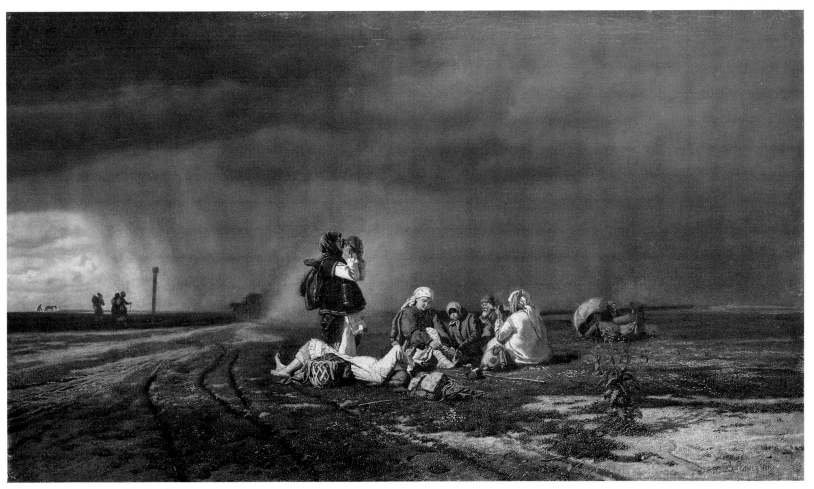

Popov, *Pilgrims*, 1861 (*see* Cat. No. 64)

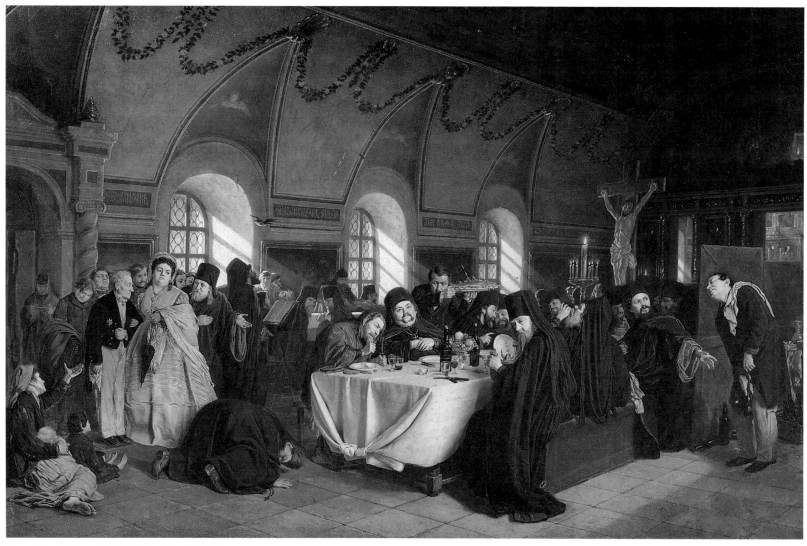

Perov, *The Refectory*, 1865-1876 (*see* Cat. No. 57)

by those earnest but modest beginnings, the Wanderers now entered on the high road to recognition, lucrative sales, and success.

The very fact that the art of the Wanderers has become synonymous with Russian Realism is testimony of their success. Strictly speaking, the name Wanderers (*peredvizhniki* in Russian) applies only to members of the Association (which lasted until 1923) and by extension to those painters who chose to show their works in the Traveling Exhibits, which offered the only alternative to the Academy's shows until the 1890s. But the ambience of the Association's activities was so forceful and distinct in every way – its independence from the official world, its dedication to Russian themes, its ability to attract the best talents and to gain widespread support among the public as well as critics and collectors – that for most Russians to this day the art of the Wanderers (*peredvizhnichestvo* in Russian) stands for both realism and the national art.

The longevity of the Wanderers' success was remarkable, as was the ubiquity of their appeal. True, the Association did not always hold to the moral standards of Kramskoy or to the civic penchant of the 1860s; its shows were filled with placid landscapes, banal social genre, and portraits of wealthy patrons. Nevertheless, each exhibit displayed one or two or more canvases whose explicit commentary on problems that agitated the educated public and was intended to elicit viewer response.

For example, the First Traveling Exhibit, held in 1871, took place in an atmosphere of concern for the fate of the reforms. The liberals gave the show a political welcome, hailing it as "a step of free, creative...artists," as an assertion of their "liberation from serf-like dependence on the Academy." And they singled out Nikolai Ge's canvas presented here in an 1872 version (cat. no. 13) of Peter the Great, the Tsar-reformer, questioning his rebellious, reactionary son Alexis, as a reminder that the reforms of the 1860s would fail unless there was continuing pressure and commitment from society. The response in the provinces, where the Traveling Exhibits brought not

just "free" art but fine arts as well for the first time, was equally ardent. Reviewers there exclaimed that the experience was like a "fructifying rain" which would "irrigate the parched soil and make it come alive again." Art, they felt, would "transform all people and all activities for the better."

The subject-matter and thrust of the Wanderers' paintings changed during the long period of their creative and sometimes irregular creative ascendancy. Broadly speaking, the Wanderers went through three stages, each with a different dominant spirit that expanded their repertory and their appeal. During the 1870s their art responded to and portrayed the rise of populism and the intelligentsia's search for solutions to the country's problems based on the wisdom of the common people (the *narod*) rather than through institutional reform *per se*. The new respect accorded to ordinary folk was reflected in the Wanderers' representation of the peasantry. Ivan Kramskoy's *The Forester* (1874; cat. no. 26) is a study of an intelligent, free-spirited character – a far cry from the sentimental portrayal of the downtrodden peasants who

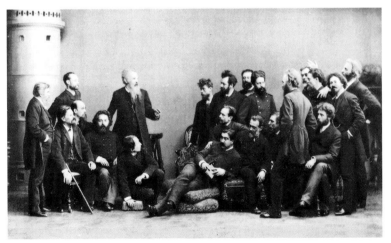

A gathering of The Wanderers in 1888. (standing, left to right) Beggrov, Dubovskoy, Shishkin, Maksimov, Briullov, Pozen, Yaroshenko, Savitsky, Nevrev, V.E. Makovsky, Repin, Miasoedov (seated, left to right) Kiselev, Volkov, Kuindzhi, A.M. Vasnetsov, Kuznetsov, Lemoch, Klodt, Prianishnikov, Bodarevsky

typified Realism during the preceding decade.

During the 1880s the Wanderers' art lost much of its reformist spirit. Nationalism engulfed the intelligentsia after Russia became embroiled in helping to liberate the Southern Slavs from Turkish rule. Thereafter, the Wanderers' art became more explicitly engaged in rendering the *Russianness* of various themes. This new turn is well exemplified in Mikhail Nesterov's *The Hermit* (1888; cat. no. 50), which depicts the deep spirituality of Russian religious tradition infused with elements of a pagan, pantheistic identification with nature. The interest in the earlier non-reformed Russia – i.e., before Peter the Great's attempt to elevate it to Western standards – which now surfaced in the Wanderers' history paintings (discussed below) is also evident in Apollinarii Vasnetsov's re-creation of seventeenth-century Moscow, *The Voskresensky Gates* (1900; cat. no. 91).

In part, the rise of nationalist preoccupation with things Russian for their sake prepared the way for the third stage, when the cherished hallmark of the Wanderers – the strictly observed separation between official art and free art – disappeared. In the 1890s Alexander III, eager to enhance the standing of his autocratic rule with a national school of painting, in effect co-opted the Wanderers.

The Tsar invited the leading Wanderers in 1891 to help reorganize the outdated Imperial Academy, which had remained unchanged since the 1860s and was still intent upon perpetuating "high art" in its Neoclassical garb. His overture split the Association. Its most talented members – Ilya Repin, Vasilii Polenov, Ivan Shishkin – joined Alexander III in reforming the Academy, for they were eager to rejuvenate the stale artistic scene with better schooling, up-to-date teaching methods, and, no doubt, the implicit official recognition of their own art. Two pictures in this exhibit relate to that episode, namely, Repin's portrait of Count Ivan Tolstoy (1899; cat. no. 74), who was appointed by the Tsar to reform the Academy with the

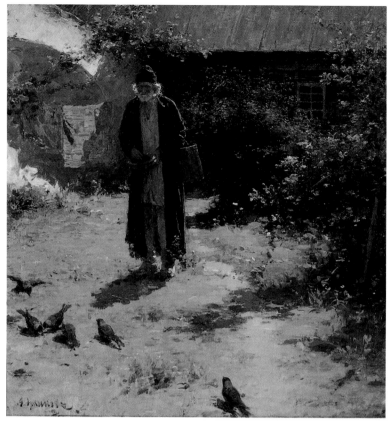

Arkhipov, *Lay Brother*, 1891 (*see* Cat. No. 1)

Wanderers' help and his *At the Academy Dacha* (1898; cat. no. 73), where teachers and students left the studios to paint outdoors.

The less talented Wanderers, opposed to any stylistic innovation, kept aloof and denounced their colleagues' cooperation with the Academy as a betrayal of free art. They continued to mount "independent" exhibits, but it must be noted that the character of these shows changed fundamentally. Already in 1890, before Alexander III embarked on his reform of the Academy, the Association for the first time enacted rules governing the style deemed appropriate for the Traveling Exhibits. The rules specified that submissions should "represent not painting for its own sake" but "should be...typical and of [general] interest. The Association also tried to stem the tide of change by exerting pressure on collectors to not purchase works that deviated from the strict canons of the representational Realism its members wanted to perpetuate. For instance,

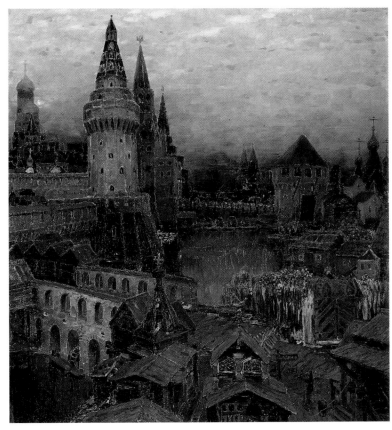

Vasnetsov, *17th Century Moscow at Dawn. The Voskresensky Gates*, 1900
(*see* Cat. No. 91)

they urged Pavel Tretiakov not to "infect" his gallery by buying a *plein air* portrait of a young woman painted by Repin's most talented pupil, Valentin Serov.

Neither faction in the Association, however, managed to rejuvenate or preserve Russian Realism. The 1890s marked the start of another creative surge in Russia's artistic life which soon blossomed into movements that contributed significantly to the mainstream of world art. Yet, despite the ferment and momentous changes of this period, the Wanderers continued to paint the old themes in the old way. Some, like Abram Arkhipov in his *Laundresses* (1899; cat. no. 2), were able to infuse their art with temperament and vigor. Others, like Nikolai Bogdanov-Belsky, represented here by two canvases, *At the School Door* (1897; cat. no. 5) and *Sunday Reading in a Rural School* (1895; cat. no. 6), continued to paint sentimental and banal repetitions of the Russian peasantry clad in their inevitable rags and bast shoes.

## THE PUBLIC RESPONSE

When the Wanderers defied the Imperial art establishment in 1870 by forming an independent association, they took more than a financial risk; they also faced official displeasure and obstruction for years to come. At the outset the Academy tried to patronize and co-opt them. After the First Traveling Exhibit opened in the Academy's cavernous halls, a Grand Duke proposed that the Wanderers combine their shows in St.

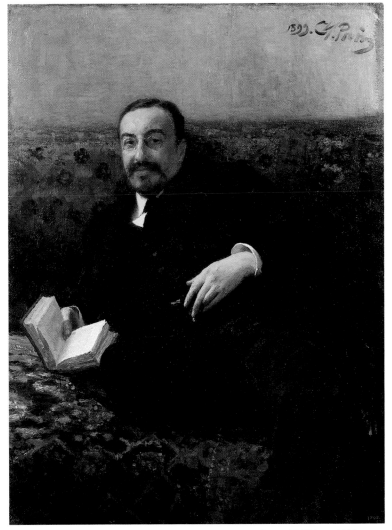

Repin, *Portrait of the Vice-President of the Academy of Arts, Count I.I. Tolstoy*, 1899
(*see* Cat. No. 74)

Petersburg with the annual Academic exhibits. When his proposal was turned down, the official world resorted to outright harassment. It refused them space in which to exhibit their traveling shows, and it never gave the Wanderers permission to construct a building where they could work, teach, and exhibit. Moreover, the Academy organized its own competing traveling shows, and the government altogether stopped commissioning works from the Wanderers.

The Association, however, did not fail because the public gave it their vote of confidence, both with their feet and their purses. Even though the rival Academic traveling exhibits were larger and visited more provincial cities, they never succeeded in outshining the Wanderers' shows, which were seen by more viewers, and from which more pictures were sold.

The rise of a new, middle-class patronage helped to alleviate the financial strain caused by the discontinuance of official commissions, and the range of the new patrons' interests sustained a variety of trends in the national school. The slim figure of Pavel Tretiakov (1832-98), the Moscow textile manufacturer, towered above this new class of patrons. He gave up collecting seventeenth-century Dutch art in the early 1860s, switched to purchasing contemporary Russian Realist art, and in 1874 opened his collection to public viewing. Tretiakov tended to favor documentary realism and regarded his collection as a patriotic mission that challenged the official stance and policies of the goverment and its Academy. Interestingly, until the opening of the Tretiakov Gallery, which flourishes in Moscow to this day, there was not a single museum in the vast Empire devoted solely to Russian art.

Equally important to Tretiakov, though for different reasons, was the railroad tycoon, Savva Mamontov (1844-1909), whose portrait by Valentin Serov (1891; cat. no. 79) hangs in this exhibit. Although Mamontov's tastes ran mainly to the decorative, he was avidly interested in all the arts – painting and sculpture, as well as theater and music. At his spacious home in Moscow from 1870 on and at his country estate Abramtsevo, which was set up as an artists' colony, painters mingled with writers and composers, including Rimsky-Korsakov, and theater directors like Stanislavsky. The genial host's enthusiasms for collaborative art often led to innovative ventures. In 1883, for example, Mamontov produced a Rimsky-Korsakov opera, *The Snow Maiden*, based on a Russian fairy tale, for which Victor Vasnetsov painted a decor patterned on the exuberantly detailed architecture of medieval Moscow. Mamontov's patronage inspired and supported the Wanderers' departures from strict Realism and topical subjects, helping to enrich their work with themes derived from the rich lore of medieval tales and epics, and with stylistic elements based on folk art.

The backing of the critics was no less crucial to the success of the Wanderers. Critical commentary sharpened the sense of challenge and novelty by juxtaposing the independent and innovative Wanderers' exhibits to the tired clichés presented at the Academy's shows. Beyond that, there was no uniform response. As was the case during the 1860s, different reviewers expected the new, free art to perform different public roles. Basically, there were two critical trends among supporters of the new, independent art. One trend carried on the original reformist traditions of the 1860s, while the other introduced new loyalist elements of appreciation and veneration for all things Russian.

Vladimir Stasov (1826-1906) was the most famous among those in the reformist camp. He is best known in the West as the promoter of the nationalist composers, who were known as the Mighty Five. But his ambitions and influence ranged far wider. In fact, the critic saw himself as conducting a troika of reforming talents – Modest Mussorgsky in music, Mark Antokolsky (cat. no. 27) in sculpture, and Ilya Repin in painting.

In painting, Stasov relentlessly pressed for the expression of a national and popular spirit. He wanted Russian art to be "national" in the sense of being readily identifiable (mainly through content) as different from French or German art. It also had to be "popular" in the sense of representing the life

of the common people, in order to awaken a greater under-
standing of their plight among the middle and upper classes.
Stasov's advocacy of a return to the national path, however,
was not coupled with a blind reverence for native traditions.
For one thing, he did not regard the peasantry as the reposi-
tory of all moral and poetic values. He looked at the people
*(narod)* solely from the social side. For him, the common folk
and their mentality epitomized Russia's ills – political, cultural
and social. The *narod*, he believed, had to be wrenched out of
their backward ways and isolation so that the country could be
transformed. Thus, his message was a reformist one, and
Stasov denounced the "passion for the past" as the prime
obstacle to change ranging from contemporary interest in
medieval history to then popular fixation on peasant bast
shoes.

Adrian Prakhov (1846-1916), an art historian and critic, saw
the mission of the Wanderers in a different light. In the 1870s
he briefly published an illustrated magazine, *The Bee*, which
was instrumental in popularizing these painters through
numerous reviews and reproductions. But Prakhov's apprecia-
tion of the Wanderers' art derived from another premise. The
aim of his magazine, subtitled "Russian Illustration," was to
provide "a pictorial geography and ethnography of Russia and
the Slavic World" – in other words, its intent was to inform
and to popularize, not to enlighten or change mankind. To
this end, Prakhov advocated that the Wanderers cease being
associated exclusively with "tendentious" social issues and
embrace, instead, the full richness of national life as displayed
and preserved by the common people in their customs, songs,
and legends.

Although Prakhov praised the Wanderers' art for being
"free" and referred to the 1863 secession as the day on which
Russian art was liberated, he gave the words a novel meaning.
Realist art, he felt, was not set free from Academic controls to
serve the transformation of Russia, but to depict native sub-
jects of interest to everyone.

The Prakhov line is significant because it was close to the

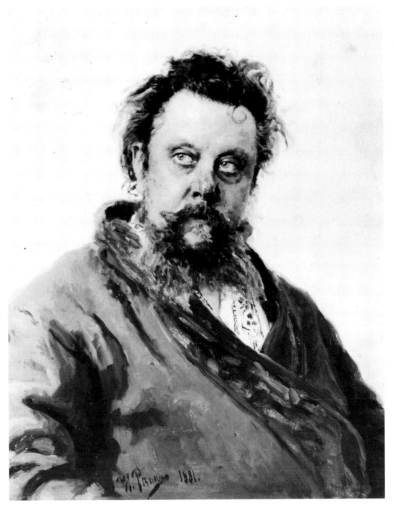

Repin, *Portrait of M.P. Mussorgsky*, 1881 (Tretiakov Gallery)

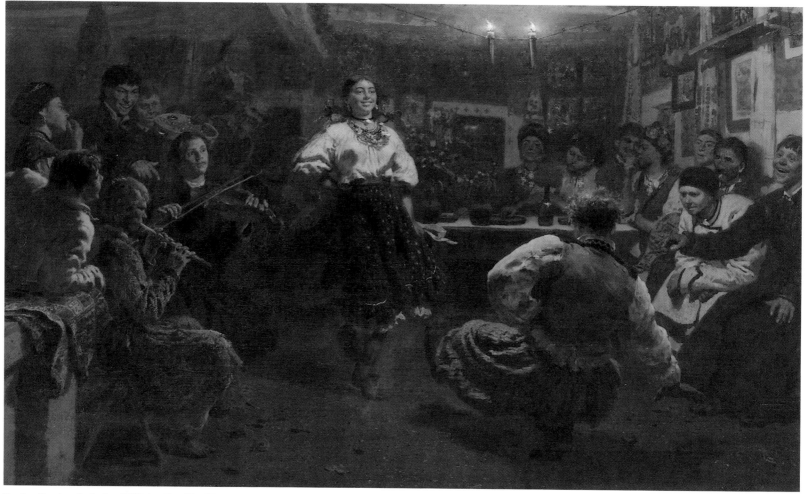

Repin, *Evening Gathering*, 1881 (*see* Cat. No. 69)

expectations and responses of the public at large. It also bears similarity to that of the composers who sought to create a national music. Modest Mussorgsky (1839-81), for one, became engrossed in the high drama of Russian history before Peter the Great (pre-Petrine), and wrote operas, *Khovanshchina* and *Boris Godunov*, dealing with seventeenth-century events. More specifically, both in the operas and songs and in other works like "Pictures at an Exhibition," he labored to write music that expressed the cadence and the idiosyncracies of everyday Russian speech. As he wrote to his good friend Ilya Repin: "It is the people I want to depict; when I sleep I see them, when I eat I think of them, when I drink they appear to me – integral, large, unvarnished...What an inexhaustible ore for grasping everything that is real in life!"

The correspondences between the art of the Wanderers and literature are not as close and direct. The search for national roots did not much affect the important contemporary writers. Since the age of Pushkin early in the century, Russia had a genuine national literature dealing with Russian subjects and written in the everyday spoken language – a literature that was not overtly patterned on foreign models. There was no felt need among the intelligentsia to free Russian literature from foreign domination, as was the case with painting and music.

Nevertheless, the populist trend in literature during the 1870s did to some extent parallel developments in art by seeking inspiration from and portraying the fate of the peasants. Here the work of Vsevolod Garshin (1855-88) is fairly typical. He enlisted in the war against Turkey so as to report the suf-

ferings of the common soldier. His heightened sensibility about an artist's obligation to the people emerges clearly in his short story, "The Artists," in which he contrasts two types of painters – the one blithe and carefree, producing idealized landscapes; the other obsessed with how to show compassionately the sufferings of the worker. Reviews by Garshin and other populist writers of the Traveling Exhibits interpreted the Wanderers' canvases within the parameters of this dichotomy of commitment.

Reviews of the First Traveling Exhibit noted that the Wanderers had "spoken with a new language" hitherto characteristic of poets and novelists but not of painters. What were the elements of this new language that spoke so eloquently to the public, enabling the Wanderers' art to hold center stage for such a long period? Three qualities – emotional commitment, typicalness and topicality – assured its appeal and continuing popularity.

Kramskoy's comment in a letter of 1885 to a publisher on the attitude of the painter toward his subject furnishes a revealing clue of the basic approach of the Wanderers:

"An artist, as a citizen and as a man, . . . without fail *loves* something and *hates* something. One assumes that he loves that which is noble and hates what deserves hatred. Love and hatred are not in the least logical deductions but are feelings."

This attitude indicates that personal commitment was uppermost for these painters. Indeed, emotional involvement became, over time, more important than critical commentary. Whatever they painted – whether a landscape, Christ, or an imprisoned revolutionary – the Wanderers did so with intensity and expected viewers to respond in a like manner. In 1891 Repin wrote eloquently to Stasov that the "artist must believe in what he paints..., and the viewer must not judge whether [a canvas] is well or poorly painted; he should be captured by the image, the live people and the drama of life." Elsewhere he commented that a picture should touch the viewer like a chord in music – and overwhelm him emotionally. His *Evening Gathering* (1881; cat. no. 69) aptly makes this point, as

Savitsky, *A Group Saying Farewell*, 1880 (*see* Cat. No. 76)

its swirling composition reinforces the sense of music, dance, and fun.

A second quality the Wanderers cultivated was to paint the general, the common, not the incidental or the particular. Kramskoy's correspondence with other artists abounds with admonitions to paint the typical scenes and the typical representatives of different social classes. (At present), he argued in a letter of 1878 to V. Vasnetsov, "type alone constitutes the whole historic task of our art." This approach was also the view

that guided Tretiakov in his selections. He wanted his Gallery to provide his contemporaries and the generations to come with a representative account of Russia: its history, its landscape, its people and activities.

Even if a Wanderer's canvas portrayed but one person or event, it was meant to convey some typical, characteristic, or general concept. Thus, when Nikolai Yaroshenko painted a portrait of Anna Chertkova, who with her husband was active in publishing educational readings for the lower classes, he called it *The Girl Student*. By giving the painting a general title, Yaroshenko intended the portrait to commemorate the dedication that characterized these populists engaged in bringing enlightenment to the people.

Thirdly, the Wanderers painted topical subjects. Essentially, they narrated the story of what Russia was living through during the thirty or so years of their ascendancy, times that were marked by rapid social, economic and cultural change. Their pictures gave viewers a commentary on current happenings, and to succeeding generations a pictorial documentation of the past. In this sense, Klavdii Lebedev's *Visiting Their Son* (1894; cat. no. 35), showing a simple peasant couple's encounter with their citified offspring, is not simply a sentimental story. It also records the vast social change the country was undergoing as a result of industrialization and urbanization. Similarly, Konstantin Savitsky's large *Off to War* (of which an 1880 fragment is shown; cat. no. 76) depicts not just the tearful parting of soldiers before boarding a troop train, but also Russia's support for the Bulgarians in their uprising against their Turkish overlords, a policy of the Tsarist regime that was widely endorsed by the liberal intelligentsia.

THEMES IN THE WANDERERS' PAINTINGS
The range of themes covered by the Wanderers was another source of their popularity and accounts for why they came to be regarded as the national school, a designation that transcends the narrower aims of their initial Association. The best demonstration of this is the fact that *landscape* painting, dis-

Lebedev, *Visiting Their Son*, 1894 (*see* Cat. No. 35)

missed as "pointless" by radicals and liberals alike, occupies such a large part of their *oeuvre*. At the First Traveling Exhibit, 22 canvases out of 46 were landscapes, and in subsequent exhibits the proportion was sometimes even higher.

Aleksei Savrasov's *The Road into the Forest* (1871; cat. no. 77), with its unaffected view of the Russian countryside marked a sharp break with the idealized vision that had characterized the nascent Realist art of the 1860s – a manner that has been

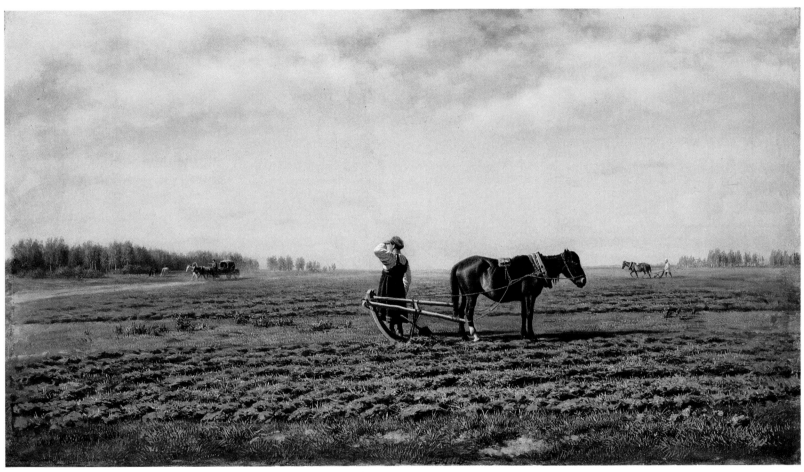

Klodt, *In the Ploughed Field*, 1871 (*see* Cat. No. 20)

patterned on Western trends, either the Dutch or the Düsseldorf schools. These early trends are represented in the exhibit by Aleksei Bogoliubov's *The Mouth of the Neva* (1872; cat. no. 7) and M. K. Klodt's *In the Ploughed Field* (1871; cat. no. 20). With Savrasov, the poetic rendition of quintessential aspects of Russian scenery entered the idiom of the Wanderers.

Most Wanderers liked to depict the gentle, unassuming beauty of their native land. Russian scenery had been similarly described and celebrated in literature since Pushkin, but it was the Wanderers who first captured it in pictorial language.

They painted the meandering, not the mighty, flow of the country's numerous rivers, as in Vasilii Polenov's *The Oyat River* (1890; cat. no. 63); the promise of spring after the long harsh winter in two works by Levitan (cat. nos. 36 and 42); the stillness of deep forest, for which Ivan Shishkin was renowned (cat. nos. 80, 83, 84), and the enveloping expanse of endless fields, as seen in another Savrasov landscape (cat. no. 78). Isaak Levitan (1860-1900) was the most celebrated and technically most accomplished painter of Russian landscapes. He was a close friend of Anton Chekhov, who highly valued the painter's gentle, evocative canvases.

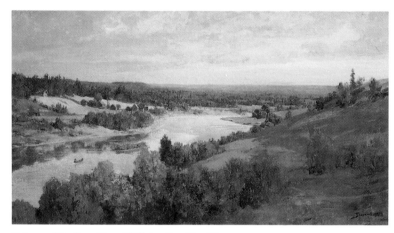

Polenov, *The Oyat River*, 1890 (*see* Cat. No. 63)

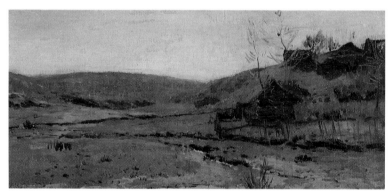

Levitan, *Spring. Khotkovo*, 1880s (*see* Cat. No. 42)

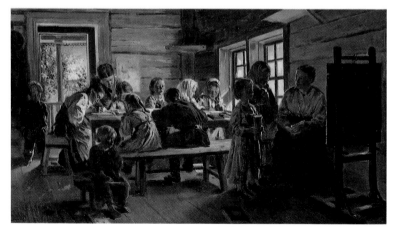

Makovsky, *In a Country School*, 1883 (*see* Cat. No. 46)

Arkhip Kuindzhi's more dramatic use of color and choice of subjects, excellently displayed in his four canvases in this exhibit (cat. nos. 29, 30, 31 and 32), stand somewhat apart from the commonly appreciated hallmarks of the Wanderers' landscapes. This difference, noted at the time, was often attributed to his Greek background.

The great majority of the *social genre* scenes produced by the Wanderers was similar in intent to their landscapes, though of far lesser artistic excellence. They painted the customary happenings and pastimes. This exhibit gives a representative sample: religious holidays (Vasilii Baksheev's *Maundy Thursday*, 1915; cat. no. 4); family celebrations (Aleksei Korzukhin's *Grandmother's Holiday*, 1893; cat. no. 22); other familiar activities (Vladimir Makovsky's rural school scene, 1883; cat. no. 46); and traditional sights and events of the countryside (Illarion Prianishnikov's *Returning from the Fair*, 1883; cat. no. 65).

It cannot be inferred, however, that the Wanderers wholly abandoned their original ethos. Their *portraiture* and their commemoration of the revolutionary movement attests to its continuity. To be sure, they painted lots of ordinary, run-of-the-mill portraits of wealthy patrons or beautiful women. But they also bequeathed to the nation an extensive gallery of cultural luminaries. Their likenesses of Tolstoy and Dostoevsky, for instance, are to this day the mental image most Russians have of the two writers. In part, this project was sponsored by Tretiakov, who wanted his gallery to be a pantheon of national culture and so commissioned numerous portraits of writers (cat. nos. 54 and 55), composers (cat. no. 68), and scholars (cat. no. 66). In some cases the portraits were painted posthumously, such as Kramskoy's portrait of the witty playwright and poet Aleksandr Griboedov (1873; cat. no. 25).

But the painters also regarded these commissions as their patriotic duty and strove to convey the importance and lofty aims of their sitters. Kramskoy's 1877 portrait of the civic-minded poet Nikolai Nekrasov well exemplifies that spirit. When Kramskoy started the portrait, the poet was sick, and the

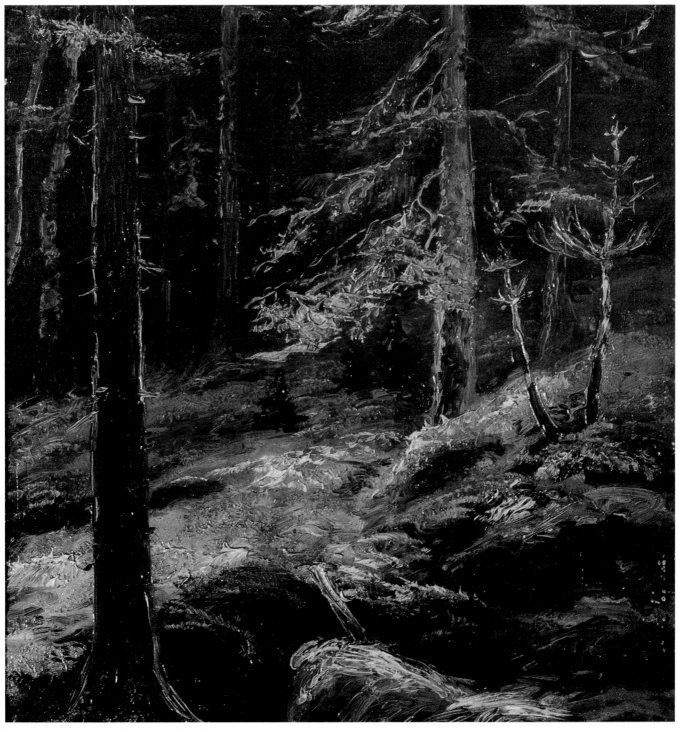

Shishkin, *Mixed Forest*, 1888 (*see* Cat. No. 84)

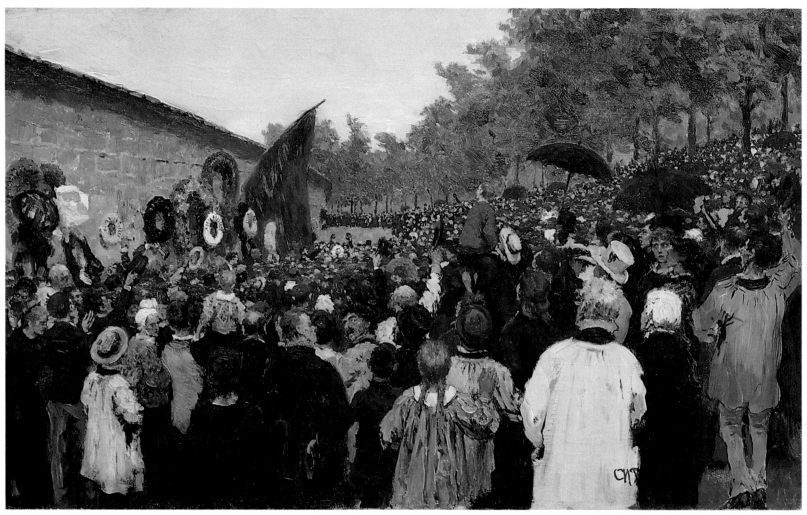

Repin, *Annual Meeting in Memory of the French Communards at the Père Lachaise Cemetery in Paris*, 1883 (*see* Cat. No. 71)

first sketches simply showed him reclining in bed, surrounded by allusions to his passion for hunting – a hound dog, guns, etc. Nekrasov died before the portrait was finished, and Kramskoy altered the composition drastically. Paper and pencil were put in the subject's hands and the hunting equipment was replaced by more consequent references: a bust of the critic Vissarion Belinsky (1811-48), who first broached the issue of moral-civic responsibility in literature; portraits of the radical critic Dobroliubov and of the Polish romantic poet and patriot Adam Mickiewicz. Instead of an anecdotal portrayal of the ardent hunter trapped by illness, there emerged the personification of a dedicated public life with the attendant symbols.

The portrait of Nikolai Ge (1890; cat. no. 96) is a fine example of how the same linkage between an individual and a public cause survived in the Wanderers' best canvases. Yaroshenko's work is not merely a likeness of the painter but also a statement redolent with references to issues that agitated the cultural elite at the time. By including a fragment of Ge's religious painting *What Is Truth?* in which an arrogantly self-assured Pontius Pilate questions a haggard-looking Christ – Yaroshenko celebrates Ge as a religious painter of Tolstoyan persuasion. By 1884 Ge had become a convert to Tolstoy's heretical religious views, and he painted a series of canvases designed to point up the contrast between true religion based on individual conscience (as advocated by Tolstoy), and false

religion (that imposed by the Russian Orthodox Church). The portrait was an outspoken gesture in support of the civil courage of Tolstoy and his followers, who ran a grave political risk in rejecting the state creed – a stance for which Tolstoy was eventually excommunicated in 1901.

The Wanderers were cherished by the intelligentsia for commemorating their revolutionary endeavors. This exhibit is fortunate to have one fine example by Ilya Repin, who painted the best and most renowned canvases on the *revolutionary theme*. His *Annual Meeting in Memory of the French Communards at the Père Lachaise Cemetery in Paris* (cat. no. 71), done in 1883 during a visit to France, is a painterly testimonial of the first rank to Repin's keen interest in the Paris Commune and the hopes embodied in radical protest, which could be openly expressed abroad.

*They Did Not Expect Him* (1884), Repin's best work of this genre, represents a more oblique comment on the situation in Russia, where the absence of free political institutions shaped public attitudes. The painting deals with a new turn in the history of Russia's revolutionary movement. Beginning in 1878, young radicals turned to terrorism. In 1882 Alexander II was assassinated by a bomb thrown under his carriage and several young women were involved in the plot. This act of regicide compelled the intelligentsia to re-examine its objectives and the means by which to achieve them. Opposition to autocracy was shared by all Russians of principle. Hence, even though few condoned terrorism, none could repudiate their active anti-tsarism either. The revolutionaries' commitment and the courage of their convictions elicited admiration among armchair liberals at the same time that terrorism aroused revulsion.

These conflicting attitudes, indeed the loss of certitude, are subtly conveyed in Repin's canvas through the undefined, enigmatic relationship between the returning prisoner and the assembled company. We are not sure how he is related to the two women and the children – is he a son, husband-father, or a brother? We are unsure of how he is going to be received

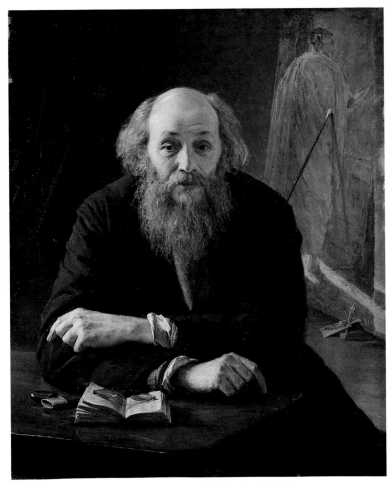

Yaroshenko, *Portrait of the Artist N.N. Ge*, 1890 (*see* Cat. No. 96)

– with reproach or with open arms? The uncertainties and ambiguities are underscored even more in the returning man's facial expression, a mixture of suffering, confusion and guilt. One critic, sensing the dilemma suggested by the canvas, asked: "Are we witnessing the end of one tragedy, or the start of a new one?"

The Wanderers' canvases on the revolutionary movement were, in a way, *historical* paintings of contemporary events. (Indeed, *They Did Not Expect Him* was occasioned by the general political amnesty proclaimed by Alexander III at his coronation, when Chernyshevsky, among others, was released from exile after almost thirty years.) But the Wanderers also painted the past. At the outset, the best known canvases dealt with Peter the Great, the inescapable symbol of Russia's Westernization and an apt subject for commenting on the fate of reforms at that time. As mentioned above, the First Traveling Exhibit displayed Nikolai Ge's *Peter and Alexis*, showing the Tsar interrogating his disloyal and reactionary son. It was a pointed if oblique reminder to the public that the impetus for reform, begun in the 1860s, should not slacken. By contrast, Aleksei Bogoliubov's *Peter the Great Bicentennial Celebration* (1872; cat. no. 8) is an example of the objective attitude toward the past. Its predominant interest is in costume, color, and tonality, not in latter-day analogies.

By the 1880s the rise of neo-Slavophile nationalism among the intelligentsia spawned great interest in the pre-Petrine period, as well as in the glorification of Russia's military exploits in the distant and not so distant past. Vasilii Surikov was the most talented of the history painters who pursued this later trend. This exhibit includes three of his studies for a large canvas *Boyarina Morozova* (1887; cat. nos. 86, 87, 88), which glorified in lush colors the martyrdom of the religious sect of Old Believers for their defense of the old rituals against the modernizing reforms imposed by the state in the seventeenth century. Surikov's study of Cossacks (cat. no. 85) is related to a topic that occupied him later – Russia's conquest of Siberia.

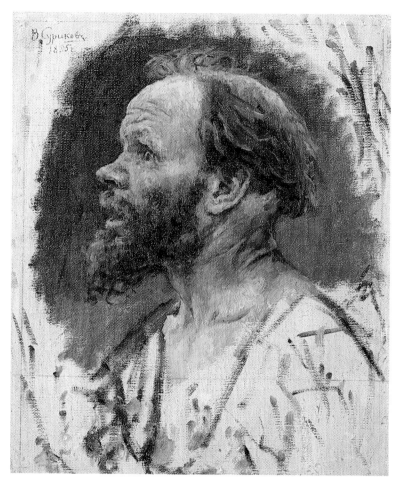

Surikov, *Head of a Fool*, 1885 (*see* Cat. No. 86)

It is worth noting that while the liberal exponents of the original Wanderers' ethos welcomed and supported the pre-Petrine, the Muscovite, and subjects in music, they frowned upon their use as subjects in painting. Stasov suggested to Borodin that he compose an opera about the semi-legendary, twelfth-century Prince Igor, who defended Russian fiefdoms against invading Mongols, and Stasov enthusiastically endorsed Mussorgsky's opera on the Old Believers, *Khovanshchina*. But he made a chilly dismissal of Surikov's *Boyarina Morozova*, noting that "we cannot be moved any more

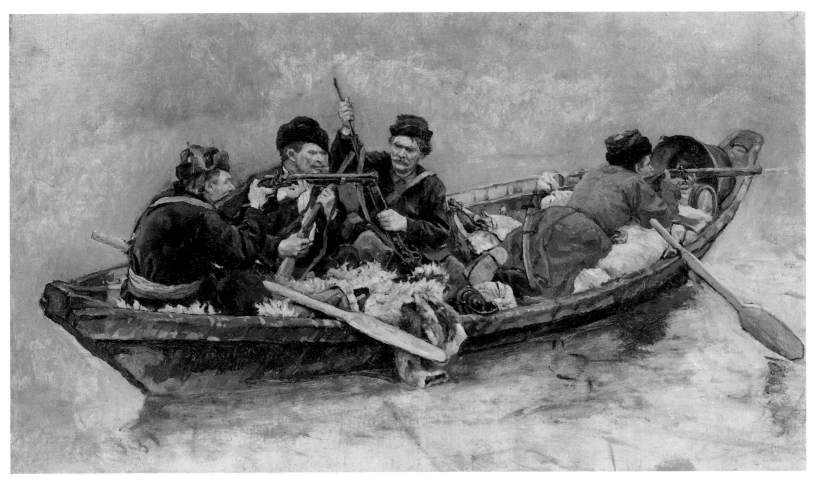

Surikov, *Cossacks in a Boat*, c. 1893 (*see* Cat. No. 85)

by the issues which agitated this poor fanatical woman some two hundred years ago; we are now faced with completely different problems, deeper and broader." Garshin was not taken with "Morozova" either. For him, she was nothing but a misguided fanatic who embraced martyrdom to uphold some obscure rituals and tenets of the old religion, and could not serve as inspiration to those who labored for justice, truth and goodness. Kramskoy, for his part, kept reminding painters that they should select "meaningful" subjects that were more in keeping with the Association's civic-minded and morally reflective principles. But both Tretiakov and Mamontov, no less than the public, readily approved of the new trends – an infatuation with the mythic, epic past and with Russia's manifest destiny – and these subjects came to predominate in the Wanderers' later historical genre.

CONCLUSION

The story of the Wanderers as a style and institution would not be complete without some reference to the subsequent fortunes of the movement after its creative phase had passed.

During the 1890s, at the same time as the Wanderers gained preeminence as the officially blessed-national school, they lost respect among creative artists. That decade saw signs of revolt against the Wanderers. Painters young and old, dissatisfied with the by now hoary routine and lack of artistic plurality, began to hold either their own one-man shows or to organize competing exhibiting associations. The long monopoly the Wanderers had enjoyed, expressing and defining the course of art in Russia, came to an end.

True, the best contemporaneous art historian, Aleksandr Benois (1870-1962), did acknowledge the Wanderers' contribution, especially that of Ilya Repin, for having enlivened the scene with genuine artistic temperament. But in the avalanche of changing styles and groups that appeared in Russia before the outbreak of World War I – beginning with the Symbolists and ending with the Cubo-Futurists – the Wanderers were contemptuously dismissed for their lack of talent and uniformly criticized for their stranglehold on the nation's artistic life through the Academy of Arts, which controlled not only education but government commissions as well.

After the Bolshevik Revolution the fortunes of the Wanderers fared even worse. The change in the system brought them further opprobrium; they were charged with being part of the oppressive political institutions of the past. That reputation was so constraining that after the 47th Traveling Exhibit in 1922, several younger members of the Association bolted. They set up a rival grouping, the Association of Artists of Revolutionary Russia (known as AKhRR in its Russian acronym) and proclaimed adherence to a new "heroic" Realism to serve the revolution and the Soviet regime. Their offer, however, was not taken up by the authorities. Despite their monopoly of political power, the Communists abstained from controlling the art scene, and as a result, a multitude of styles and groupings functioned freely during the 1920s. The situation changed drastically in 1932 when the government dissolved all artistic associations, plac-

ing them in a single, nationwide professional organization, the Union of Soviet Artists. Furthermore, the government imposed a single official style – that of Socialist Realism – decreeing it to be the style best suited for the construction of a socialist society.

Socialist Realism was first defined by the government for writers, who were regimented like all the other creative professionals, as the "true and historically concrete depiction of reality in its revolutionary development [aimed at] educating the workers in the spirit of Communism." As for painters in 1933, Socialist Realism was more succinctly defined by a functionary in the new cultural administration as "Rembrandt, Rubens and Repin...from whom our painters should learn, whom our painters should take as their starting point" in order to best "serve the working class."

Thus, by a cruel turn in history, the Wanderers – whose chief contribution to Russian art was to liberate it from stylistic routine and official control – came to be resuscitated by the government some 60 years later as a means by which to help enslave creative expression on a scale that was never attempted in Tsarist Russia. The Wanderers' art became the obligatory model for an official art serving narrowly defined political ends. The post-1932 resuscitation and rehabilitation of Russian nineteenth-century Realism was carried out by such illegitimate means as falsified art history, doctored art exhibits, and the wholesale purging of art museums of various post-Realist trends denounced as "decadent."

Through such measures Stalin's regime managed to transform the rich and praiseworthy heritage of the Wanderers into an impoverished and despicable formula that had little in common with the original liberationist spirit of the Association and its freely rendered service to the Russian public. The Stalinist reinterpretation of the Wanderers' history glorified their least laudable features – those which the Association acquired during the movement's decline – such as intolerance toward innovative trends at home and abroad, and unquestioning loyalty to the political establishment.

Dr. Sarabianov's essay in this catalogue is eloquent testimony to the de-Stalinization that has taken place in Soviet art history in more recent times. He presents a number of revisionists views that restore historical veracity. First of all, Dr. Sarabianov relates the rise of Russian Realist art to the general European context, thus putting an end to the past Soviet tendency to present the Wanderers as a unique Russian phenomenon – and one of unmatched excellence at that. Furthermore, he outlines the different phases of the movement – not all of them of equal creative importance – as well as distinguishes between the true talents and the epigones. During the Stalinist period, all Wanderers – from the enormously talented Ilya Repin to the banal genrist Konstantin Makovsky – received the same unstinting praise. Finally, Dr. Sarabianov gives a well-rounded, full description of the Wanderers' commitment – to art as well as to society. He thus rescues the group from the distorted Stalinist version that pigeonholed them as single-minded followers of Chernyshevsky's positivist aesthetics.

In a sense, then, this exhibit, the first to introduce American viewers to an important phase of Russian art, marks yet another milestone. It is accompanied by an essay, written by the foremost Soviet historian of Russian nineteenth-century art, which documents in a tangible sense the tremendous cultural transformation occurring in the USSR at the present time – a liberating transformation that, among other things, also involves the de-politicalization of culture.

Bibliography

Benois, Aleksandre. *The Russian School of Painting*. New York: Knopf, 1912.

Bird, Alan. *A History of Russian Painting*. Oxford: Phaidon, 1987.

Gray, Camilla. *The Russian Experiment in Art, 1863-1922*. London: Thames and Hudson, 1986.

Hamilton, George Heard. *The Art and Architecture of Russia*. New York: Penguin Books, 1983.

Kennedy, Janet. *The 'Mir Iskusstva' Group and Russian Art*. New York: Garland, 1977.

Sarabianov, Dmitrii. *Russian Art: From Neoclassicism to the Avant Garde (1800-1917)*. New York: Harry N. Abrams, Inc., 1990.

Stavrou, Theophanis G., ed. *Art and Culture in Nineteenth-Century Russia*. Bloomington, Ind.: Indiana University Press, 1983.

Valkenier, Elizabeth. *Russian Realist Art, the State and Society*. New York: Columbia University Press, 1989.

Valkenier, Elizabeth Kridl. *Ilya Repin and the World of Russian Art*. New York: Columbia University Press, 1990.

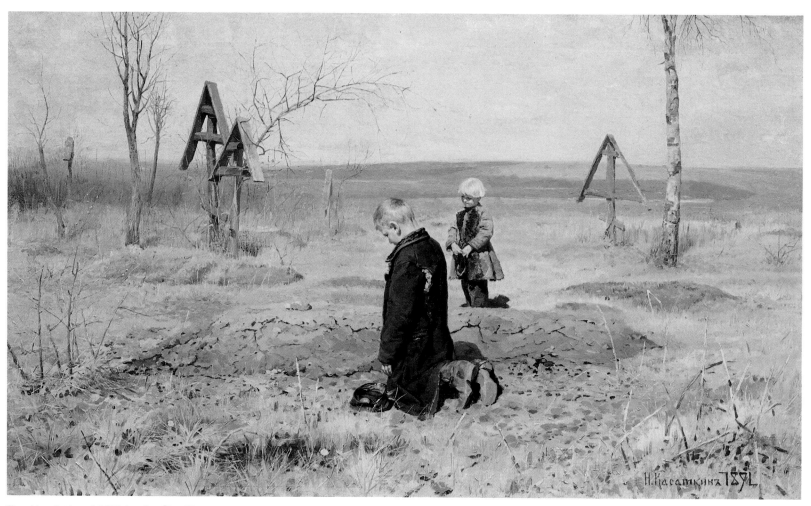

Kasatkin, *Orphaned*, 1891 (*see* Cat. No. 17)

# The Rise and Fall of the Wanderers

BY DMITRII SARABIANOV

In November 1869, the St. Petersburg Artists' Cooperative (Artel) was contacted by a group of Moscow artists who suggested the formation of an Association of Traveling Art Exhibits. These Moscow artists included Grigorii Miasoedov, Vasilii Perov, Nikolai Ge, and Aleksei Savrasov, but their letter was also signed by Ivan Kramskoy, then residing in St. Petersburg. A business correspondence ensued, which codified the statutes of the proposed Association. A year after the Muscovites' initiative, in November 1870, the Association which was to become known as the "Wanderers" (*peredvizhniki*) was legally established and endured to the year 1923.

Several stages mark the history of the Association, the first two decades, 1870-1890, were its years of greatest creative achievement. Of equal importance in the history of the Wanderers' movement is its prehistory. Here, one might glance beyond the borders of Russia, to set the Association within a more general framework. From the very beginning of the nineteenth century, artists in various countries were seeking new procedures for pooling their resources. By that time, former methods of operation, such as guilds and large *ateliers* attached to palaces, had become obsolete. The academies, which in the eighteenth century had played a considerable role in establishing a system of education and in defining relations between artists and the state, were gradually emerging as citadels of conservatism and as obstacles to artistic evolution. This situation further revealed the need for new types of artistic organization, which would have to differ sharply from earlier ones in order to accommodate the individualization of

artistic activity itself. Easel painting was now the dominant art form, replacing the decoration of palace halls or vast churches; it was best suited for private dwellings, exhibition display, and museums.

In the early and mid-nineteenth century some attempts were made in western Europe to bring artists together within a traditional religious context. The German Nazarene movement, which gave rise to the Brotherhood of St. Luke, somewhat resembled a medieval guild; it was romantic in aspiration and religious conviction. Several decades later the Pre-Raphaelite Brotherhood likewise concerned itself with spiritual values and cultivated archaizing artistic goals.

The Salon form of exhibitions possessed greater vigor and appeared more promising. It had already played a considerable role in eighteenth-century France; in the nineteenth century, the power of the Salon increased as it became the main arena in which various artistic tendencies played out their battles. Its important function as a museum-like exhibition setting for the art of the period was somewhat attenuated by the ephemeral nature of the event, which prevented the development of a common ground for any artistic goals or programs.

The Wanderers' Association combined the ideological scope of a brotherhood with the Salon tradition as a center for exhibitions and sales. The result was a new type of organization. There had been similar attempts in other countries. In Germany, an artists' circle of 1848 was followed by the Union of German Artists of 1866; in Bohemia, there were the Artists' Union and the Artistic Assembly; in Italy, the painters of realist

tendencies founded the group known as the Macchiaioli, but failed to strengthen it through a formal organization. In France, the bitter opposition of Realists to the Academy might have stimulated their forming a cooperation; at the time of the Universal Exhibition of 1855, Courbet prepared his personal exhibit of Realism in his own pavilion; but when, a few years later, a group of students who declared themselves to be his followers left the Academy, no organization resulted. By the time new organizations did arise, such as the Salon des Indépendants, which included the Impressionist painters, the realist stage of artistic development was already well past.

In Russia, where developments lagged behind those in the West, the foundation of a new type of artistic union coincided with the growth and maturation of Realism. There was a close identification between Realism and the Wanderers, although the Russian group possessed a distinct prehistory. The Association's immediate forerunner was the St. Petersburg Artists' Cooperative (Artel), founded in 1863 when a group of students headed by Kramskoy left the Academy in protest against the rules governing their Gold Medal competition. A comparison between the Cooperative and the Wanderers' movement reveals some major differences between them. Both were free organizations, supported by no one, helped by no one, depending upon no one's taste or dictum. However, the Cooperative's utopian ideology undermined its effectiveness. Its artists worked and accepted commissions in common. Their financial objective was limited to a minimum aimed at covering their expenses and the support of their families. In contrast, the Association was established to operate more in keeping with the capitalist ethic of the bourgeois. This aim, which intensified with time, favored those artists whose works were popular with the public. Without that principle the group could not have survived the 1870s, a decade of profound socio-economic change. In contrast to the 1860s, the market principle came to dominate all spheres of life, especially in the cities.

In addition to this commercial goal which was considered by

the Association's founders as a precondition for the creative activity of its artists, there was another objective – to popularize art through exhibitions that "wandered" to various cities of Russia and especially to those in the provinces. This "artistic enlightenment" could not but be affected by the general trend of the times toward social enlightenment. This trend predominated in the activities of the Wanderers, transforming

V.G. Perov

the group into an organization with democratic goals and a fairly precise, albeit unwritten, socially progressive program. The educational nature of the association's activities constitutes its most distinct difference with the Cooperative. It must also be pointed out, however, that the sixties, the period of the Cooperative's existence, had been one of genuine idealism. The progressive segment of society was imbued with the faith that Russia, tired and sick though it was, would be able to regain its health, if only its social ills were submitted to the light of criticism. For the most part, in the painting of the sixties, these ideas were given expression in the work of Moscow artists rather than those belonging to the St. Petersburg Cooperative, who had, after all, been educated in the tenets of the Academy before leaving the institution. In Moscow there arose a group of artists, under the leadership of Vasilii Perov, that became the precursor of the Wanderers. Nearly all of them were graduates of the Moscow School of Painting, Sculpture, and Architecture, whose students enjoyed much greater independence and freedom from regulations than those of the St. Petersburg Academy. Although these Moscow artists had no formal organization, they worked side by side in close collaboration, formulating their common themes and subject-matter, which derived in large measure from current literary and theatrical sources. These sources, in turn, relied upon their knowledge of Moscow itself for their realist depiction of scenes from ordinary life. The Moscow painters developed compositional and painting methods which, while still dependent on academic teachings of the first half of the nineteenth century, constituted an important step toward Realism.

Thus, it is evident that the direct predecessors of the Wanderers emerged from two groups. The first, the Artists' Cooperative, provided a model of artistic organization without contributing significant artistic ideas. The second, Moscow painters of the sixties who had no organization, prepared the ground for the Wanderers' artistic success. Both groups supplied leaders to the new Association. Ivan Kramskoy, the moving spirit behind the student revolt at the Academy and the

Cooperative's director, was one; the other was Vasilii Perov, the true leader of the Moscow school, albeit without a title. They were both active in setting up the Wanderers' organization and later became part of its membership.

The sixties presaged a trend that developed more fully in the seventies, during which the collective seemed to absorb the individual. This phenomenon was all the more remarkable

Repin, *Portrait of N.N. Ge*

since the preceding half century had been marked by the appearance of strong individuals, intent on asserting their own personalities rather than following current artistic formulas. One of these was Pavel Fedotov, whose training at the Academy was minimal; he achieved a high mastery of art and gave new meaning to the painting of genre; his later works succeed in expressing the full tragedy of human existence. Such also was the case of Aleksandr Ivanov who overcame the academic system from within by imparting a new direction to history painting. Even earlier, in the twenties and thirties of the nineteenth century, Aleksei Venetsianov, who gave rise to a whole school of followers, developed a poetic interpretation of contemporary peasant life through his own vision. By the sixties and seventies the individualism of these predecessors was transformed into a belief in "collective wisdom" which affected all members of the Wanderers' group. It is no accident that strong personalities felt constrained within the Wanderers' ranks. One example is Nikolai Ge. Innately a romantic to his dying day, he submitted to the canons of the Wanderers' art. It was not until the first serious crisis of the movement in the nineties that he was able to achieve the late unfolding of his talents. Worth mentioning also, is the original work of the landscape painter Arkhip Kuindzhi, who resigned from the Association at the end of the seventies. Equally telling, is the fate of Ilya Repin, another strong individualist, whose intentions fully seemed to coincide with the general principles of the Association, yet who had periods of estrangement, of departures and returns to the fold. In short, there reigned a system of collective artistic thinking that embraced a general creative method, its artistic execution, and fundamental principles relating to the artists' goals and their social implications.

The dominant ideas were those of the Russian democratic critics, first expressed in the forties by Vissarion Belinsky and further developed in the fifties and sixties by Nikolai Chernyshevsky who insisted that art is an educational tool; that reality must always have priority over art; that art must bear witness to reality; and that it must articulate society's verdict, teach and enlighten.

Repin, *Portrait of Vladimir Stasov*, 1873

Obviously, not all the Wanderers followed these directives to the letter – far from it. Genuine social activism very often gave way to a passive attitude toward life which resulted in descriptive genre and cast doubt on the very premise of art's service to society. Furthermore, by the seventies and eighties, the height of the Wanderers' movement, Chernyshevsky's opinions had lost some of their luster. There were now additional voices: Tolstoy's sermons, the precepts of Dostoevsky, and some influence on social thinking on the part of the later Slavophiles; the ideas of the Populists, who admired the peasantry and were ready to face execution for its sake but failed to make themselves understood by the common folk, were widely disseminated. One cannot regard the Wanderers as followers of any one of these tenden-

cies. Rather, their social ideas developed under the influence of various ideologies, to which were added their own interpretations of the surrounding world and of artistic problems.

Despite its complex origins, the Wanderers' program may be reduced to three fundamental concepts: Realism, populism, and national identity. Similar beliefs motivated the liberal critics who gave support to the Wanderers. Their opinions were most prominently formulated by Vladimir Stasov, a steadfast and passionate fighter for the realization of the Wanderers' program. His judgments, however, were excessively rigid and lacked insight into the visual aspects of art. A more finely-tuned interpreter of the Wanderers' principles was Ivan Kramskoy, who left scatterings of interesting ideas, sharp judgments, and just appraisals in his correspondence.

The theoreticians of the movement were generally the artists themselves. It was their intention to express as honestly as possible the truth about facts, social phenomena and human personality. As for their populist leanings, it was not necessarily part of the Wanderers' intentions to create an art which the masses of the countryside or the cities could understand. Rather, they believed that a fundamental artistic problem was to understand and reveal to their audience the best interests of the people. In contrast to the politically active Populists, they did not mingle with working people or try to explain their goals to them. The viewers of the Traveling Exhibits came not from among the working class or the peasantry, but most often from the middle class, although those who purchased the Wanderers' paintings also included high-ranking civil servants, generals, and members of the high nobility, not excluding those of the imperial family itself. By the same token, the collectors of academic painting were not restricted to representatives of the higher stratum of society either. Just as there was no strict division between "academic" and "realist" artists, so the market demand was not strictly apportioned according to social status.

The Wanderers associated Realism with national identity from their earliest years. Kramskoy believed that art which truly expresses its own time and arises organically out of national life must necessarily possess a national identity. Nevertheless, a more self-conscious desire for national forms of expression intensified during the eighties, particularly in Viktor Vasnetsov's art. More specifically, there came about an interest in national customs, rituals, and traditional decorative styles. These tendencies transcended the bounds of the Wanderers' movement to become part of Russian modernism by the early twentieth century.

Realism was the principal component of the Wanderers' triad of beliefs, and in that sense they felt part of the European mainstream of nineteenth-century art. The very term, Realism, as is well-known, originated with the French painter Courbet and was also used by Proudhon, Baudelaire, and Champfleury. The term took hold in Russia as well, but its meaning there was broader at first. It was introduced by Chernyshevsky's associate, Nikolai Dobroliubov, in the sixties, in artistic and literary criticism where it was used to define a truthful reflection of life in contradistinction to a distorted and prettified version of it. In looking back today at the position of Realism in European life of the nineteenth century, we can distinguish certain characteristics more clearly. Realism was linked to the philosophy of Positivism which dated back to the first part of the century and was itself connected to the revolutionary discoveries of natural science. Artistically, the Realist movement's depiction of contemporary life was predicated on the importance of a social context and its practitioners tended to gravitate toward radicalism; its engrossment with reality as valid subject-matter resulted in an acute awareness of the concrete in artistic expression. Realism put the artist in direct contact with nature, which became the subject of a close analysis. The movement developed an internal structure of its own with main themes, subtypes, and favored subjects, and it acquired a distinctive poetic sense – all unmistakably different from preceding and later styles.

In addition to common traits, Realism took on a different quality in every country. The Russian school had its own peculiarities which shaped the development of art through the seventies and the eighties. In mid-nineteenth century Russian society, fundamental social problems could best be stated by

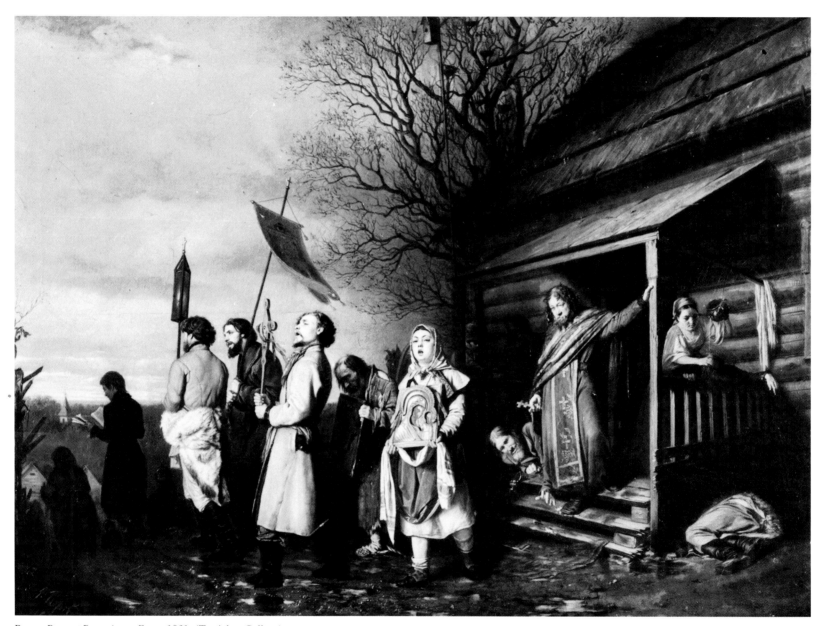

Perov, *Peasant Procession at Easter,* 1861. (Tretiakov Gallery)

means of art. As Aleksandr Herzen argued, literature, theater, and painting were to be "the platform" from which to proclaim, for all to hear, the conflicts inherent in Russian life and the burning problems of Russian reality. Since reaction to the political ferment which pervaded nearly all European life at that time was throttled in Russia, it was condemned to a hidden existence. Art and literature provided one of the few outlets for its expression. This situation reinforced liberal and democratic ideas which took the form of Realism. The style acquired a critical edge in Russia and, hence, might be called Critical Realism, but it also had analytical propensities. In representing some specific aspect of everyday life, or any particular hero, the artist as a rule was setting the stage for their evaluation. He was either affirming or denying, singing praises or accusing, he was announcing his diagnosis and passing judgment. The stages of nineteenth-century Russian Realism were determined by the artists' connection to everyday events. If one overlooks the work of certain predecessors such as Venetsianov and his followers, and the German painters of the Biedermeier style, Russian Realism may be said to have sprung into being with Pavel Fedotov. Like Gogol in literature, he invented a new mode of expression which combined a poetic vision with a critical eye. He was followed by artists of the sixties, headed by Perov, who took a resolutely critical stance. They expressed it either through the disclosure of evil, or through its obverse, by showing compassion for suffering and oppression. In the seventies and eighties this situation evolved further. Russian society could no longer expect changes brought about by criticism alone. The question for thinking people was: "By what means can Russian society move forward?" There was a more intense search for positive steps to improve the quality of life. The period of the Wanderers was at hand.

A new hierarchy arose in the categories of art. In the sixties, social genre dominated. It permitted art to condemn the unjust and to show sympathy for the poor. Landscape and portrait painting presented no such possibilities, because they lacked critical potential. History painting, on the other hand, became a subgroup of social genre; it could be accusatory and show aspects of living conditions. Still later, the Wanderers introduced even greater variety. The ability to present social problems as aspects of the ordinary gave traditional genre new impetus, so that it continued to predominate. Portraiture emerged in a new role as part of social genre by presenting authentic contemporary heroes. History painting began to praise the deeds of former heroes, while at the same time calling attention to the hardships associated with progress. Landscape painting took on new energy by expressing the beauty of the Russian land and combining it with an implication of new beginnings. Social genre lost its primacy and new categories and themes were given equal standing with it: history painting, portraiture and landscape received new stimuli for development.

The many aspects of everyday life depicted by the Wanderers comprise a variety of topics which may be further subdivided. The life of the peasants, their work, and their customs were the most common choices; the life of the city preoccupied the Wanderers as well; certain artists devoted their work to the representation of heroes of the Populist revolutionary movement. Each type of picture made different artistic demands. For example, the painters of peasant life usually used group compositions, or "choral paintings" as Stasov called them, which focused the action around some particular event. The city-based paintings usually took the form of a novella-like story centered around a few protagonists. The paintings based on the life of revolutionary heroes showed them in confrontation with their enemies, either exposed to danger or accomplishing a heroic act.

There were certain traits which united these paintings no matter how varied the subjects. In addition, a change occurred early on in the Wanderers' social genre painting which continued to grow and develop with time. In paintings of the sixties by Perov and his circle, the accusatory scenes had been enacted by players who, as a rule, performed predetermined roles. Their facial expressions, their poses, their behavior were all planned ahead of time. They were the demonstration of an idea rather than an expression of particular lives.

Perov, *The Last Drinking House at the Gate,* 1868. (Tretiakov Gallery)

Repin, *Barge Haulers on the Volga,* 1870-73  (Russian Museum)

This was evidenced by the artists' interest in the anecdotal rather than in characterization or in the depiction of an inner life.

Even though the inner life of the subjects did gain ground as the sixties advanced, the primacy of the anecdotal over the dynamics of the event continued to prevail. This is evident even in Perov's best works in the late sixties, such as *The Last Tavern on the City Outskirts* (1868). The woman sitting in the evening mist, the single protagonist explicitly shown, arouses intimations of the numb hopelessness she feels waiting outside the tavern, but the viewer's response is deduced from the situation rather than the imagery.

During the early 1870s, the Wanderers' subjects began to act, to think, and to feel. The emphasis shifts to them even though the artist still provides his commentary. Instead of

directly expressing outrage or despair, as Perov did, the painter becomes a careful observer and analyst; his approval or judgment becomes less evident. In specific instances, his subjects act according to the social consciousness of the artist in addition to the situation in which they find themselves.

This characteristic new conception is most forcefully expressed in Ilya Repin's *Barge Haulers on the Volga* (1870-1873), even though the artist painted it while he still held a fellowship from the Academy and could not yet exhibit with the Wanderers. Repin undertook special trips to the shores of the Volga River, where he studied and observed the life of the haulers over an extended period of time. He filled his painting with men of varied disposition, character, and fate. There is a sage-philosopher, a former priest, and a mighty hero as naïve as a child, an erstwhile sailor or soldier, also a Kalmuk, a

Miasoedov, *Zemstvo at Lunch,* 1872  (Tretiakov Gallery)

Greek, a youngster not yet resigned to the hauler's strap, and an old man awaiting his last days. Here we find the whole populace of pre-reform Russia, with its cruel constraints and its dormant power. Here also is the essence of genre painting as interpreted by the Wanderers, where protest is mingled with faith in the nation's awakening. The shift to a positive premise which pervades the painting is given further expression in its monumental scale. The composition serves a similar end: its frieze-like organization and low horizon line allow the Volga haulers to be clearly silhouetted against the background of water and sky.

The paintings of other Wanderers in the seventies do not compare with the *Barge Haulers,* but they do express closely related aspirations. In 1874, Konstantin Savitsky painted *Repairs on the Railroad Line* in which we find a critical judgement allied to a positive outlook, very similar to those of the *Haulers.* Grigorii Miasoedov, in 1872, composed his most famous painting, *Zemstvo at Lunch,* where the artist moderates the sixties' traditional contrast of riches and misery; one finds the focus shifted to individuals: a group of peasants, each one totally engrossed in his own skimpy meal and his own private meditation. In *The Sorcerer's Arrival at the Peasant Wedding,*

1875, Vasilii Maksimov – the most poetic of genre painters among the Wanderers – is less interested in his subject as social comment than in the opportunity to explore the beauty of traditional ways and rituals.

A certain change took place in the eighties as artists became absorbed in representing a more generalized picture of Russian reality based on specific events in national life. The broadest interpretation along these lines is, once again, the achievement of Repin in his *Religious Procession in the Kursk Province* (1880-1883). Without recourse to the methods of monumental art such as he had used in his *Barge Haulers on the Volga,* Repin succeeded here in producing a more generalized image which encompasses all manner of human activity within the crowd, an encyclopedic record signifying Russia. The artist, with singularly authentic impact, constructs and elaborates on a fragment of reality which, for the viewer, expresses a whole epoch in Russian history. Genre now acquired characteristics formerly associated with history painting. In directing a critical pathos, disguised as objectivity, towards observed social realities, the artist investigated "human material," juxtaposed temperaments and social groupings, as well as revelations of character traits, which all coalesce into the complex organism of a polyphonic composition.

Other artists' attempts to realize a similar breadth and universality in the interpretation of popular subjects were not as successful. Their efforts led only to artificial devices, unjustified expansion in the size of canvasses, and loss of the type of veracity most characteristic of social genre in the eighties.

It was also Repin who led the way in the choice of other genre subjects. Between the late seventies and the early nineties he painted a whole cycle of pictures dedicated to heroes of the Populist movement, sometimes in several versions, such as *The Propagandist's Arrest, The Meeting, The Refusal to Make Confession before the Execution, They Did Not Expect Him.* It is as if Repin had planned to lead his hero into every conceivable form of tribulation: the collapse of illusions brought

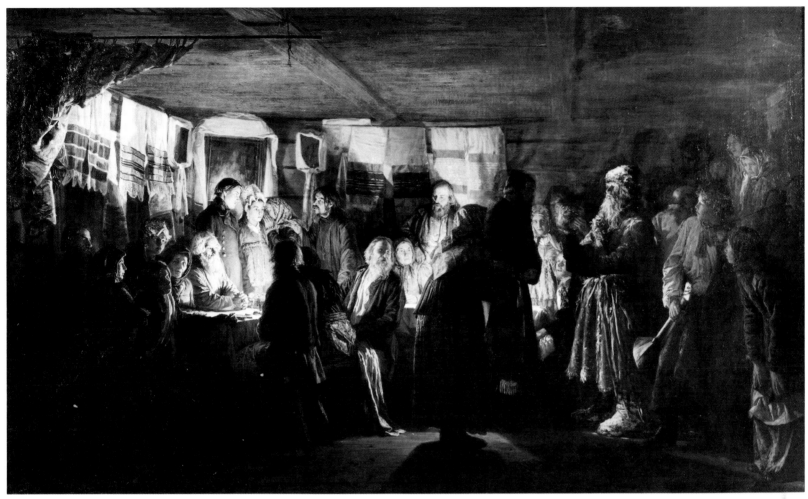

Maksimov, *Arrival of the Magician at a Peasant Wedding*, 1875 (Tretiakov Gallery)

about by people's lack of understanding, terrorist plots, heroic death. Only the best of these paintings, *They Did Not Expect Him*, brings its protagonist back to the family circle. The canvas, with its *plein-air* elements, attests to Repin's painterly attainments, but it does not present a positive portrayal of a populist hero.

Vladimir Makovsky occupies an important place among the genre painters of the movement. He was interested in amusing situations, and he depicted with humor domestic scenes usually observed in a city setting. His work was socially conscious, but presented in an entertaining way. Makovsky often dwells on the depiction of everyday life for its own sake and cultivates an anecdotal mode. He represents a Wanderer's middle course by appropriating his colleagues's achievements to his own advantage.

There is a sense in which Makovsky proved to be a precursor of the changes that were to take place in the genre painting of the nineties. With its overlay of social meaning fading away, social genre increasingly began to fuse with landscapes or interiors, very often by striving for poetic expression and acquiring lyrical overtones. Among the older Wanderers, Maksimov, Makovsky and a few others represent this tendency. This was usually true of Maksimov but also occasionally of Makovsky when he chose to represent peasant life, for example, *Night Watch* (1879), in the exhibition (cat. no. 44). This treatment of genre was most seriously attempted by "the younger ones," Abram Arkhipov, Mikhail Nesterov, and Andrei Riabushkin. These artists excluded eventful scenes or activities from their pictures. Their heroes are given to contemplation and are at one with nature, as in the exhibition's *The Lay Brother* (cat. no. 1) by Arkhipov and *The Hermit* (cat. no. 50) by Nesterov. New motifs are introduced, among them,

the moment of expectation in *Waiting for the Newlyweds* (cat. no. 75), by Riabushkin, processions, and others which draw on an iconography of life in Old Russia.

It must be said that not all artists of the new generation felt comfortable within the ranks of the Wanderers' Association. This is true not only of Arkhipov and Riabushkin, but also of Valentin Serov and Isaak Levitan. When, at the turn of the century, new groups were formed such as The World of Art and the Union of Russian Artists, many of these painters left the Association to join the newer organizations. Nevertheless, the tradition of social genre painting survived into the first decades of the twentieth century.

Portrait painting also evolved, flourished, and gained in importance in the seventies and eighties as new perspectives opened up. Rooted in the desire to discover new prototypes of the Russian personality, portrait painting became more than a reflection of the individual. The artists were searching for the most meaningful and representative examples of national characteristics. They chose Tolstoy, Dostoevsky, Nekrasov, Saltykov-Shchedrin, Stasov, Strepetova, Solovyov, Turgenev, among other notable figures to portray. Often, they also chose as their hero a peasant in whose inner life they detected as yet untapped depths of meaning and beauty. These painters discovered that portraiture required the close observation of an individual's spiritual life, as manifested in those characteristics which we usually associate with psychology. They found new ways to describe these characteristics in specific modes. Insofar as Russian art of the second part of the nineteenth century took man as its central concern, any essential probing of the epoch's spiritual and intellectual life was bound to include portrait painting. Among the best portraitists of the seventies and eighties one must count Perov, Kramskoy, Ge, Repin, and Nikolai Yaroshenko. Somewhat later, Valentin Serov became the foremost portrait painter.

Perov, Ge, and Kramskoy emerged almost simultaneously in the late sixties. They had painted portraits before, but those lacked a programmatic, deeper meaning. Perov, by transposing certain qualities and methods of genre painting into portraiture, achieved in his best likenesses a profound understanding not so much of a man's character as of his condition. In his portrait of Dostoevsky the writer's condition stems from his capacity to suffer not only his personal illness but that of others as well.

The next landmark in the Wanderers' development of portrait painting is Kramskoy's *Tolstoy*. Like Dostoevsky, Tolstoy, too, is preoccupied with the "cursed questions" of his time. But he does not lock these within himself. His glance, directed at the viewer and seeking to plumb the depths of his conscience, reveals the connoisseur and great analyst of man. Both Perov and Kramskoy valued, above all, moral qualities in a man: his ability to respond to an appeal, to accomplish good deeds, to live in unison with suffering mankind.

Repin attained the highest rank among the portrait painters, just as he did in social genre. His is the most developed understanding of psychology, the most direct transcription of his model. In his portrait of Modest Mussorgsky, painted only a few days before the great composer's death, it is as though the artist were looking into the very soul of the dying genius, into the abyss where thoughts and emotions swirl in a tangle; Repin halts the movement of these feelings and thoughts, accidentally, as it were, in one moment that threads together the composer's past and future.

The Wanderers' portraiture is quite simple. In the triangle of elements that constitutes a portrait – subject, artist, and work of art – the stress falls on the subject. The deeper the artist's understanding of his subject, the more successful he was in accomplishing his task.

New questions were raised in the 1890s. As Serov used a vigilant eye to examine his subject for the most telling characteristics, he also interpreted them with great artistry and an uncommon degree of painterly freedom. However, the full expression of such a novel approach did not occur until the early years of the twentieth century after Serov broke away from the Wanderers.

Genre and portraiture both had certain traits in common with historical painting. In the former instance, their common ground was the composition of a scene showing two or more figures in action. In the latter, it was the depiction of a hero. Portrait painting became a component of historical painting when it became apparent that dramatic episodes called for images of psychological confrontation. The psychological portraits of the 1870s were a necessary transition to the painting of Vasilii Surikov whose historical topics were presented more clearly in terms of introspection than of outward events. The sixties had not contributed much to history painting. Among those few artists who may be considered significant is Viacheslav Schwarz. Although he did not live to see the formation of the Association, he did lay some of the groundwork for its attitudes towards painting, especially its attention to truthful detail. It may also be mentioned that Ge, who was to become a founder of the group, was working in Italy in the 1860s as a fellow of the Academy when he painted his *Last Supper*, as early as 1863. The work still relies on academic concepts in certain ways, but its iconography is quite innovative: instead of representing the traditional image of Christ sitting at the table with his Apostles and announcing his coming betrayal by one of them, the scene is set at a later moment when Judas is shown scurrying away. Ge's interpretations of the Gospels as historical subjects derived from Aleksandr Ivanov as well as Western painters. The Wanderers' historical genre painting acquired its new meaning by meshing Schwarz's approach, centered on everyday life, with that of Ge, which favored psychological drama. This trend flourished during the seventies thanks to the efforts of various artists who often were not history painters: Ge, Kramskoy, Perov, and Repin. It is only in the early eighties that the remarkable art of Surikov made its appearance in Russian painting and raised historical genre to new heights.

The first Wanderers' exhibition included Ge's painting, *Peter the Great Interrogating Tsarevich Aleksei in Peterhof* (1871) (cat. no. 13, 1872 version). The artist's carefully recorded historical

Kramskoy, *Portrait of L.N. Tolstoy*, 1873 (Tretiakov Gallery)

Ge, *Golgotha*, 1893 (Tretiakov Gallery)

setting presents a convincing, genre-like adherence to detail. The scene depicted was intended not only for its factual description, but more importantly, to present the collision of opposing forces. Ge transposed to history painting the virtues of portrait painting by endowing his subjects with psychological veracity: Peter's fit of anger contrasts sharply with the resignation of the weak-willed, condemned Tsarevich. In the scene, Peter was intended to assume the role of a positive hero, so long awaited in Russian painting. It was as if he were taking the place of a contemporary, a hero still absent in the early seventies: as if he were stepping in as an activist for social bet-

terment until such a contemporary appeared. Only a few years later, such figures did in fact appear in history painting. Ge's symbolism, though, did not prevent the artist from situating his hero in a very specific historical context and achieving a serious and profound commentary on an era long past.

In later years, Ge underwent a complex creative crisis which forced him to abandon painting for a time. He then set aside traditional history painting in favor of biblical subjects and created a cycle of paintings based on Christ's passion. These works predate Expressionism in their ecstatic manifestations of spiritual tension, dramatic transports, and in their sense of despair.

It should be evident that the artist's later work no longer pertains to a discussion of the Wanderers' Realism. This factor in no way diminishes Ge's significance to the group in the seventies, though, a period in which he strongly influenced their treatment of history painting for two decades to come.

A year after Ge completed *Peter the Great*, Kramskoy painted *Christ in the Desert*. This canvas also bears a complex relationship with other painting genres, but in this instance it is closer to portrait painting. Kramskoy's Christ, shown at the moment of temptation in the desert in a pose demonstrating a painful inner struggle, bears a resemblance to Perov's portrait of Dostoevsky, which is far from incidental; his crossed hands and lowered head express doubt, pain, and yet resolve. More than once Kramskoy declared that he had used the figure of Christ in order to refer to more general themes. He called this "the language of hieroglyphs." By means of this language, he posed one of the most basic questions of the times: "Given Russia's historical position in the second half of the nineteenth century, just what was the individual's moral obligation in upholding ideas of good and justice?"

We shall not dwell on the work of other artists who contributed to the development of historical genre: Perov, Repin, and others who together with Ge and Kramskoy prepared the ground for Surikov in the eighties. Surikov, who moved from distant Siberia to St. Petersburg, and became a student of the

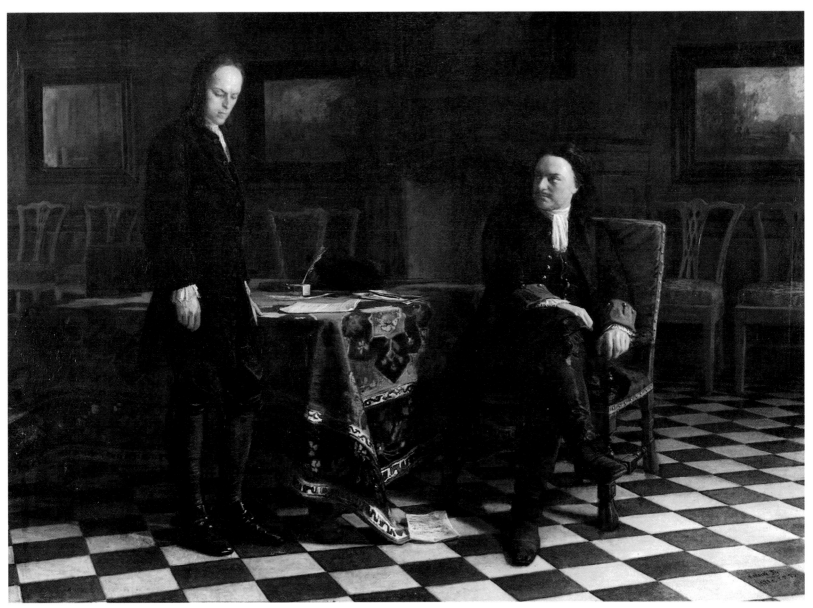

Ge, *Peter the Great Interrogating Tsarevich Aleksei Petrovich in Peterhof*, 1872 (*see* Cat. No. 13)

Academy in the seventies, failed to find inspiration within the confines of that institution. It was not until he reached Moscow, the ancient capital whose very streets and squares, the walls of the Kremlin and the churches all "remembered" history, that he realized his calling as a history painter. In the course of the eighties he created three paintings, *The Morning of the Execution of the Streltsi, Menshikov in the Town of Berezov,* and *Boyarina Morozova,* which were internally linked in thematic substance as well as in their exploration of artistic problems. The episodes chosen by Surikov are significant historical turning points, each marking a break between Old Russia and Imperial Russia – a break experienced directly by the people, a time of social progress accomplished only at the cost of tragic conflicts. Taken together, Surikov's three masterpieces may be viewed as an original psycho-historic trilogy, acted out by the masses as well as by individuals. In each situation, the hero's relationship to the people is described differently; so is

his relation to history. At crucial moments in Russian history – the religious Schism, Peter's reforms, and also their later consequences – nearly all the distinguishing features of national existence are revealed. These include elements of popular anarchy controlled only with difficulty through the most severe measures; repressive attitudes toward the past which in turn gave rise to reactionary movements; a lack of consistent direction in historical evolution; the banishment of those people who struggled for their ideals; the inexhaustible and mysterious strength of the people; the Russian inclination to solve problems collectively and communally.

Surikov was thoroughly engrossed in these questions, and he created archetypes of Russian history, which embodied the national essence and bound together this chain of events. His success in formulating these historical truths was due not only to his Cossack background and a youth spent in far away Siberia with vital links to the past, but also to his own gifts as a visionary and his talent as an artist who thought in images. Whereas Repin always portrayed his reactions to life with immediacy, Surikov shared this trait, but he was also methodically inventive. He calculated and constructed, and spoke of his love of "the mathematics of painting." For him, composition went beyond the description of a dramatic event; it was also the formulation of an artistic organism, the attainment of balance, of completeness. Surikov worked on a much larger scale than did most Wanderers. His painting, epic in content, bursts the bounds of easel painting to attain monumental proportions like those of mural painting. In this respect, *Yermak's Conquest of Siberia* (1895), is typical. Surikov's paintings cannot be said to fall within the confines of Realism. Dostoevsky referred to his own style as "superrealism," a term which may be applied to Surikov's art. This is due not only to the psychological "superrealism" which allowed the artist to delve into depths of the human soul seemingly invisible to the eye, or his ability to flesh out with an all-seeing gaze historical scenes that appear to be happening in front of us, but also to the nature of his painting which synthesized monumentality and symbolism.

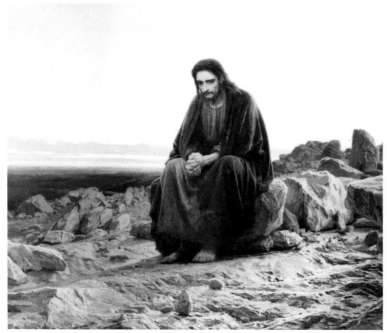

Kramskoy, *Christ in the Desert*, 1872 (Tretiakov Gallery)

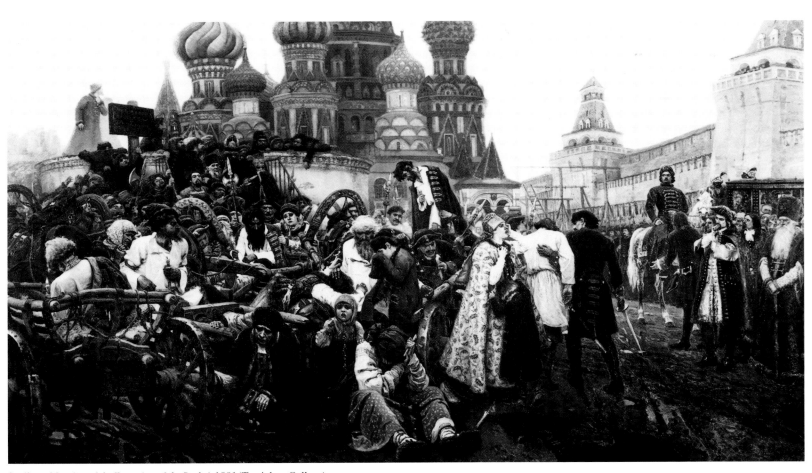

Surikov, *Morning of the Execution of the Streltsi*, 1881 (Tretiakov Gallery)

Surikov, *Boyarina Morozova*, 1887 (Tretiakov Gallery)

Surikov, *Yermak's Conquest of Siberia*, 1895 (Russian Museum)

It is not surprising that Surikov was popular with artists of later generations, even in the 1920s when the Wanderers' painting was considered quite old-fashioned. Surikov and Repin were opposites in many ways, but taken together their accomplishments represent the height of Russian Realism in the second half of the nineteenth century, and therefore of the Wanderers' movement.

Last but not least of the Wanderers' painting types, and certainly the most widely practiced and cultivated, is landscape. It gave the broadest latitude for individual variation to Aleksei Savrasov, Ivan Shishkin, Arkhip Kuindzhi, Vasilii Polenov, Isaak Levitan, as well as Fyodor Vasiliev, who was not a member of the group but was closely associated with it through his ties to Kramskoy and Shishkin. Each of these artists was different, even if certain common traits distinguish all Russian Realist landscape painting. The most distinguishing characteristic, relating to the Wanderers as a group, is the affinity of landscape to narrative. This does not mean that each landscape includes elements of genre painting, but rather that the influence of social genre permeates landscape indirectly. The components of these landscapes imply a time sequence, a sense of place related to human habitation. Significantly, even those Wanderers who occasionally painted in Italy or in Switzerland were most successful when they used Russian motifs, hence reflecting their simultaneous discovery of locale and of national consciousness. In this respect, Russian landscape painting in the second half of the nineteenth century differs considerably from that of the first half, a time when the most successful examples of this type are works by Sylvester Shchedrin or Aleksandr Ivanov done in Italy.

The Wanderers' landscapes most commonly represent country life. Realist landscape painters rarely depicted views of the city, but when they did, they focused their attention on a city's outskirts or on cozy little yards in some town or village. The only exceptions are those who retain vestiges of Classical or Romantic tradition from the early nineteenth century, like Aleksei Bogoliubov, represented in the exhibition by his 1872

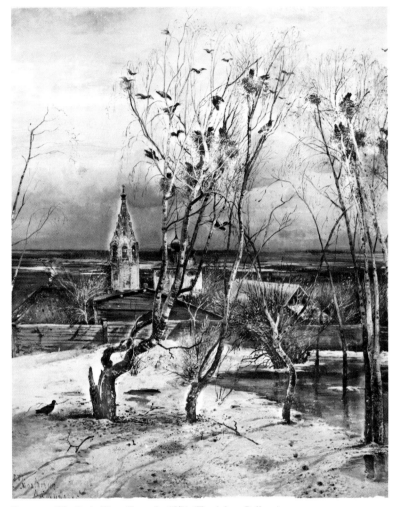

Savrasov, *The Rooks Have Flown In*, 1871 (Tretiakov Gallery)

*Mouth of the Neva River* (cat. no. 7). For the most part, these traditions were replaced by new Realist principles, as exemplified in paintings by Savrasov and Shishkin. With the exception of Kuindzhi, the Wanderers chose to depict simple motifs and prosaic aspects of nature so as to create a sensation or a mood without the artist's interference.

The older landscape painters among the Wanderers were Savrasov and Shishkin, who matured in the sixties, but reached their highest development a decade later, when there arose a stimulus for genuine change in the seventies. This factor gave rise to the concurrent success of the elderly Savrasov, the young Vasiliev, the experienced Shishkin, and the early achievements of Kuindzhi in the next decade. The differing personalities of Savrasov and Shishkin determined in many ways the two principal directions of Realist landscape painting. The first, a more lyrical mode that induced a certain serene frame of mind, was introduced by Savrasov before being brilliantly carried forward by his pupil, Levitan; the second was a monumentally-realist manner represented by Shishkin's paintings of epic proportions, which exemplify nature's permanence, its substantiality and grandeur. Shishkin had his followers, too, as many of his methods were adopted by Efim Volkov and Mikhail Klodt, and to a lesser extent Aleksandr Kiselev and Nikolai Dubovskoy, all of whom are represented in this exhibition. A different road was followed by Polenov whose oeuvre includes social genre, history painting, battle scenes, as well as landscape; his accomplishment was based on his adoption of *plein air* painting and on endowing even his studies with an intrinsic artistic value. The qualities of Kuindzhi's methods and style are of an entirely different order and derive from the Romantic tradition. His paintings reflect special moments in nature: the bright light of the sun

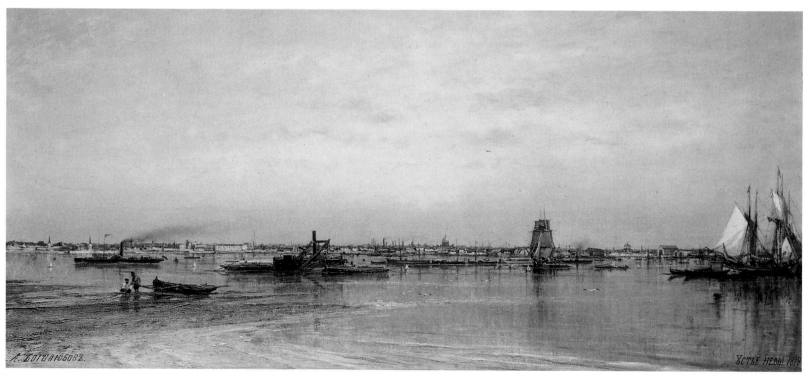

Bogoliubov, *The Mouth of the Neva River*, 1872 (*see* Cat. No. 7)

Shishkin, *Corner of an Overgrown Garden*, 1884 (*see* Cat. No. 82)

or the moon, and the earth's radiance after rainfall. Kuindzhi loved contrasts of color and light; for him, nature was always sumptuous and surprising in its manifestations.

The most important aspect of the Wanderers' landscape imagery lies in its lyricsm. Savrasov's fundamental wish was to correlate nature with man's inner life. Levitan borrowed this principle from Savrasov but carried it further by raising its poetic expression to the level of a universal philosophy. Another teacher of his was Polenov who introduced him to *plein air* painting. As a result of Polenov's influence, the early eighties produced an early form of Russian Impressionism which developed independently from the French. This more moderate form of Impressionism became the starting point not only for later Wanderers, but also for the painters of the Union of Russian Artists, who in many ways carried on and transformed the Wanderers' traditions.

Another transformation among the Wanderers was the reversal of their position from one of leadership to being in the rearguard. In the 1890s the Association began to lose its former position as an innovative group. Although its ranks were replenished with some representatives of a new generation who injected a certain amount of fresh energy into the Wanderers' activities, the organization itself floundered along as a result of internal contradictions and the dogmatization of its artistic tenets. No serious artistic achievement distinguished the remaining period of slightly more than two decades of the Association's activity. No longer attuned to the times in the early twentieth century, the Wanderers found themselves in the rearguard of artistic development. In the early 1920s, their existence came to a rather inglorious conclusion as many Wanderers rallied to the ranks of the Association of Artists of Revolutionary Russia, an organization in implacable conflict with Russian avant-garde artists. The course taken by the Association over its half-century of existence was almost inevitable. The origins of the Wanderers came about through their efforts to overcome academism and the canons of taste of the Academy, while creating a new

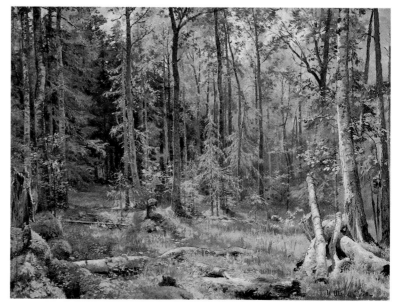

Shishkin, *Thickets*, 1881 (*see* Cat. No. 83)

Realist art. Overturning formulas, iconoclasm, was integral to their stance. In the process, they hammered out their own methods, their own painting style, and they clarified their own artistic goals. The first and, in part, the second generation of Wanderers fully put these principles and this style into practice. When the time came, however, to bequeath the results of their efforts to the younger artists destined to replace them, they transformed their principles into immutable laws, sometimes even requiring the young artists to follow the strict regulations of the past. They failed to observe the changing times and the new problems which necessitated the unfolding of a new artistic vocabulary. The Wanderers' reversal of their original principles may be explained by the rapid pace of the changes taking place between the generations of artists, writers and social activities in Russia throughout that half century.

This change, well established by the early twentieth century, did not mean that the movement's influence, deriving from the classical phase of the seventies and eighties,

simply vanished. Rather, its influence became oblique rather than direct. By the end of the first decade of this century the avant-garde was swiftly gaining ground. Its representatives and their manifestoes stoutly repudiated the Wanderers and the previous half-century's legacy of Realism. Yet, their work often betrayed an unconscious debt to the Wanderers' principles. Mikhail Larionov and Nataliya Goncharova, who proclaimed a neoprimitivist orientation closely allied to Futurism, denied all traditional attitudes, but still gravitated toward narrative content and the representation of incidents which reflected everyday life in the country or the city. Obviously, the artistic language and style of these masters shares no common ground with nineteenth-century Realism. Nevertheless, it reflects a still vital tradition, inwardly maintained. This is manifest even in the works of such consistently avant-garde artists as Pavel Filonov and Kazimir Malevich, who incorporated complex and conflicting aspects of life into paintings as they strove to serve as witnesses to their time. The best of twentieth-century art is precisely that which relates in this manner to Realist traditions. On the other hand, when artists of the same period deliberately tried to revive the old language and style of painting, they condemned themselves to sterility and anachronism, because they were transgressing the historic laws that have always determined artistic development.

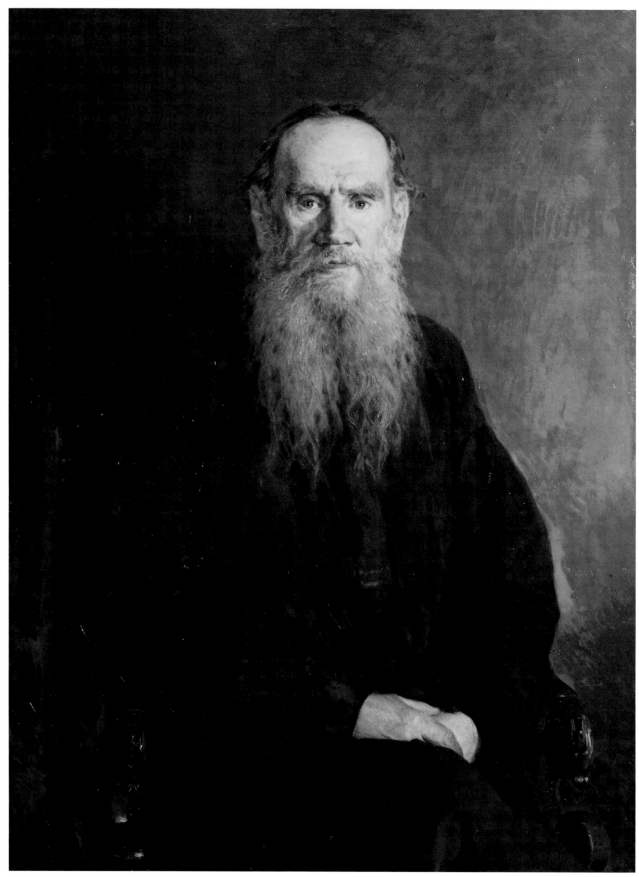

Yaroshenko, *Portrait of the Writer L.N. Tolstoy (1828-1910)*, 1894  (*see* Cat. No. 97)

# The Wanderers and
# The European Avant Garde

BY RICHARD R. BRETTELL

Every university student in the United States knows the names of Dostoevsky and Tolstoy, and many have read their novels as well as those of their compatriots: Lermontov, Gogol, Goncherov, and Turgenev. Indeed, the position of Russian Realist literature in the canons of world literature is secure. And the same can be said of Russian music created by the composers Tchaikovsky, Mussorgsky, or Rimsky-Korsakov.

Unfortunately, that is surely not the case for their contemporaries in the world of painting. I. E. Repin, the most famous Russian painter of the second half of the 19th century, is scarcely known outside the Soviet Union, and his name would be recognized by only a minority even of art history graduate students in this country. And the names of Repin's greatest contemporaries, Perov, Ge, Kramskoy, and Makovsky, would be indistinguishable to most Americans from minor bureaucrats, chess players, or ballet dancers in a list of 19th-century Russian notables.

Yet these artists were among the premier vanguard figures in Russian 19th-century culture. Their paintings were met with the same mixture of disdain and fear that greeted now famous works by Manet, Renoir, and Whistler in France. Their exhibitions were as subversive and – as "modern" – as those of the Impressionists and their progeny in France. Their art was aimed at a mass public, not at the elite of the Academy or the court. And their imagery was tied, ultimately, to modern life.

What can explain the comparative neglect of Russian Realist painters in the West? Was their art associated too closely with Russian culture, making it less comprehensible to a western audience than the work of their contemporaries, the novelists? This could hardly be seriously argued when both painters and writers based their art on observations of daily life in Russia. Was their art nationalist in the worst sense, reinforcing, one could argue, the sentimental beliefs of the men and women who upheld the virtues of Old Russia? This idea is even more preposterous in light of the fact that paintings by all the major Russian Realists dealt frankly with the rapaciousness of the clergy, the greed of local bureaucrats, the misery of the peasantry, and the difficulties of family life in a modern world. Indeed, the realism of the Russian painters was as probing and profound as that of the writers.

The answer to these questions has less to do with the art itself than with the Soviet systems of culture that have dictated the ways in which westerners have been exposed to Russian art throughout this century. Whereas the music of Tchaikovsky and Mussorgsky was performed outside of Russia during the lifetimes of these composers, and was even available in published form for performance everywhere from Paris to Buenos Aires by 1900, the work of the greatest Russian painters of the 19th century has remained virtually unknown outside of Russia and, until recently, has not been allowed by the Soviet Union to travel beyond its borders. Whereas the novels of Dostoevsky and Tolstoy were available in every European language during their lifetimes, reproductions of works by their contemporaries, the Russian Realist painters, were largely confined to Russian and then Soviet

I.E. Repin

publications, away from the eyes of western artists, collectors, and curators. Even today, there are no more than a handful of major Russian 19th-century paintings in American museums, and private collectors of this material outside the Soviet Union are equally rare. And, as if in a crueler twist of fate, when Russian artists like Kandinsky and designers like Bakst became members of international vanguard movements in Germany and France in the early 20th century, the works of the great Realist rebels of a generation earlier were already discredited even in Russia.

It is tempting, given this comparative neglect, to treat Russian 19th-century painting in the same isolated, national context in which it has survived the 20th century. But this would surely be wrong. In fact, exactly the opposite tack should be taken in our attempt to consider Russian Realist painting; we should view it primarily as art and secondarily as Russian. There is little doubt that Russian Realist painting relates a good deal to the various facets of Russian nationalism. Yet, even the connections between painting and nationalism can be considered in a larger, western context.

Nationalism itself was the prevailing 19th-century ideology, and, in its various manifestations, linked people and ideas from various nations. In art, the works of Josef Mánes in Czechoslovakia, Giovanni Segantini in Switzerland, and even Jean François Millet in France have an undeniable connection to nationalist sensibilities, forging an aesthetic bond between viewers of pictures and workers of the native soil. Indeed, the majority of "nationalist" paintings are immediately comprehensible to citizens of another nation, and those produced by the Russian Realists are no exception. Any American or Frenchman can easily interpret a painting by Repin or Kramskoy.

Russian Realist painting, then, can be readily understood as part of the larger history of 19th-century Realist movements and, by extension, of vanguard art. Like the French Realists Courbet and Manet, whose works now define a sort of international canon, the Russian Realists conceived of their art in an

anti-academic atmosphere and introduced it to the public through the vehicle of large-scale temporary exhibitions. Also, in keeping with the French Impressionist movement that followed them, the Association of Traveling Art Exhibitions, the primary organization associated with Realist painting in Russia, was created expressly to bring independent art directly into contact with a large public through exhibitions curated, designed, and marketed by the artists themselves. Hence, Russian Realist art shares two primary characteristics with French Realist art: an anti-authoritarian stance and a belief in independent entrepreneurship. How relevant both these concepts sound today!

Issues of censorship have plagued the history of modern art since the mid-19th century. Perhaps the best known example is the political force exercised by the Salon jury which, in 1863, rejected a record number of paintings from the Paris Salon, including Manet's infamous *Dejeuner Sur L'Herbe*. Afterwards, the emperor Napoleon III called for the formation of a "Salon des Refusés" so that the public itself could "judge the jury," and the verdict, if we are to believe the French press, was harsher on the artists than on the repressive system that judged them. Similar occurrences litter the pages of texts on the history of modern art in every western country. Yet, we must not be too quick in our condemnation of the governments and jurors who struggled to disentangle from the vast art production of the 19th century a few thousand works for the public to see. Indeed, in an age before television, mass sporting events, and video, the art exhibition played a very large part in the leisure habits of modern urbanites, and, in this case, Russia was no different from any other European country.

In fact, the case in Russia is remarkably similar to that in France, where a national academy attempted both to set standards and to react to the creative forces active in the art world. Russia had its Academy, and, as Elizabeth Valkenier and Dmitrii Sarabianov explain elsewhere in their essays, it emerged from a period of intense imperial control with the

Perov, *Portrait of the Writer I.S. Turgenev (1818-1883)*, 1872 (*see* Cat. No. 55)

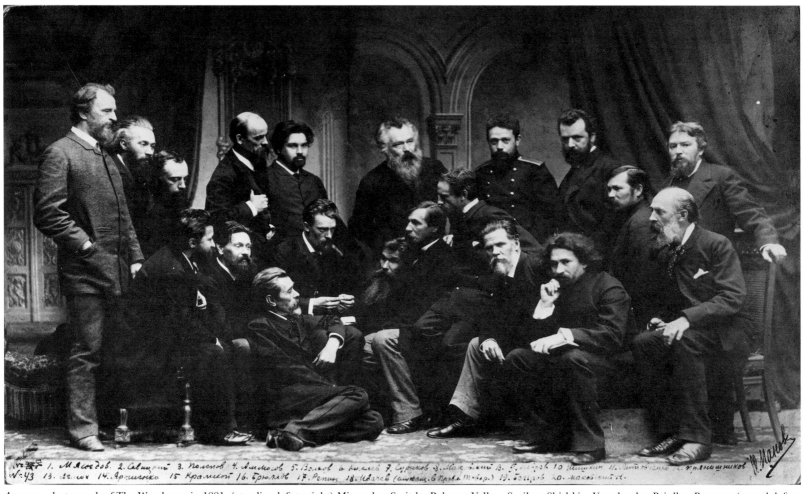

A group photograph of The Wanderers in 1881. (standing left to right) Miasoedov, Savitsky, Polenov, Volkov, Surikov, Shishkin, Yaroshenko, Briullov, Beggrov (seated, left to right) Ammosov, Kiselev, Nevrev, V.E. Makovsky, Prianishnikov, Litovchenko, Lemoch, Kramskoy, Repin, Evachev, H.M. Makovsky

death of Nicholas I in 1855. Just as the Salon des Refusés created a public scandal in France in the spring of 1863, a group of fourteen Russian artists banded together in the fall of that same year and refused to submit entries to the Gold Medal competition because the government had set the subject, the figures, and even the props for the contest. For the fourteen artists led by Kramskoy, issues of individual artistic freedom were of paramount importance, and this group of young artists risked the ruination of their promising careers by publicly protesting government censorship.

Why is it that we read almost constantly about the heroic exploits of French Realist painters and so little about the equally important fight for aesthetic liberty that rocked Russia at the same time? The Russian artists were not minor rebels, but brilliant, promising artists. Their works were based on a tradition of criticism and theory closely related to that of the French, but independent of it. The great critic Nikolai Chernyshevsky published an important essay in 1853, entitled *The Aesthetic Relations of Art to Reality*, that formed the theoretical groundwork for a Russian Realist movement in all the arts. And Proudhon's French text, *De Principe de L'Art et sa Destination Sociale*, was translated into Russian the same year in which it was published, 1867, further linking the radical aesthetic sociology of Courbet's friend to the artistic theory of the Realists in Russia.

Neither Moscow nor St. Petersburg (later Leningrad) were artistic or intellectual backwaters in the 1860s and 1870s. On the contrary, the Russian intelligentsia was attuned to the very highest levels of vanguard literature, art, and politics throughout Europe. It is no accident that many of the early critical works by the great French Realist novelist, Emile Zola, were written not for a French audience, but for publication in Russia, where Zola had never been and was never in his life to visit. And the exchange between France and Russia was not one-way in the second half of the 19th century. Not only were Russian artists, government officials, businessmen, and writers frequent visitors to France, but many Russian books and criti-

cal essays were translated almost immediately into French and other European languages. Not only did Repin, the greatest Russian Realist painter, spend two years studying in France, but the writer Turgenev maintained an active correspondence with Flaubert and even advised the French Realist author – with no success – on the manner in which he should write *Bouvard et Pecochet*. Realism, for the Russians, was part of a general European movement rather than an isolated response to Russian social and aesthetic conditions.

## RUSSIAN REALISM AS AVANT-GARDE

In 1962, the great Italian critic, Renato Poggioli, wrote perhaps the most persuasive general study of the Avant-Garde in any language. His treatment of the subject stresses less the aesthetic style of a vanguard movement in art or literature, than it does their group dynamics and politics. For Poggioli, a vanguard group must first conceive of itself as being literally in advance of the host society to which it is attached and which, paradoxically, it serves to invigorate by promoting change within that society's structures. A vanguard group must be a cadre of men and women, closely related in their aims, and mutually supportive. Such a structural definition of vanguard movements fits Russian Realism completely.

Created initially in 1863 as an artists' cooperative called the Artel (the St. Petersburg Artists Cooperative), the movement was strengthened in 1870 when The Association of Traveling Art Exhibitions was created. The early Artel consisted of only thirteen members, and the subsequent Association started with a membership of fourteen. These small groups literally challenged the various artistic establishments of Russia, and their success was remarkable, when compared to vanguard movements in other countries. Unlike the Impressionists and the various subsequent artists' groups in France, they were well organized, made money, and succeeded in their aims of promoting Russian art throughout the country. The efforts of the Association of Traveling Art Exhibitions at marketing works by their members, both in terms of sales and exhibitions,

were generally well organized and fruitful, and the success and long life of the Association may be perhaps the greatest reasons for our 20th-century neglect of it. Modern criticism has surely taught us that we like our vanguard movements better if they are disorganized, small, and short-lived. The more successful they are, the more we tend to think that their members capitulated to the forces – and standards – of the establishment.

If, on the other hand, we remember that the very idea of the Avant-Garde stems from the military theory in which the vanguard group surveys the territory in advance and apprises the leadership of its character, the success of the rear guard is a measure of the success of the Avant-Garde. Thus, by direct analogy, the Association of Traveling Art Exhibitions defined specific aims for the artist in a modern mercantile society, acted upon those aims, and succeeded in most of those actions. Their wisdom, in recognizing that Russia was entering a new age dominated less by the clergy and the aristocracy and more by mercantile forces, was proved not by the revolution that toppled the old order, but rather by their success in reaching the mercantile class of Russian cities through their art and their exhibitions. None of the French vanguard movements was as successful in its collective aims during the lifetimes of the artists as that of their Russian contemporaries.

If the basic aim of the Association of Traveling Art Exhibitions was to reach a modern mercantile class, its medium was exhibitions and its goal the sale of the art in them. Indeed, when interpreting paintings such as Maksimov's *Family Division* of 1876 or Repin's slightly later *The Refusal to Make Confession before the Execution*, modern viewers must be mindful of the original audience, many of whom grappled with problems of inheritance, taxation, and religious domination in their daily lives. For this reason, the paintings can be interpreted less as a direct attack on the aristocracy and the clergy than as a reinforcement of certain social prejudices of the urban bourgeoisie.

In actuality, the purpose of the Association was not so much to promote a particular idea of art, but rather to make works by individual artists widely available through collective exhibitions. Indeed, "opening up new opportunities for the marketing of works of art" was an aim shared directly by the Association in Russia and the Impressionist movement in France. Each group had as its central problem the striking of a balance between openness and entrepreneurship, on the one hand, and aesthetic quality and unity, on the other. Neither group succeeded in stamping a collective "style" on its members, even though the recognition of diversity was more central to the aim of the Association of Traveling Art Exhibitions than it was of the Impressionists, whose movement finally collapsed under the weight of diversity after only twelve years of rather fitful existence.

A SOCIAL ICONOGRAPHY: RUSSIAN REALIST SUBJECTS

When analyzed in terms of their subjects, paintings created by members of the Association of Traveling Art Exhibitions can easily be divided into the three major *Realist* subject areas: genre scenes, landscape, and portraits.

Surprisingly, still-life painting was much less popular in Russia than it was in Continental Europe or the United States. In the Realist subject areas, genre scenes are clearly the most interesting, providing, as they do, an entrance into the social world of late 19th-century Russia. In many ways, the paintings, like the novels and short stories of contemporary writers, form a sort of visual ethnography of daily life in Russia. Scenes of marriage, death, religious festivals, domestic preparations, hunting, working, taking confession, painting, dancing, and driving along rural roads are common, and a student of daily life in 19th-century Russia can learn as much from these paintings as from the novels, letters, and diaries of this much described period. In many of the paintings, the imagery is benign and uncritical, allowing the viewer access to a simpler and better world than that of most 19th – or, for that matter, 20th-century cities. Yet, in others, there is an unmistakable

aura of the dissension, bitterness, class conflict, and sexual repression that is so evident in the novels of Gogol and Dostoevsky. The painters both celebrated and criticized Russian life in ways not at all dissimilar to other European Realist artists, and, as the 19th century recedes further and further into the past, the usefulness of these social documents for a full understanding of that cataclysmic century will increase.

RUSSIAN REALISM AND VANGUARD STYLES

Perhaps the major problem with Russian Realist painting of the 19th century is its style – and, by extension, quality – when judged against contemporary French art. There is little doubt that the pictures in this exhibition – as well as many of the major masterpieces that remain on permanent exhibition in Russian museums – were hung with *academic* art in a large museum installation like that of the Musée d'Orsay or the Metropolitan Museum of Art in New York. The most *advanced* paintings have clear relationships with contemporary works by such masters as Pierre Puvis de Chavannes, Raffaelli, Gervex, Fantin-Latour, and Bastien-Lepage, rather than with works by Courbet, Manet, Degas, Renoir, or Pissarro. Their pictorial constructions are complex, their space clearly legible, and their facture at the service of representation.

In recognition of these facts, the several works by Russian artists hanging today at the Musée d'Orsay are placed with the academic paintings and, even in the Soviet Union, works by members of the Association of Traveling Art Exhibitions are kept strictly separated from the vanguard French paintings at the Hermitage and the Pushkin. How does one respond to this situation?

It is pointless to deny the assertion that Russian Realist painting is a form of modern academic painting like that practiced throughout Europe and her colonies in the second half of the 19th century. Yet, a recognition of the connection between Russian Realism and masterpieces of academic painting in France and other countries does not constitute a con-

demnation of the Russian artists. On the contrary, a careful examination of Russian Realist painting in a broad international context will contribute significantly to the large-scale revision of 19th-century art history currently being planned by European and American historians of art.

A recognition of the stylistic pluralism evident in European painting is critical to a full understanding of 19th-century culture just as it is of 20th. The standard art history taught in universities is a sort of genealogical history of vanguard artists who "beget" each other, occasionally forming groups that, in turn, spawn future groups. When viewed in this way, significant art forms a linear stream of masterpieces and styles from Realism to Impressionism to Post-Impressionism to Fauvism to Cubism and onward. In fact, that sequence, stated in its most simplistic way, is not really simple at all. However, when its complexities of style and chronology are overlaid with the larger history of painting in Europe and its colonies, the result is so complex and polyvalent that a logical, sequential explanation defies description.

It is perhaps easier to place Russian Realist painting in the context of the various regional and national artistic centers of Europe than in the context of a French vanguard movement. When considered with painting in other European capitals such as Vienna, Munich, Berlin, Amsterdam, Prague, Budapest, Cracow, and Stockholm, Russian Realist painting becomes part of the larger history of European representational painting, a history that is described only in sketch form in the current writing about 19th-century art. Even the most tolerant and open-minded modern historian, Robert Rosenblum, has relegated the vast majority of 19th-century paintings to the sidelines in his immense history of art from the last century. He, like many academic critics and historians, has created a kind of academy of the French Avant-Garde, an academy that is as rigidly defined, as closed, and as impervious to criticism as the 19th-century Academy against which the vanguard fought. When Hilton Kramer attacked the inclusion of academic art in the carefully tended garden of the

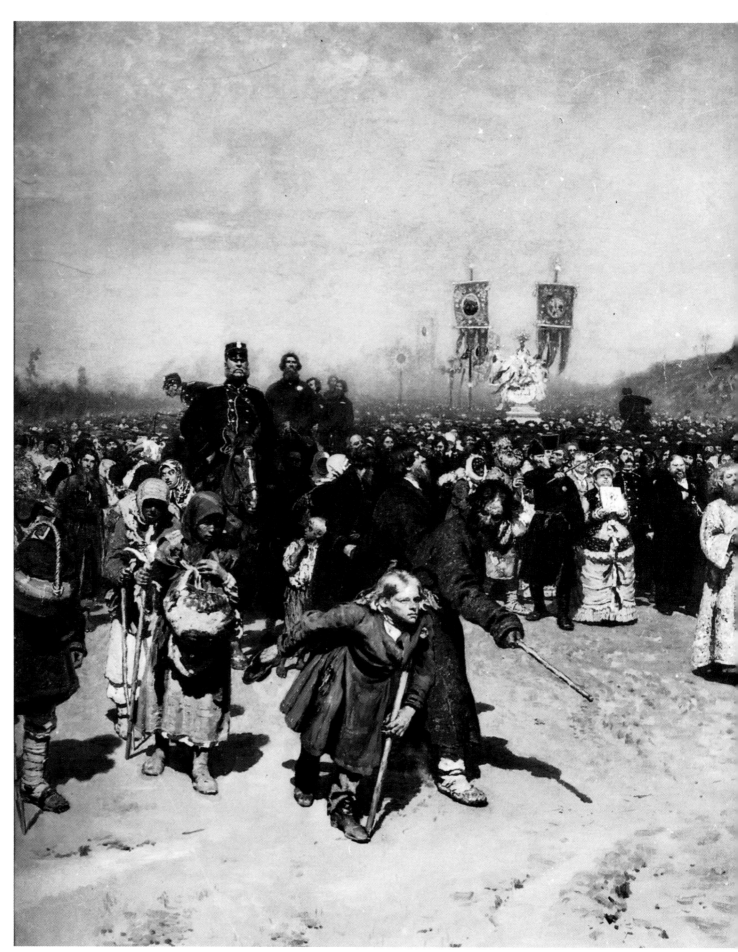

Repin, *Religious Procession in Kursk Province*, 1880-83 (Tretiakov Gallery)

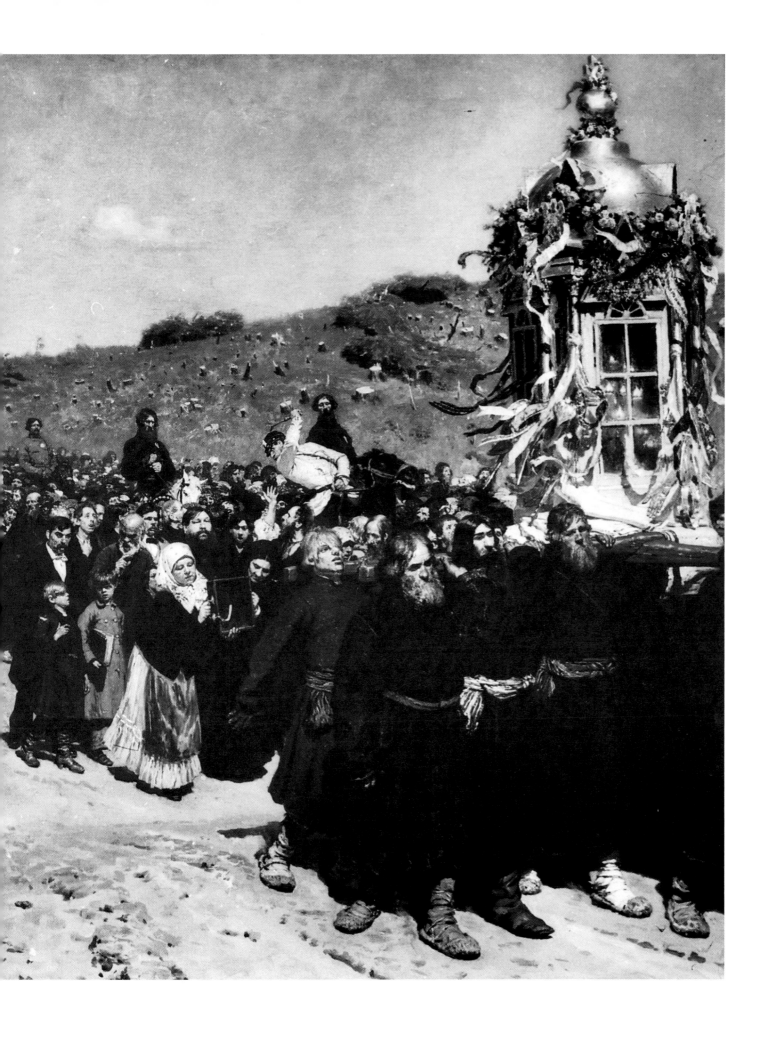

Metropolitan Museum's collection of 19th-century painting, he issued a battle cry against the kind of contemporary revisionist art history that includes the best of all kinds of art produced in the past and that aggressively decries standards of excellence that exclude all but a minority of past artistic production.

A re-evaluation of the history of Russian Realist painting of the late 19th century is, when viewed in this critical context, part of the larger re-evaluation of 19th-century European and Colonial Art in general. The storage rooms and galleries of art museums throughout the world are filled with hundreds of thousands – indeed, with more than a million – 19th-century paintings, only several thousand of which have been canonized by critics and historians. The case of the exclusion of Russian Realist art from this canon is, at first glance, the result of accidents of history. When examined more closely, it becomes clear that even if the works of Russian Realist painters – canonized by the Russians themselves – had been widely available in the West during the 20th century, we would have rejected them anyway, because they do not conform to the norms set for the history of French vanguard art!

## THE NEW 19TH CENTURY

The history of the 19th century – with its explosion of nationalism, of urban expansion, of technological change, of mass migrations, of wars and changing boundaries – was not easily painted. Indeed, the cataclysmic sweep of 19th-century time is embodied more fully in literature than in painting. *War and Peace, Moby Dick, The Brothers Karamazov, Dead Souls, The Human Comedy, Les Miserables, A Tale of Two Cities* – all these texts and many others inform and absorb us in that cataclysm. In them, characters of all types abound, but their individuality pales as they participate in the larger dramas of history. Even Gibbon, in *The Decline and Fall of The Roman Empire*, Ranke in *The Ecclesiastical and Political History of the Popes in the 16th and 17th Centuries*, Michelet in *The History of the French Revolution*, and Ruskin in *The Stones of Venice*, shaped time into such

tremendous forms that the individual has little more identity than a flute or a violin in a Brahms symphony.

Nineteenth-century painting describes another 19th century. Courbet's dour studio is temporary home to the homeless of the mind and body. Manet's *Olympia* looks in perennial contempt at whatever customer confronts her. Seurat's profile figures seem like cutouts in a full-scale theater of people pretending to be at leisure. Gauguin's *Where Do We Come From, What Are We, Where Are We Going?* poses eternal questions, not from the 19th century, but from a fallen paradise. None of these French masterpieces, however, can compete with the worlds created by the novelists and the epic poets, or actually described by historians. Yet, in several epic canvasses and in their collective endeavor, the Russian Realists did.

Perhaps the most critical Realist painting produced in Europe during the 1880s is Repin's monumental canvas, *Religious Procession in Kursk Province*, painted over a four-year period between 1880 and 1883. Indeed, this canvas is arguably the greatest painted epic of the 19th century, the single canvas that contains all of modern time. In it are beggars and bourgeois, soldiers and prisoners, peasants and clergy. All and none of these figures are important, and a viewer in front of Repin's masterpiece needs at least an hour to scan, and a lifetime to understand, the world within the picture.

Noticeably absent though, are telltale signs of a vanguard painting – flattening of the pictorial space in recognition of the integrity of the picture plane, manipulation of the viewer's sense of self, and construction of the picture by means of consciously made painted gestures that assert the existence of the artist rather than of the representation he creates. Instead, we, the viewer, become part of a procession into time. We are swept up, moved along, and, in that process, made conscious of our littleness, of our inability to comprehend the world in front of us.

Many of our fellow travelers in this procession into time have had hard lives, and, if they haven't, we dislike them for their arrogance. The chubby bourgeois lady, who might have

been the wife of the mayor, the puffed up military man on horseback, the benign patriarch, all these characters play roles in a pictorial history that is beyond even the painter. Repin attempted to transcend the act of painting and the result of that process in a painting, and, in so doing, he created a world in which his own existence was subsumed in the larger traumas of human history. Even the gods of men are but idols in this relentless, eternal procession. Seldom in the chronicles of western art has so much history, action, and panoply been compressed onto a single surface. Repin has pushed painting beyond its very limits. If we can accept the idea of the omniscient observer in literature, we need to accept a similar role performed by Repin in analyzing this painting.

The very existence of this masterpiece forces us to re-evaluate the history of painting in the 19th century. It cannot be explained by – or even included in – the histories written to date. And the ideological and aesthetic system that produced it must be analyzed so that its existence makes sense. All art history hinges around masterpieces – around certain works that seem to defy time and our comprehension, again and again. Such a work is Repin's *Religious Procession in Kursk Province*. In this painting, a Russian Realist, who flirted with the work of Manet and the Impressionists while working in Paris, returned to Russia and encapsulated the entire nation – its history, its political system, its religions and ideologies, its successes and failures – in a single canvas.

Let us learn about the Russia – and the Realism – that gave rise to this painting.

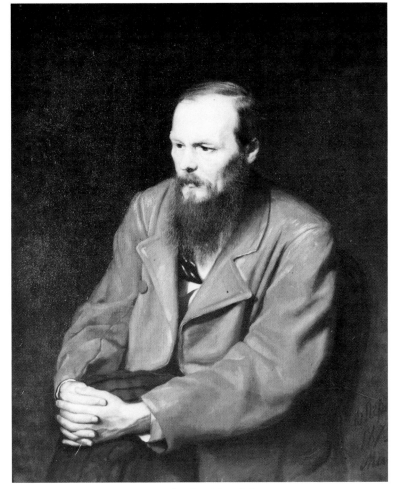

Perov, *Portrait of F.M. Dostoeyvsky*, 1872 (Tretiakov Gallery)

Dosekin, *Portrait of P.M. Tretiakov*, 1911 (*see* Cat. No. 9)

# Private Art Collecting
# 19th Century Russia

BY GALINA SERGEEVNA CHURAK

The history of art collecting in Russia is closely inter-twined with the historical development of Russian art and of Russian culture as a whole. The emergence and individual identity of the Russian school of painting in the nineteenth century was to find its own reflection in the nature of collecting and accumulating art collections in Russia. The collecting of art works grew out of private collecting in a broader sense. Even pre-Petrine Russia, or the period before the beginning of the eighteenth century, had witnessed the growth of many family collections, in which all kinds of rare and precious objects, so-called "art objects" and "curiosities," were gathered. The modern history of art collecting in Russia begins with the eighteenth century, and is related to transfor-mations in all spheres of Russian life – political, economic, and cultural – which occurred under the reforms of Peter the Great.

Peter, with his unquenchable thirst for knowledge in various spheres of science and art, became one of the first Russian collectors. The natural science portion of his collection was to form the basis of the so-called "Imperial Office" out of which, in turn, grew the first museum in Russia to be opened to the general public – Cabinet of Curiosities (the *Kunstkammer)* with its natural history collections. Works of art acquired by Peter, and later on by special purchasing agents for paintings and sculpture in cities throughout Europe, began to enhance the palace collections, of Peter and later those of his descendants. Beginning in the eighteenth century, collections arose among the court aristocracy in imitation of the imperial collection.

What interested these collectors was classic Western European art. By the middle of the eighteenth century, the Imperial Hermitage and private picture galleries contained extensive collections of first-class works by the old European masters of the Dutch, Italian and French schools.

Secular painting in Russia became distinct from religious art only in the early eighteenth century and went through a brief, but intensive period of so-called "apprenticeship" with European art, just as it began to develop as an independent school. The works of Russian masters were not yet considered classics by those who loved fine arts and were connoisseurs of painting, and so were not, naturally, considered worth collecting.

Yet it was, nevertheless, among the Russian elite that the first collections of national painters emerged. These were primarily family portraits, executed either by serf artists from the family estates or by painters whose works were com-missioned after they had become well known in St. Petersburg or Moscow. For example, in the palaces of the Sheremetev counts near Moscow, along with classic European paintings – mythological compositions, land-scapes, still-lifes – we find portraits of the Sheremetev family, painted by their serf artists, the Argunovs. The serf por-traitist F. Rokotov began to work for his master Prince I. Repnin. But it was still too early for such portraits to be regarded as works of high artistic quality, rather than as fami-ly heirlooms.

The only center where works by Russian masters were accumulated with some consistency was the museum of the

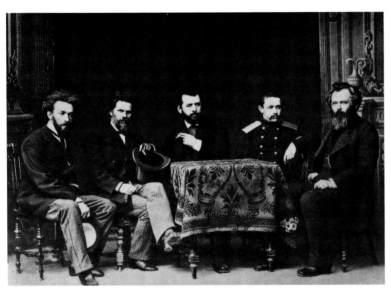

Members of The Wanderers (from left): Savitsky, Kramskoy, Briullov, Yaroshenko, Shishkin

Petersburg Academy of Arts, which arose almost simultaneously with educational courses in the mid-eighteenth century as a collection of "applied art exhibits" for its pupils. The museum collection included pictures of Rembrandt, Poussin, Rubens and other great masters, acquired by the first Head of the Academy, Count I. I. Shuvalov. The museum was soon filled with the best works by the gold-medal winners among the Academy's pupils. The collection likewise included the finest works sent from abroad by Academy "fellowship holders," those graduates pursuing advanced study in Italy, France and Germany at the Academy's expense. The museum also held works by artists who were granted appointments as Academician or Professor. Hence, the Academy grew rather quickly, and by the mid-nineteenth century comprised approximately 400 works of painting and sculpture, constituting one of the largest collections of Russian painting. Meanwhile, the Academy museum still did not include a single work done outside the halls of the Academy of Arts, even though non-academic art was a rather solid and widespread phenomenon at the time. We might recall here the work of Aleksei Venetsianov, Vasilii Tropinin, Pavel Fedotov and other true founders of Russian democratic Realism.

One of the first attempts to create a collection especially devoted to Russian painting was that of Emperor Alexander I, who in 1825 founded a Russian gallery in the Imperial Hermitage. Several renowned paintings by Russian painters were transferred to it from the Academy of Arts, such as Karl Briullov's *Last Day of Pompeii* (1833). But although the gallery enjoyed the powerful patronage of the Emperor, it did not become a place where Russian art was accumulated systemically. Works ended up there on a haphazard basis, and only if they were in keeping with the tastes of the current regime. All the collections in the Hermitage, including the Russian gallery, were closed to the public, and free access to the halls of the Hermitage was not granted until 1866.

The private collections, independent of any official regulations or views, served as the only focal point in which the independent

spirit of younger Russian artists was met with understanding and serious interest.

A feeling of national consciousness, which had developed in Russian society throughout the eighteenth century, along with an interest in national history, intensified after the 1812 war between Russia and France under Napoleon. Patriotic fervor, awakened by the war, aroused not only respect for "everything native," but a desire to study the history of Russia in depth and to develop its national culture. It was in this atmosphere that the first collections of Russian painting began to appear. By the beginning of the nineteenth century, Russian painting had begun to develop successfully. It should be noted that from the very time such collecting began, many private collections tended to be museums which were open to the public. But the achievement of this goal was still a long way off. Neither Russian art nor Russian society was yet prepared for it. In the early nineteenth century, St. Petersburg was to play a leading role in the collection of Russian art.

Pavel Svinin (1787-1839) deserves mention as the first collector of our national art. As publisher of the St. Petersburg journal, *Notes of the Fatherland*, he was greatly respected. Svinin recalled that the idea of creating an art museum first occurred to him in 1816. "After studying objectively the degree of success we had achieved in the arts," he wrote in his journal, "I had every reason to believe in the possibility of establishing a Russian school." By 1829, Svinin's collection included more than 80 paintings by Russian artists of the eighteenth and nineteenth centuries, among which were works by the gifted masters K. Briullov, O. Kiprensky, F. Bruni, A. Venetsianov, M. Vorobyov and others. In addition to painting, Svinin created a magnificent sculpture department, where works by F. Shubin, M. Kozlovsky, I. Martos, S. Pimenov and F. Gordeev were represented.

"In spite of the fact that I have begun to collect my national gallery only recently," wrote Svinin in *Notes of the Fatherland*, "and that I have found it impossible to devote a great deal of capital to it, I already possess works of painting and sculpture

Svinin, Engraving, 1830s

Tomilov, *Portrait of O.I. Kiprensky*, c. 1828

which I would not be ashamed to display next to the works of the finest masters of all the famous schools, nor would they be overshadowed in the best of galleries." In addition to a picture gallery, his collection included medallions, antique silver, a collection of Russian minerals, and an enormous library containing manuscripts of sixteenth-century books and printed materials, but which related primarily to Russian history of the eighteenth century. Unfortunately, due to financial difficulties, Pavel Svinin was forced to sell his collection at auction in 1834. He had proposed earlier that the government acquire it so that the collection might serve as the basis for a Russian Public Museum, but this proposal did not meet with any support. One special feature of Svinin's collecting activity was his interest in early Russian Realism, to which he gave substantial support through his acquisitions. In this regard Svinin was a direct precursor of Russian art collectors in the years to follow.

It was this same independent and open-minded attitude towards contemporary Russian painting that made the collecting of A.P. Tomilov (1799-1848), a St. Petersburg landowner of modest means, so distinct. He was on friendly terms with many artists, often people his own age, such as O. Kiprensky, A. Varnek, and I. Aivazovsky. Tomilov's collection, in addition to completed works, included studies for painting and sculpture, whose spontaneity and freedom of artistic expression he greatly appreciated. Tomilov was one of the first to show an interest in collecting drawings.

Each of the emerging private collections had its own personality and individual characteristics. For example, the collector N.D. Bykov (1812-1884) had a special interest in portraits and artists/self-portraits, of which he had an entire gallery, although he likewise enjoyed buying, exchanging, and receiving as gifts paintings, sketches, drawings, wood-engravings and letters by artists. He closely followed the initial successes of young painters. Bykov supported the talent of Ivan Shishkin early in the latter's career, and the young Fyodor Vasilev; he acquired the paintings of the young Aleksei Bogoliubov as well. By the early 1880s his collection amounted

to some 250 works of the Russian and European schools. Pride of place in his gallery was given to the works of Russian masters, from the eighteenth century to the decade of the 60s in the nineteenth. This collection was, no doubt, among the finest in terms of artistic quality and comprehensiveness. However, like Svinin's museum, Bykov's collection was dispersed after its founder's death in 1884, with the paintings falling into various hands, and a number of which were purchased by Pavel Tretiakov.

In St. Petersburg, the Kushelev Gallery was opened to the public inside the halls of the Academy of Art in January 1873. Its owner, Count Nikolai Kushelev-Bezborodko (1834-1862), owned a first-rate collection of works by great artists from the sixteenth to the eighteenth centuries. Among them were works by Jordaens, Ruisdael, Rubens, Poussin, Boucher and Battoni. Also included in the collection were works by European painters of the first half of the nineteenth century – Delacroix, Dupre, Corot and others. Together with the works of Russian artists from the same period – Bruni, Briullov, Aivazovsky, Bogoliubov – they presented an impressive picture of European painting in the first half of the nineteenth century.

The Kushelev Gallery enjoyed great popularity among art lovers and artists. The paintings it included from contemporary European schools, especially the French Barbizon School, were of great significance to the development of Russian painting, especially the landscape genre. A preface to the catalogue of this gallery, published in 1886, stated: "...thousands of viewers have received aesthetic enjoyment and instruction from it, and for several generations of pupils at the Academy and lovers of painting who practice copies from this gallery, it has served as a marvelous school for skills and good taste."

However, the only collection of Russian painting to which the public gained access during the lifetime of its owner, and which was, moreover, acquired by the state and turned into a museum, was that of Fyodr Prianishnikov (1793-1867). It was the most famous collection in mid-nineteenth-

I.M. Prianishnikov

century St. Petersburg, and was highly valued both for its comprehensiveness and for the high quality of its contents. It was said at the time: "In spite of the fact that this precious gallery is quite recent, it is justifiably noteworthy, and its fame has spread beyond Russia. This gallery includes examples of all that has been produced so far by our best artists, and we have here a most faithful, most eloquent history of Russian painting."

Prianishnikov was a prototype of the enlightened patron of the arts, who took pleasure in helping artists and supporting talent. His sponsorship extended, for example, to Ilya Repin, at that time still a student at the Academy of Arts. For more than a quarter of a century, Prianishnikov gathered together his collection, setting for himself the goal of establishing a historical gallery of Russian painting from the mid-eighteenth century, i.e. from the moment the Academy of Arts was established until recent times. In Prianishnikov's gallery were 173 paintings by 84 Russian artists. "All at once," it was written at the time, "you can admire here the marvels produced on the Russian canvas and study the history of the fantastic speed with which painting has developed in Russia." Portraits, landscapes, historical compositions by eighteenth-century painters, the first steps taken by the Russian Realist school of the nineteenth-century paintings by Fedotov, Venetsianov and Tropinin were the basis for Prianishnikov's collection. But its mainstay was the work of Briullov, an artist highly valued by the collector.

In 1865 the Prianishnikov Gallery was acquired by the state, but left for use by its owner during his lifetime. In 1867, after Prianishnikov's death, this collection was transferred in its entirety to the Rumiantsev Museum in Moscow.

The accomplishments of Count Nikolai Rumiantsev (1754-1826) deserve special mention. He was among the most enlightened people in Russia in the late eighteenth and early nineteenth centuries. As Chancellor and Minister of Internal Affairs under Alexander I, he devoted himself to the compilation and study of historical documents in addition to his busy

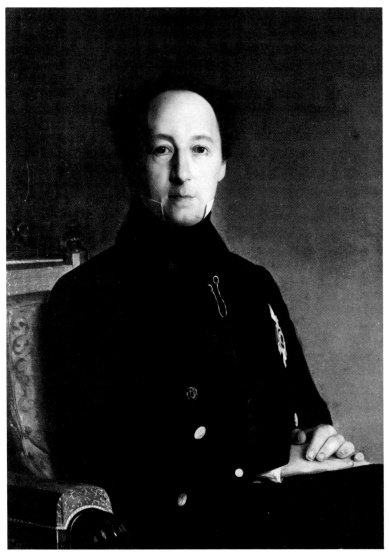

Prianishnikov, *Portrait of S.K. Zarianko*, 1840s

government activities. Rumiantsev was known as a patron of Russian learning, and as a collector and publisher of materials on Russian history. Around him gathered a circle of like-minded scholars and historians, archaeologists and numismatists, who assisted and in many respects facilitated his collecting and educational work, and the result of which was a most valuable collection consisting of ancient Russian manuscripts and books, numismatic and archaeological materials, and an ethnography section. Especially large was Rumiantsev's library, which comprised 28,000 volumes. After the October Revolution, this valuable collection became part of the Lenin Library in Moscow.

In Rumiantsev's circle, as far back as the early nineteenth century, the idea to create the first Russian national museum was born, one that would be a source for "knowledge about the state of the Fatherland" and would inspire "genuine respect for it." Rumiantsev's death in 1826 prevented him from carrying out this idea himself, but nevertheless, in accordance with his testament, a public museum, one of the finest in Russia, was opened in his St. Petersburg town house in 1831. It should be pointed out that it did not contain a picture gallery, and, deprived of government support, it soon came upon hard times. But it was precisely this museum, begun in St. Petersburg, which was to have a direct impact on the history of collecting and museum-building in Moscow. In 1862 the Rumiantsev collection was moved to Moscow and was used to establish the Moscow Public Museum. It was conceived of as a universal collection including a historical section, a library, zoological holdings and, necessarily, a picture gallery with a collection of Western and national art. About 200 works by European masters were transferred there from the Imperial Hermitage. The Russian part of the picture gallery was made up of the Prianishnikov collection, the Aleksandr Ivanov's famous *Christ Appearing Before the People*, donated to the museum by the Emperor, and many studies for it. Although the museum was conceived of as "the main depository in Russia of contemporary European and Russian paint-

ing," it could never live up to this task because, in the mid-nineteenth century, the center of art collecting shifted from St. Petersburg to Moscow.

Moscow, of course, occupies a special place in the history of Russian culture, having long been associated in the minds of Russians with greater freedom of thought than St. Petersburg, and with a greater interest in national issues. Moscow saw the emergence of special characteristics in Russian painting, distinct from those of St. Petersburg. When the Moscow Art Society was founded in 1833, it fostered increased interest in art among the Moscow public. The formation of the Moscow School for Painting in 1843 played an enormous role in the artistic life of Moscow, and of the country as a whole. At the time of its opening it was said that the School was to lend Russian art a "national spontaneity." "In this regard, much progress could be made in Moscow, where the physical appearance of the city, the monuments of the past, and historical remembrance – all of these together would generate new discoveries in art. Having imbibed the treasures of Western artistic origin through the Northern capital, Moscow has been called upon to give them its own national flavor."

A fierce polemic was conducted during those years by Moscow and Petersburg journals over the ways in which Russian art should develop. As part of this general interest in the nation's cultural heritage, so actively pursued in the middle of the century, an interest in collecting Russian painting was only natural.

Contemporaries noted with regret as early as the 1860s that Moscow was "incomparably poorer" than St. Petersburg in the field of art collections. Yet as compared with St. Petersburg magnates, the Moscow elite in the eighteenth and early nineteenth centuries had accumulated magnificent collections of old Western European art in their palaces and country estates. The Ostankino palace and Kuskovo, which belonged to the counts Sheremetev, and Arkhangelskoye, which in turn belonged to the Yusupov princes and were later converted into museums, are excellent proof in this regard. Towards the

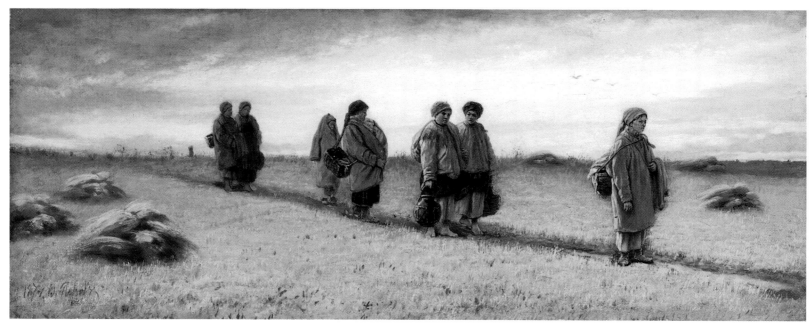

Perov, *Reapers Returning from the Fields in the Riazan Province*, 1874 (*see* Cat. No. 56)

middle of the nineteenth century there was a radical change in the interests of collectors and in their ranks. At about that time the princely families declined, their old estates fell into ruin, and once-rich collections were dispersed. New people, engaged in industry and trade, emerged with new fortunes and became actively involved in science and culture and in collecting art. This new stratum stemmed from the Russian merchant class, which had been developing in Moscow for more than half a century.

In the 1850s and 1860s collections began to be formed in these same Moscow merchant homes, with paintings becoming an obligatory possession. A great deal depended on fashion, and on the collector's desire to make a reliable investment. Against this broad background of interest in collecting, there appeared a number of exceptional collections, and Moscow, in the middle and second half of the nineteenth century, was rich in such collections.

The home of Aleksei Khludov (1818-1882), who had gathered

an extremely valuable library of old manuscripts and antiquarian books, was noteworthy for its small but fine collection of Russian nineteenth-century painting. In it were works by K. Briullov who was prized by collectors, of I. Fedotov, and the paintings of V. Perov, in whom A. Khludov had a special interest.

One point of interest in Moscow was the picture gallery of D.P. Botkin, which included European painting and works by Russian artists, especially V. Perov, and studies by A. Ivanov, which P.M. Tretiakov dreamed of acquiring.

Another active collector of European and contemporary Russian art was the Moscow merchant A. A. Borisovsky, who commissioned V. Perov to paint *The Refectory*. Borisovsky was friends with A. Savrasov and bought a number of his paintings, as well as landscapes by I. Shishkin.

The fate of one of the largest Moscow collections of the mid-nineteenth century, that of Vasilii Kokorev (1817-1889), is of some interest. He was involved in one of the first attempts

by Moscow collectors at turning their collections into a public picture gallery. An extraordinary individual, Kokorev was a product of the remote Russian provinces, with no education, but he was endowed with exceptional intelligence and indomitable energy. He managed to achieve not only wealth and social recognition, but also became one of the most respected Russian cultural figures. A merchant of the First Guild who became rich in the wine trade, he was a founder of banks, and many industrial and trade enterprises, and was the first Russian oil magnate, with millions to his name. He was also a writer-publicist, the author of articles on economic issues, a public statesman, a patron of the arts and, finally, an art collector.

Having begun to collect paintings in the 1850s, Kokorev quickly accumulated a substantial collection of European and Russian painting. The major part of his collection was made up of works by Russian masters. With a view to making his collection accessible to the general public, he transformed the town house he owned in a narrow Moscow street into a picture gallery, which he opened to the public in 1862. After going bankrupt, however, Kokorev was forced in 1869 to begin selling his collection. When the government failed to express an interest in acquiring it, he sold the museum piecemeal to various buyers. Some works belonging to Kokorev were purchased by P. Tretiakov and are now among the holdings of the Tretiakov Gallery. Others were dispersed throughout numerous collections. A significant portion of the works ended up in the Imperial court collections, and were later concentrated in the Russian Museum in Leningrad.

At that time, in the late 40s and early 50s, a collection was being formed by Kozma Soldatenkov (1818-1901), an enlightened figure from the Moscow merchant class. Soldatenkov has a place in Russian culture not only as a collector, but as the largest book publisher in Russia. Although he came from the lower and rather ignorant stratum of the Russian merchant class, his sense of purpose and tireless desire for self-education enabled him to become one of the most cultivated people of

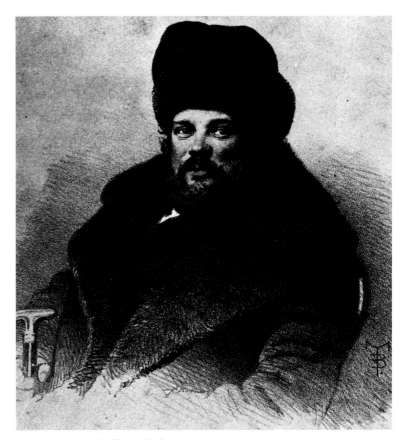

Kokorev, *Portrait V.F. Timm*, 1856

his time. His artistic and aesthetic interests always involved "high" academic art. Although Soldatenkov collected paintings for more than 50 years, throughout his long life his taste did not undergo any significant change, and he remained indifferent to the latest trends in the Russian school of his time. Nevertheless, Soldatenkov was one of the most remarkable individuals in Moscow artistic life. He was generous in lending works from his collection for numerous exhibitions, sacrificed huge sums of money for artistic purposes, and founded a scholarship fund for pupils at the Moscow Art School. Artists and writers were guests in his Moscow home and at his country home near Moscow. He bequeathed to the Moscow Rumiantsev Museum his entire art collection and a large library which were transferred there after his death in 1901.[1] This was the background against which the Moscow merchant, Pavel Mikhailovich Tretiakov (1832-1898), the famous Russian collector and founder of the Tretiakov Gallery, began collecting in the late 50s and early 60s.

Tretiakov made his first acquisitions in 1856, and then, for more than 40 years until the end of his life, he obtained paintings of Russian artists by the dozen, and sometimes by the hundred per year. In terms of the sheer scope of his collecting, Tretiakov had no equal. He was not simply a collector, with an obsessive passion for accumulating and acquiring paintings for his own personal pleasure; from the outset he had a lofty goal, formulated as early as the 1860s and expressed in his first *Testament Letter:* I leave funds in the amount of 150 thousand silver for the establishment of an art museum in Moscow...I can have no better desire, as a sincere and passionate lover of painting, than to lay the foundations for a public depository of precious art objects with access for all, which would be useful to many and enjoyable to all." The testament contained an important postscript: "I would like to

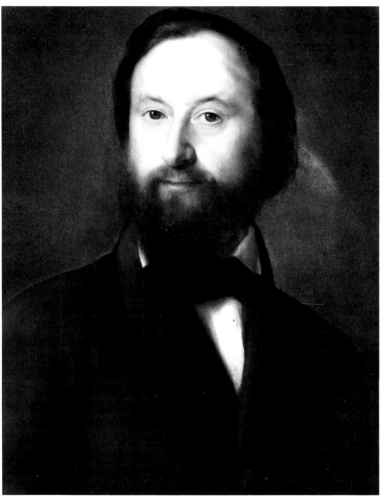

Soldatenkov, *Portrait A.G. Govarsky,* 1857

---

1 *In 1925 the major part of the collection of paintings from the Picture Gallery of the Rumiantsev Museum was merged with that of the Tretiakov Gallery, where many of the works by Russian painters belonging to Soldatenkov can be found today. At that time the Tretiakov Gallery received from the Rumiantsev Museum A. Ivanov's* Christ Appearing Before the People *together with the studies in preparation for it.*

leave behind a national gallery, that is, one made up of paint-
ings by Russian artists." Tretiakov devoted the rest of his life to
fulfilling that noble goal.

While relying on the previous experience of collectors,
Tretiakov nevertheless acted independently. His collection was
different from previous ones because of the new nature of
artistic interests, the maturity of Russian art, the emergence of
a democratic trend within it, the atmosphere of the times, and
widespread access to artistic pursuits enjoyed by the liberal
strata in Russian society. As a committed witness to the strides
made in Russian art of the late nineteenth century, Tretiakov
reacted with enthusiasm to new events in his country's cul-
ture, and closely followed everything shown at the exhibitions
and in artists' studios. He welcomed every success in Russian
painting and saw to it that anything marked by true talent and
a realistic reflection of life made its way into his collection. As
someone without any special artistic education, but with a
high degree of culture and a flawless artistic instinct, he was
able to choose from among a large number of paintings those
works that were most significant and characteristic of Russian
painting in particular. Tretiakov was never guided solely by his
own personal tastes and sympathies in this regard, but he
knew how to make an objective evaluation of the significance
of a painting for the history of Russian art. The collector
enjoyed enormous authority among artists, but the support
and trust involved in establishing the first museum of Russian
art were mutual. Collector and artists thought alike on this
general issue.

Whenever the tall, gaunt figure of Tretiakov appeared in
some artist's studio, it was a major event in the life of that
artist, especially if he was a new one. Frequently, artists both
young and venerable made significant concessions in price to
Tretiakov, since Tretiakov's purchase of a painting meant
social recognition for the artist and was regarded as an honor.
"I must confess to you most frankly," wrote Repin to Tretiakov
in 1877, "that if I were to sell, it would only be into your hands
and to your gallery that I would do so without regret, for I tell

P.M. Tretiakov in 1884

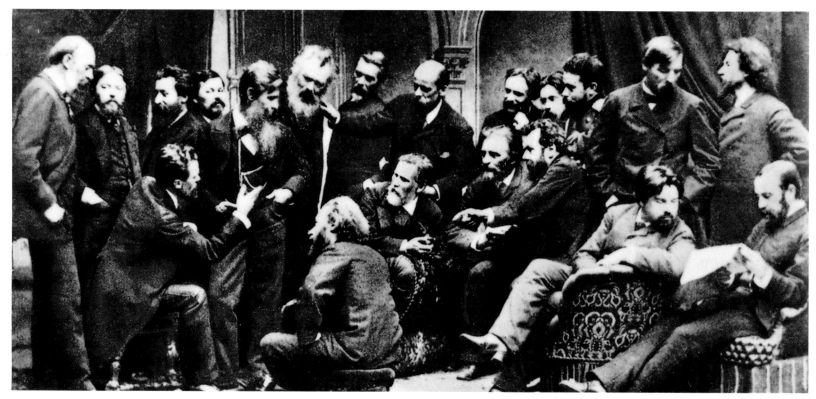

Members of The Wanderers as photographed in 1886. (standing, left to right) N. E. Makovsky, Beggrov, Ammosov, Evachev, Litovchenko, Shishkin, Nevrev, Volkov, Lemoch, Kiselev, Yaroshenko, Prianishnikov, Repin (seated, left to right) V. E. Makovsky, Savitsky, Kramskoy, Miasoedov, Briullov, Surikov, Polenov

you at the risk of flattery that I deem it a great honor to see my works there."

As a collector Tretiakov was most interested in artists with democratic leanings, for whom he had a deep sympathy and on whose success he pinned his hopes for the flowering of Russian art. In the Wanderers – I. Kramskoy, V. Perov, V. Surikov, I. Repin, V. Vasnetsov – Tretiakov saw artists akin to him in spirit and conviction, and they, in turn, saw him as a collector with values similar to their own. The formation of the Association of Traveling Art Exhibits in 1870 marked the coming of age of democratic art. Tretiakov's *rapprochement* with the artists from that association, and his acquisition from the group's exhibitions of paintings which were becoming increasingly significant in Russian art history, made Tretiakov's collection unique among all other collections of that time. Even today, the gallery owes a debt of gratitude to Tretiakov, for the collection he assembled still contains the fullest representation of one of the most important genres in

Russian art – Realist painting of the late nineteenth century.

Tretiakov's collection acquired a special nature when, in the 1870s, he began systematically to create a portrait gallery of figures from Russian culture as part of his collection. With a profound realization of the significance of his famous contemporaries and a desire to preserve their living images for posterity, Tretiakov commissioned portraits of "writers, composers, and figures from the world of art in general" from the best artists – Perov, Kramskoy, Ge, Repin. Because of Tretiakov's commissions, there exist today portraits of Dostoevsky, Apollon Maikov, Tolstoy, Anton Rubinshtein, Tchaikovsky and many other prominent figures in the nation's art. Tretiakov established this gallery with a lofty sense of responsibility, and his very choice of those portrayed is an indication of the collector's understanding of their contribution to Russian culture as a whole.

Tretiakov's gallery and the collector as an individual attracted a great many famous people of that time. His home in the

tranquil Lavrushinsky Lane, not far from the Kremlin, had, by the early 1870s, already become one of the most important spiritual centers in Moscow. Artists saw in Tretiakov not only a buyer for their paintings, but a man of broad artistic interests and the most profound spiritual qualities. While he was outwardly severe, silent and even unsmiling, Tretiakov attracted people with his democratic instinct, his forthrightness, his boundless modesty, sincerity and kindheartedness. "The home of the Tretiakov family, where I have met with such affection, warmth and hospitality, is somehow an expression of the best side of Russian life," recalled the artist Vasilii Maksimov. Not only artists, but also writers and musicians were invited guests to the patron's household. Tretiakov was bound to many of them not simply by bonds of acquaintance, but by mutual respect for one another's activity, and often simply by friendship. Ivan Turgenev frequented Tretiakov's home as an old friend and favorite writer. Leo Tolstoy came to spend time in the gallery and to see the Tretiakovs, for whose endeavors he had great respect. Tretiakov, in turn, was a profound admirer of the great writer and was fond of him, even though they argued a great deal about cultural convictions. Tchaikovsky, the composer brothers Anton and Nikolai Rubinshtein, and well known musicians, both Russian and European, visited the Tretiakov home quite frequently, starting in the 1870s, when musical evenings were organized there. The atmosphere in his home was suffused with a sincere love for art, appreciation of its best manifestations, and a fervent desire to support all great talent.

Tretiakov did not confine his art interest to the Wanderers alone. He collected on a much wider scale and was able to see talent in the younger, burgeoning artists and their artistic movements. "I have set myself the goal of collecting Russian art in its course of development," wrote Tretiakov to one of his correspondents. He had a deep understanding of the living connection of past to present in the development of the nation's culture. Art of the early nineteenth century – the works of Briullov, the studies by A. Ivanov, the paintings of

Tropinin and of Venetsianov, eighteenth century painting, and later medieval Russian art – all this gradually entered into Tretiakov's collection, portraying Russian painting in all aspects of its historical development.

Evaluating Tretiakov's personality as a collector and as a historian, of sorts, of Russian art, one of his contemporaries rightly said that Tretiakov was "a scholar by nature and by erudition." Tretiakov's acquisitions quickly grew beyond the bounds of a private collection. Already by the early 1880s his gallery had acquired the status of a genuine museum, open for viewing by anyone without distinction as to origins or knowledge. Progressive-minded Russians highly valued the collector's purpose and his legacy: "He brought his activity to grandiose, unparalleled proportions, and alone shouldered the burden of the existence of an entire school of Russian painting. A colossal, unparalleled feat," wrote I. Repin.

In 1892 Tretiakov donated all he had acquired together with a small, but marvelous collection of European painting belonging to his late brother to the city of Moscow. By that time it comprised approximately 2000 works.[2]

To the end of his life, until 1898, Tretiakov remained as guardian of the gallery, working tirelessly to expand the collection. Throughout the several decades during which he strove to create a gallery, Tretiakov was also active conducting the family business. Although he increased the fortune of his ancestors several fold, late in life he wrote to one of his daughters: "My idea has been since my early youth to make profits, so that these profits made from society also might be returned to that society (the people) through some sort of useful institutions, and this idea has remained with me my entire life."

After Tretiakov's death in 1898, a Council was elected by the Moscow City Duma to head the gallery. It included prominent Moscow collectors: Ilya Ostroukhov, Ivan Tsvetkov, the artist Valentin Serov, Igor Grabar and representatives of the

2 *Currently the Tretiakov Gallery contains more than 70,000 works of painting, sculpture and graphics.*

P.M. Tretiakov in 1897

Tretiakov family. The Council actively continued to make acquisitions, in an attempt not to leave a single significant work outside the gallery's halls.

On June 3, 1918, after the success of the October Revolution, Lenin signed a decree to nationalize the gallery, thereby turning it from municipal property into the national property of the State. In accordance with this decree, the gallery was forever to bear the name of its founder, Pavel Mikhailovich Tretiakov.

After Tretiakov donated his collection and it was converted into a Moscow city museum, St. Petersburg, the Russian capital, began in 1895 to also put together a state museum of Russian art. Unlike the Tretiakov Gallery, though, the basis for St. Petersburg's Russian Museum consisted not of a private collection, but of paintings transferred to it from the Hermitage collection of Russian paintings, from the Academy of Arts Museum, and from various Imperial palace collections. The art which entered this new museum contained excellent works by great Russian painters of the eighteenth and early nineteenth centuries: Borovikovsky, Levitsky, Briullov, Aivazovsky, Ge and many others. In historical terms, the collection at the Russian Museum would henceforth contain the fullest display of painting from the eighteenth and early nineteenth centuries, while the Tretiakov Gallery was to have a first-rate collection of paintings by the Wanderers. Currently, the Russian Museum in Leningrad and the Tretiakov Gallery in Moscow are the main repositories of Russian painting, and they represent the history of its development from its origins to the present day.

In the 1880s, when the Tretiakov collection was already known throughout Russia, a new generation of collectors appeared on the scene. Many of them belonged to the non-gentry intelligentsia. They were artists, doctors, and economists who did not possess inherited wealth, but who were widely educated and had a love of Russian art and a sincere interest in its development. Among these collections, we should highlight two whose collections were especially

Exhibit at the Tretiakov Gallery in 1898. Works by Perov, Morozov and others can be seen in the photograph.

Another exhibit at the Tretiakov Gallery (1898) with paintings by Repin, Sudkovsky, and A.M. Vasnetsov.

significant – I.E. Tsvetkov and I. S. Ostroukhov, both of whom, like Tretiakov, founded their own museums.

Ivan Tsvetkov (1845-1917) was a wealthy financier and a prominent figure among Russian bankers of the 1880s and 1890s. He purchased his first paintings in 1881, acquisitions made "at random" and "for (my) own personal enjoyment," he said. Soon, however, this new distraction became an all-embracing passion for him, and much later, on comparing his collection with the Tretiakov Gallery, he said: "Tretiakov's is an enormous, wonderful study of Russian art, which I have only in capsule form."

Along with works of painting, Tsvetkov began to collect graphic works by Russian artists and succeeded in creating a priceless collection of drawings and watercolors by masters from the eighteenth to the early twentieth centuries. While the paintings in the collection amounted to some 410 works by the end of his life, the drawings numbered 1,500. It should be pointed out that in the course of his collecting activities Tsvetkov often turned to Tretiakov for information, experience, consultation and advice. But unlike Tretiakov, who had a flair for new trends in art and quickly reflected them in his collection, Tsvetkov's interests were confined to Realist painting of the late nineteenth century. Tsvetkov took a harshly negative view of the aspirations and movements among younger Russian artists of the early twentieth century. "He has a very narrow understanding of anything new or good, or more precisely, no understanding at all," wrote the artist V.V. Pereplyotchikov, a contemporary of Tsvetkov, in his diary. "The Tsvetkov gallery was no rival to Tretiakov's," was the appraisal offered by the great Russian art historian, Igor Grabar. "Nevertheless," he continued, "it contained a number of great works of Russian painting and, consequently, made its own contribution to the history of Russian culture."

In 1900 Tsvetkov donated his gallery to the city of Moscow, but the public was allowed access to it only after its founder's death in 1917. In 1925 the best part of the Tsvetkov collection was merged with the Tretiakov Gallery, while other works

I.E. Tsvetkov

from his collection were added to the holdings of various museums throughout the country.

Ilya Ostroukhov (1858-1929) has gone down in the history of Russian culture not only as a talented landscape artist, but also as the founder of a most interesting collection of Russian painting. Like that of Tsvetkov, his collection began to take form in the 1880s. Realizing that it was impossible to compete with Tretiakov, Ostroukhov concentrated his interest primarily on collecting artists' sketches and studies. In those decades both artists and admirers alike were beginning to appreciate the value of sketch and study materials. Independent exhibits

of studies, sketches, or what at the time were called "experiments in artistic creation" were a common occurrence in Moscow and St. Petersburg artistic life.

Ostroukhov's collection displayed studies for many major works of Russian painting, including works by Repin, Surikov, Polenov, Vasnetsov; studies done from nature by Levitan, Vasilev – all these found in Ostroukhov an intelligent and understanding judge, who saved these priceless works for future generations. In addition to painting and graphics by Russian masters, Ostroukhov collected Western European art – contemporary and classical – as well as works of Western applied art. But this part of his collection was significantly smaller in size.

There were no random acquisitions in Ostroukhov's collection.

I.E. Tsvetkov in his gallery in the early 1900s

"I alone have collected everything. There is not one thing in the collection which I have not acquired by my own choice," is how Ostroukhov described his collecting activities. His contemporaries greatly appreciated his collection: "It is rare for someone of Ostroukhov's generation to approach art in so straightforward a manner, and there is almost no one to compare with him in appreciating art for art's sake, without concern for historical or antique value. And this lends charm to his collection, which is in itself a work of artistic creation," wrote the journal *Apollo* about Ostroukhov's collection in 1911. Yet another special characteristic of Ostroukhov as a collector was his interest in Russian icon painting. At the end of the nineteenth century the icon was rediscovered not only as a religious masterpiece, but as a great cultural, artistic and spiritual masterpiece as well. One of the first to begin collecting and appreciating these as works of art was Ostroukhov.

In the 1920s Ostroukhov's collection became known as the "Ostroukhov Museum of Icons and Paintings." In 1929 the major portion of the collection became part of the Tretiakov Gallery, including such important works featured in this exhibition as Repin's *Annual Meeting in Memory of the French Communards at Père Lachaise Cemetery in Paris*, (cat. no. 71), Surikov's *Nun with Hands to Her Face*, (cat. no. 87) and Kramskoy's *Reading* (cat. no. 23).

The 1880s saw the Russian provinces become actively involved in art collecting. A major role in this was played by the Association of Traveling Art Exhibits, which had shaken the artistic life of Russia. In the Ukraine, a collection was formed by the wealthy industrialist Fyodor Tereshchenko (1819-1903), whose collecting interests were directly influenced by Tretiakov. The Tereshchenko collection was later to lay the foundation for the Kiev Russian Art Museum. Other private collections arose in Simbirsk (now Ulyanovsk), Saratov, Astrakhan, Zhitomir, and Kharkov.

Also significant among collectors of Russian art were the artists, themselves, who initiated the establishment of museums by donating their own works and collections. First among such artists was Aleksei Bogoliubov (1824-1896), whose landscapes were displayed in the Association's exhibits. In memory of his famous grandfather, the eighteenth century revolutionary writer and thinker, A.N. Radishchev, Bogoliubov founded a picture gallery in Saratov in 1885, which bears the name of Bogoliubov's grandfather to this very day. The artist donated several hundred of his own works and his entire collection of Russian and European artists of the old and new schools, and the Radishchev Museum remains today, in terms of its collection, one of the most interesting museums in the Soviet Union.

In 1880 the well-known seascape painter Ivan Aivazovsky (1817-1900) built a picture gallery as part of his studio in his native city of Feodosiya, composed of his own works and landscapes by his pupils and contemporaries. Today, Aivazovsky's residence, studio and picture gallery are a single museum bearing the name of the famous painter.

The landscape artist Nikolai Dubovskoy (1859-1918), an active member of the Wanderers' Association, also laid the foundations for a museum collection. "For many years now, by exchanging my own works for those of others," he wrote, "I

The dining room of Ostroukhov's home, featuring works by Repin, Vasnetsov, and Ivanov, among others.

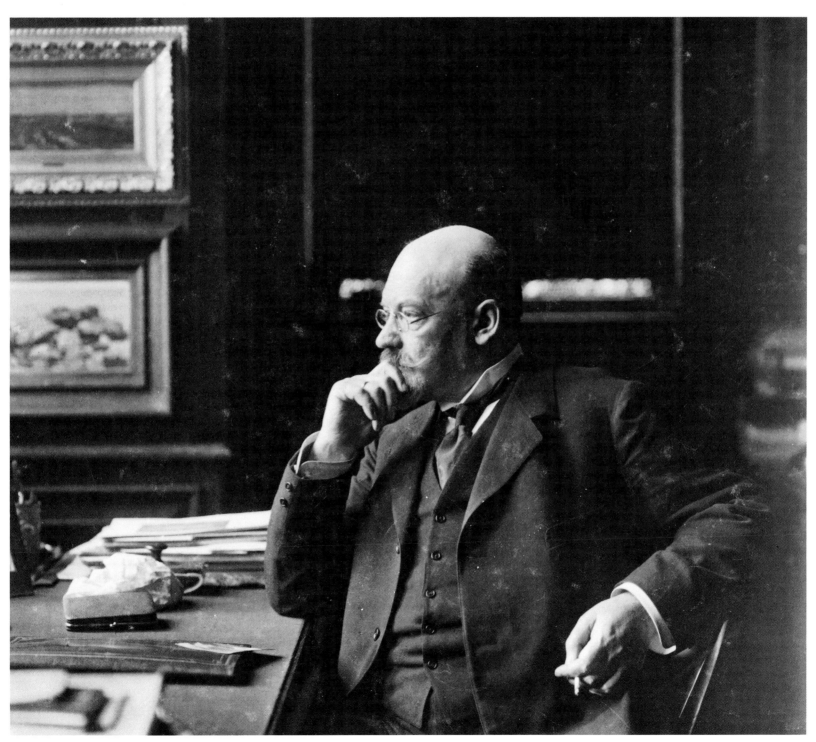

I.S. Ostroukhov, 1910s

Dubovskoy

forming a collection which, in her words, "reflects the development of watercolor painting from its beginnings to the present day." In 1897 Tenisheva donated her collection to the Russian Museum which had opened in St. Petersburg.

In the early twentieth century the Russian Museum also acquired a collection of drawings, watercolors and paintings belonging to S.S. Botkin, son of the famous Russian doctor S.P. Botkin.

Increased collecting activity was an important feature of Russian artistic life from the 1880s to the 1900s. Because private collections were the source of various exhibitions held in Petersburg, Moscow and other cities, the collections became, as a result, more "open" to the public, and the most patriotically inclined owners eventually donated their collections to educational institutions and museums, while others founded picture galleries, on their own initiative, and often at their own expense, and opened them for viewing.

It would be impossible to name all those people who were involved in collecting and preserving Russia's national art. After the October Revolution, the major portion of these collections became part of state art museums, which began to carry out the main functions of preserving, studying, publicizing and expanding the country's artistic heritage. The tradition of private art collecting, however, has continued to this very day.

At present, Soviet museums are expanding their holdings, acquiring or receiving donations of individual works, and sometimes even entire collections from private hands. Privately owned paintings are still an integral part of major museum exhibitions. The Tretiakov Gallery in Moscow, the Russian Museum in Leningrad, other museums throughout the country, and now the Soviet Culture Fund regularly present exhibits of works belonging to private collectors.

Today there are no large collections like those of Tretiakov, Ostroukhov or Tsvetkov, but every collection, even the smallest one, fulfills the noble mission of preserving for future generations those masterpieces of art which have been so lovingly gathered.

have compiled a collection of paintings by various authors, with a view to donating it as the basis for an art museum in a city where there is a special need for it. For this purpose I have gathered ... about 150 works, including 15 or 20 of my own paintings." This city was to be Novocherkassk, in the south of Russia, where Dubovskoy was born. To this day the basis for the Novocherkassk Museum collection continues to be the works donated by this artist.

In Smolensk during the 1890s, Princess Mariya Tenisheva (1867-1928) created a marvelous collection with primary emphasis in historical-ethnographic subjects. At the same time, she enjoyed collecting watercolors and succeeded in

# Catalogue Entries

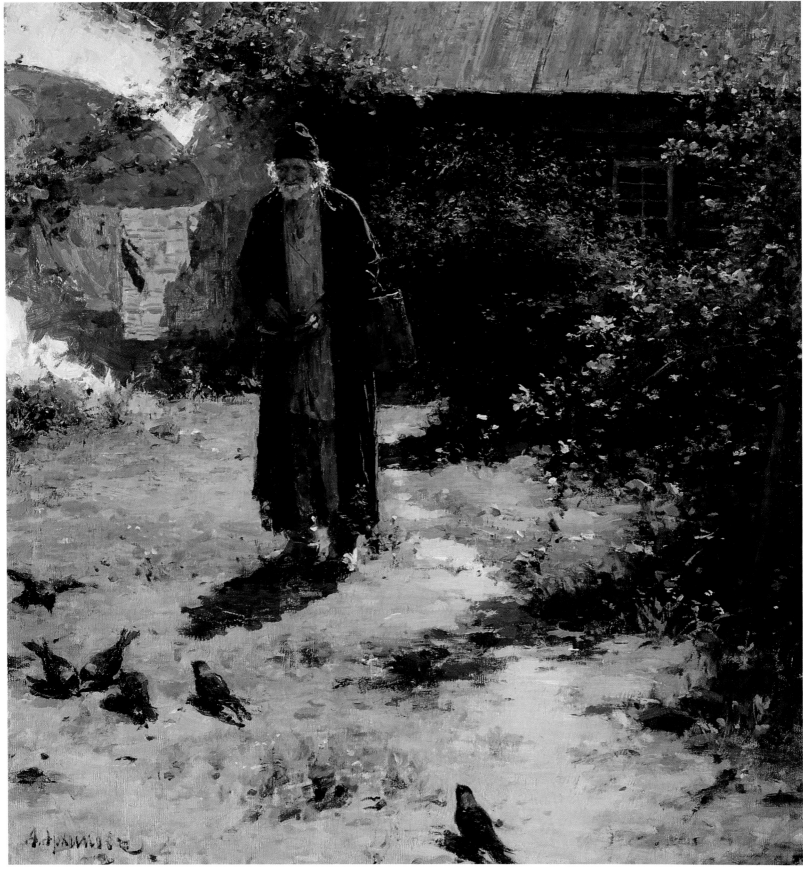

*No. 1*

No. 1

*ARKHIPOV, Abram Efimovich*
Lay Brother, *1891*
*oil on canvas, 65.4 x 61.5*
*signature lower left: A. Arkhipov*
*Tretiakov Gallery, since 1891*
*Painting acquired by P.M.*
*Tretiakov from the artist.*
*Inv. 1434*

The painting *Lay Brother* is distinctive for the modesty and even the commonplace nature of the subject, but its picturesque character gives the small canvas great resonance. The old man, having left the bustling world, finds total peace in a harmonious union with the bright, simple, curative soul of nature.

The painting shows the influence of Arkhipov's teachers – including V. Perov with his sensitivity to surroundings, to the common man, his love of the countryside. The influence of V. Polenov is even more apparent. Thanks to Polenov, Arkhipov's artistic talent developed with an interest in lively movement of color, air, and a rich palette. This work is characterized by a natural intertwining of subject and landscape lines, something which became characteristic of art at the turn of the century. As a graduate of the Moscow School of Painting, Sculpture and Architecture, Arkhipov inherited and developed in his art the finest traditions of the Moscow school.

No. 2

*ARKHIPOV, Abram Efimovich*
Laundresses, *1899*
*oil on canvas, 97 x 65.5*
*signature lower right: A. Arkhipov*
*Russian Museum, since 1930*
*Inv. 5629*

*Laundresses* is one of the key paintings by A.E. Arkhipov, in which issues of great social significance are portrayed. The concept of the painting stems from a visit by the artist to a laundry near the Smolensk market in Moscow. Before him lay a horrifying scene of urban poverty. Arkhipov persuaded the laundresses to pose for him, and he made studies of them in a dark corner of his studio where the light resembled that of the laundry. The painting depicts several laundresses doing washing in the cellar. Their condition is portrayed in a stark manner: exhausted, preoccupied faces, knotty, worn hands, stooped backs. The entire scene is clouded in steam. The artist's style is expressive. Broad, thick strokes of paint seem to sculpt the figures, highlighting the physical form and the texture.

The artist executed two versions of the painting. The second, dated 1901, belongs to the Tretiakov Gallery.

*No. 2*

*NOTE: Dimensions for works of art are in centimeters; height precedes width.*

*No. 3*

*No. 4*

No. 3
*ARKHIPOV, Abram Efimovich*
The North Sea, *1910s*
*oil on canvas, 74.5 x 93*
*signature lower right: Arkhipov*
*Tula Art Museum, since 1963*
*Inv. ZH-625*

Northern landscapes began to appear in the work of A. Arkhipov in the early 1900s, when he took a long trip to the shores of the North Sea. By that time the artist's painting technique had become totally defined – broad, free and temperamental – as can be seen in this landscape. The silvery tones in which the painting is depicted and the light, fleeting brush strokes help to convey a unique interplay of light and water typical of the North, and intensify the emotional expression of this landscape.

No. 4
*BAKSHEEV, Vasilii Nikolaevich*
Maundy Thursday, *1915*
*oil on canvas, 90 x 138*
*signature lower right: V. Baksheev 1915*
*Tver' Regional Picture Gallery, since 1937*
*Inv. ZH-16*

The creative work of Baksheev overlaps that of his contemporaries A. Arkhipov, M. Nesterov, and K. Korovin, with whom he studied at the Moscow School of Painting. The work of these artists defined an entire stage of Russian art, especially the Moscow school of painting. Social genre and landscape painting were the mainstay of Baksheev's art during the pre-revolutionary years, when artist was motivated by a desire to demonstrate the richness of spiritual life among the people, and the significance and nobility of their ideals. Landscapes were an important part of these paintings. Among these works is *Maundy Thursday*, full of lyricism, spirituality and genuine poetry. In the execution of the painting, an important role is played by the color effect of the candlelight in contrast with the cold tones of the surrounding landscape.

No. 5

*BOGDANOV-BELSKY, Nikolai Petrovich*
At the School Door, *1897*
*oil on canvas, 127.5 x 72*
*signature lower left: N. Bogdanov-Belsky 97*
   *(Letter "N" and "B" are intertwined)*
*Russian Museum, since 1908*
*Inv. ZH-5598*

The subject of the rural school became predomi-
nant in the art of Bogdanov-Belsky from 1890 to
the early 1900s. *Counting Out Loud, At the School
Door, The Voice Test, At the Sick Teacher's, The
Composition* and others, all are related to
Rachinsky's school and his pupils. (see No. 6)

*At the School Door* is a typical work in this cycle
with a poor boy depicted as the main protagonist.
Traveling from village to village, he probably came
upon the school by chance. He holds a stick and
two traveling bags which contain all he owns. The
boy's face is not visible, but the pose with which he
stands, looking at the pupils seated in class, is an
eloquent expression of his focused interest.

In this work, as in those of the Wanderers of the
older generation, we find a significant theme and
other elements characteristic of the Association: its
manner of execution, which can be seen in its strict
composition, detailed treatment of forms and
restrained color scheme.

The painting was shown at the 25th Wanderers
exhibition in 1897 and received enthusiastic
reviews in the press.

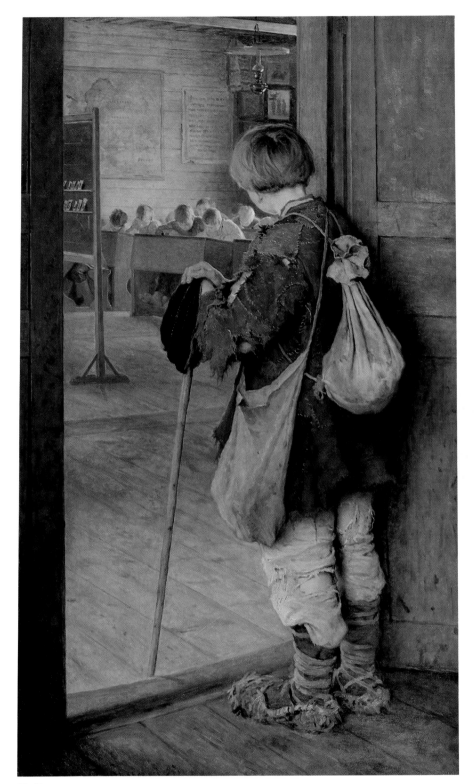

*No. 5*

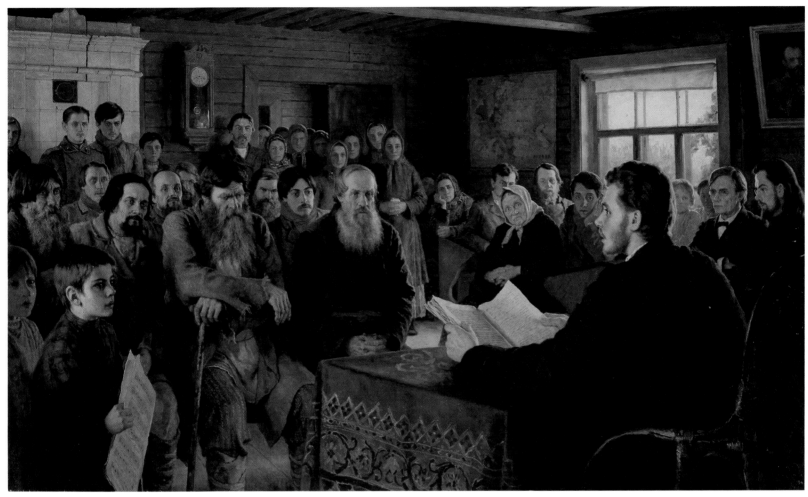

*No. 6*

No. 6
*BOGDANOV-BELSKY, Nikolai Petrovich*
Sunday Reading in a Rural School, *1895*
*oil on canvas, 96 x 154*
*signature lower left: N. Bogdanov-Belsky 1895*
*Russian Museum, since 1897*
*Inv. 2611*

N.P. Bogdanov-Belsky was prominent among the Wanderers around the turn of the century. In his early period he worked primarily on themes from peasant life related to village education. It is difficult to name another artist who worked so much in this sphere.

The most famous of Bogdanov-Belsky's works at the time was his painting *Sunday Reading in a Rural School.* The subject is simple: peasants have gathered at school on a Sunday to hear a teacher read a book. With great warmth and insight, the artist conveys the concentrated expressions of the peasants and their genuine interest.

At a window in the background, second from the right, we find Sergei Aleksandrovich Rachinsky, founder of the school where the Sunday reading takes place. A Professor at Moscow University, and the author of a number of scholarly works on botany, he left his position in 1867 and moved permanently to his estate Tatevo in Smolensk Province. There he built a school with a dormitory for the children of the poorest peasants who lived at a great distance. Dedicated to enlightening people, he succeeded in making his school a model, and he devoted a great deal of time and effort to training teachers for rural schools.

The subject was not chosen at random. Bogdanov-Belsky was a pupil in S.A. Rachinsky's school, and it was Rachinsky who first noticed the talented boy and determined his fate, advising him to enroll at the icon workshop of the Troitse-Sergeev Lavra.

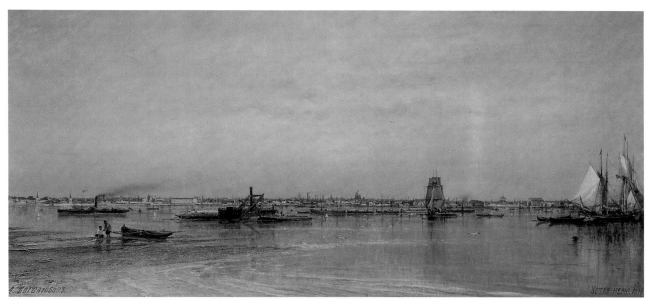

No. 7

No. 7
BOGOLIUBOV, Aleksei Petrovich
The Mouth of the Neva, 1872
oil on canvas, 54.5 x 110
signature lower left: A. Bogoliubov.
Lower right author's inscription:
    Mouth of the Neva 1872
Tretiakov Gallery, since 1872
Painting acquired by P.M. Tretiakov
    from the artist.
Inv. 815

The Mouth of the Neva is an important painting in the work of Bogoliubov. The unaffected nature of the subject, its convincing realism, the simple yet bold painterly strokes, make this one of the most marvelous works of Wanderer landscape painting.

After showing his work at one of the Wanderer exhibits, the artist became a member of the Association and an active, influential member of its Board. Bogoliubov belonged to the older generation of Wanderers. His first works, which appeared in the 1840s and early 1850s, were either cheerfully romantic in nature or were akin to the major panoramic landscapes characteristic of that time. But by the beginning of the 1870s, the artist's development took an active turn, leading to simplicity, naturalness and a life-like quality in his works, which he presented at Traveling Exhibits. Earlier in his youth Bogoliubov had prepared for a career as a naval officer, so it was quite natural for the artist to use sea subjects and naval battles as favorite themes.

*No. 8*

No. 8
*BOGOLIUBOV, Aleksei Petrovich*
Peter the Great Bicentennial Celebration
    on the Neva, *1872*
*oil on canvas, 121.6 x 194.5*
*signature lower right: A. Bogoliubov*
    *K. Gun. 1872*
*Russian Museum, since 1930*
*Inv. 2836*

On May 30th, 1872, a magnificent celebration of
the bicentennial of Peter the Great was held in St.
Petersburg, Moscow and many other Russian cities.
In the capital Peter had founded, the festivities
were especially grandiose. At Peter and Paul
Cathedral, with Tsar Alexander II present, a
requiem was performed at Peter's tomb. A prayer
service was also said at St. Isaac's Cathedral before
the procession moved to Peter's monument, the
Bronze Horseman, where the ceremony culminat-
ed in public festivities, centering on Peter's Square,
portrayed here by A.P. Bogoliubov, and the Field of
Mars.

  The painting was commissioned by the Naval
Ministry for the Imperial yacht *Livadia.* The histori-
cal painter K.F. Gun also worked on it and drew

many of the figures, which in fact are portraits.
Hence, the figure in the dark suit in the fore-
ground, leaning on the parapet of the embank-
ment, is A.P. Bogoliubov.

  The port city was a favorite theme of the artist.
While traveling throughout Russia in the 1860s and
1870s, Bogoliubov created a series of cityscapes, in
which genre elements are important. In this paint-
ing, landscape and genre are combined. The work
is distinctive because it represents a new stage of
development with its broad scope, masterful com-
position and color scheme. Yet the overall impres-
sion is one in which graphic forms prevail, and the
drawing is characteristically academic. The artist
reveals the image of the city magnificently, and por-
trays its great architecture – the ensemble of Peter's
Square (now Decembrists' Square) with the facade
of the Admiralty Building and the famous Bronze
Horseman, while on the far side of the Neva are the
Building of the 12 Colleges (new Leningrad
University), the Academy of Sciences, and the
Kunstkammer, the first Russian museum. In the dis-
tance we see the silhouettes of the Peter and Paul
Fortress and the Rostral Columns. Such accuracy
enables us to view Bogoliubov's work as a historical
document of his time.

*No. 9*

No. 9
*DOSEKIN, Nikolai Vasilevich*
Portrait of Pavel Mikhailovich
Tretiakov, *1911*
*oil on canvas, 71.3 x 51.9*
*signature lower center right: N. Dosekin 1911*
*Tretiakov Gallery, since 1927*
*Inv. ZH-9330*

Pavel Mikhailovich Tretiakov (1832-1898) was from
a Moscow merchant family and became himself a
wealthy industrialist who later founded the
Tretiakov Gallery.
    The portrait reveals a serious and extremely
respectful attitude towards Tretiakov, who for sever-
al generations of artists was an authoritative con-
noisseur and collector of their work. The portrait
was executed from a photograph for the Tretiakov
Artists' Widows and Orphans Home, built with
funds bequeathed by Pavel Tretiakov.

No. 10
*DUBOVSKOY, Nikolai Nikanorovich*
Quiet, *1890*
*oil on canvas, 76.5 x 128*
*signature lower right: Dubovskoy 90*
*Russian Museum, since 1897*
*Inv. 4392*

Dubovskoy belongs to the younger generation of
Wanderers. The full development of his creative
skills occurred in the 1880s and 1890s, at a time
when new trends in Russian landscape art were
becoming more apparent due to the influence of
Impressionism. Dubovskoy, trained in the halls of
the Academy of Arts, matured and went beyond
academic traditions, treating subjects which
allowed him to make profound statements. In
those years, he favored land and water motifs, and
the painting *Quiet* was based on a study the artist
had brought back from the Baltic seashore. In one
of his letters he wrote: "The reason for creating
this painting was an overwhelming feeling which
came over me many times while observing nature
in a period of silence before a great storm or
between two storms, when you have trouble
breathing, and when you feel your insignificance
at the coming disaster. This state of nature – the
silence before the storm – can be expressed in the
one word 'quiet.' That is, in fact, the title of my
painting." While avoiding superficially effective
color schemes, the artist builds his work around a
restrained dark blue palette, giving the image
inner meaning and enhancing its emotional
impact. Other versions of this painting under the
same title can be found in various museums
throughout the USSR.

*No. 10*

*No. 11*

No. 11
*DUBOVSKOY, Nikolai Nikanorovich*
Calm, *1899*
*oil on canvas, 87.5 x 133*
*signature lower left: N. Dubovskoy 99*
*Tver' Regional Picture Gallery, since 1937*
*Inv. ZH-69*

One of the artist's favorite themes was the portrayal of the sea and sky against a free, limitless background. Characteristic of most of his paintings is a serene narrative manner with softly flowing action. These features distinguish the painting *Calm*. Dubovskoy learned to paint accurately and in detail from his teacher the landscape painter M. Klodt. *Calm* is painted with a broad, self-assured brush stroke, without the artist overburdening the scene with secondary details, and it depicts, clearly and expressively, the main subject of the painting.

No. 12
*DUBOVSKOY, Nikolai Nikanorovich*
After the Heavy Rains, *1904*
*oil on canvas, 103 x 100*
*signature center left: N. Dubovskoy. 1904*
*Tula Regional Art Museum since 1956*
*Inv. 485-ZH*

This broad sweeping landscape features a fading horizon, a lofty sky, a little wooden house on a hill and a road wet with rain. In it Dubovskoy created a typical scene from the Russian countryside.

*No. 12*

No. 13
*GE, Nikolai Nikolaevich*
Peter the Great Interrogating Tsarevich
   Aleksei Petrovich in Peterhof, *1872*
*oil on canvas, 130.5 x 171*
*State Museum of Uzbek SSR, Tashkent*
*Inv. 1385*

At the first exhibit of the Wanderers Association,
which opened in St. Petersburg in late 1871, a
painting by the well-known artist Nikolai Ge enti-
tled *Peter the Great and Tsarevich Aleksei* drew
widespread attention. In it the artist depicted a
scene of Peter interrogating his son Aleksei, who
had opposed his policies of reform. Soon after-
wards, Aleksei was sentenced to death by a decision
of the Senate.

   In a silent, internal dialogue between father and
son, a heightened psychological drama unfolds
before the viewer, one that goes beyond a mere
personal relationship. In this painting Ge
expressed his understanding of historical develop-
ment as a constant struggle between opposing
ideas. The painting marked the beginning of a new
realistic interpretation of historical themes in
Russian paintings. Since it enjoyed great popularity,
the painting was redone repeatedly by the artist. Its
first version, however, is in the collection of the
Tretiakov Gallery.

   The art of Ge, one of the greatest and most pro-
found Russian painters of the late 19th century, is
characterized by exceptionally intense and com-
plex aspirations as expressed in subtle landscapes,
marvelous portraits, and paintings on Russian his-
tory. Especially important in his work were compo-
sitions on religious themes, in which the artist
attempted to express man's suffering as he sought
truth and failed to find it. A graduate of the
Petersburg Academy of Arts, he was one of the
founders of the Wanderers Association, and occu-
pied a special place within that organization.

No. 14
*GE, Nikolai Nikolaevich*
Portrait of Agafiya Ignatievna
   Sliusareva, *1875*
*oil on canvas, 109 x 83.5*
*Tula Regional Art Museum, since 1973*
*Inv. 882-ZH*

Agafiya Ignatievna Sliusareva (1856-1903), wife of
the artist's son, is depicted as a young woman in
Ukrainian costume fetching in her charm, simplici-
ty and frankness.

   Portraiture was quite important in Ge's work.
Among his portraits of writers and public figures
who played an important role in the spiritual life of
Russia in the 1870s and 1880s, there are, however, a
great many portraits of people who were seemingly
unexceptional. In each one, though, the artist
defines the value and significance of the human
individual, and his portrait of Sliusareva is, no
doubt, one such work.

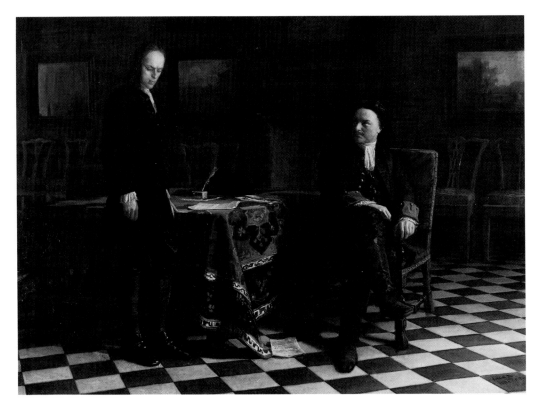

No. 13

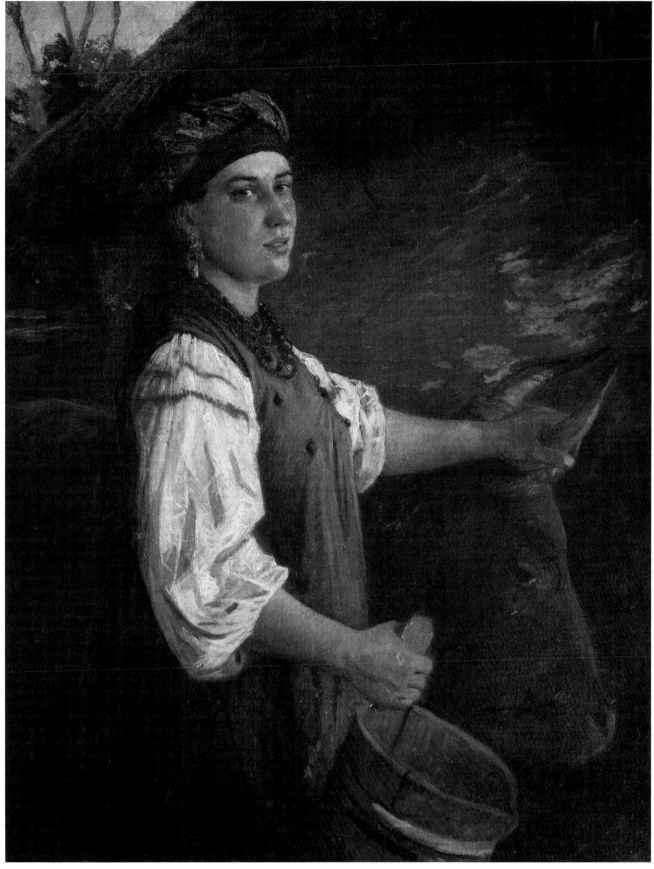

*No. 14*

No. 15
*GE, Nikolai Nikolaevich*
Portrait of Pyotr Nikolaevich Ge, *1884*
*oil on canvas, 97 x 65.5*
*signature lower right: N. Ge 1884*
*Kiev Museum of Russian Art, since 1934*
*Inv. ZH-142*

Pyotr Nikolaevich Ge (1859-post-1927) was the artist's younger son, and a literary figure, who wrote articles on art.

Ge did not paint contemporary themes, but he did record his contemporaries in a great many portraits which are diverse in their psychological characteristics and in their formal execution. They are similar to the artist's thematic paintings but pertain to human pathos.

This portrait was done when his aging father was exceptionally creative. While the religious paintings Ge did at the time were permeated with a feeling of tragic doom, his portraits express a faith in man and in the triumph of his lofty moral values. Behind the outwardly calm pose of his son and inner dynamic, we have an inkling of his troubled energetic nature. The young man's temperament is further expressed in the lively twinkle of the eyes. The color and light and dark shading are not only active formative elements, but, as in other portraits by Ge, they create an emotional atmosphere fraught with tension.

No. 16
*KASATKIN, Nikolai Alekseevich*
Rivals, *1890*
*oil on canvas, 71 x 106*
*signature lower left: N. Kasatkin 1890*
*Tretiakov Gallery, since 1891*
*Inv. 1417*

N.A. Kasatkin is a fine representative of the younger generation of Wanderers. His paintings deal mainly with themes of the working class, which in the 1890s had emerged in full force.

*Rivals* was painted by the artist at a time when the major course of his work was as yet undefined, and the young painter here used a rather traditional theme – the Russian village. But unlike the masters of previous decades, the important point in the subject for Kasatkin is not social poignancy, but its lyrical mood.

The beauty of the landscape, the clear color scheme, the subtly rendered feelings and the relationship between the two village beauties convey the artistic and emotional impact of this work.

With an instinct for exceptional talent, P.M. Tretiakov acquired the painting for his gallery, directly from the Wanderers' exhibit.

No. 17
*KASATKIN, Nikolai Alekseevich*
Orphaned, *1891*
*oil on canvas, 51 x 88*
*signature lower right: N. Kasatkin 1891*
*Russian Museum since 1947*
*Inv. 5638*

Kasatkin belonged to the younger generation of Wanderers and was the only artist at the time to devote his work entirely to portraying the life and revolutionary struggle of the working class. His links with the art of critical realism were already evident in this early work *Orphaned* (1891), in which the artist portrayed orphaned children arriving at a cemetery. Their poverty is apparent, and this painting is similar to the works of V.G. Perov in its deeply felt humanity, as well as its picturesque execution. One is reminded of such Perov paintings as *Accompanying the Deceased* (1865) and *Troika* (1866), which also reveal the hardships faced by impoverished children.

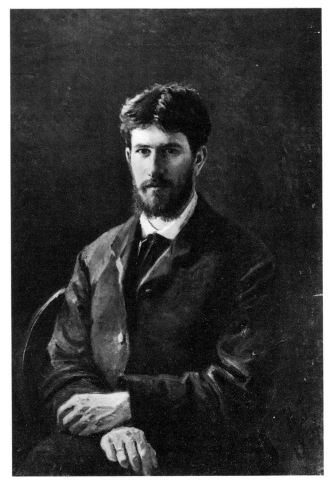

*No. 15*

*No. 16*

*No. 17*

No. 18
*KASATKIN, Nikolai Alekseevich*
In a Worker's Family, *1890s*
*oil on canvas, 75.5 x 71.5*
*Russian Museum, since 1932*
*Inv. ZH-2324*

Kasatkin's art dramatically depicts an entire gallery of workers engaged in slave-like labor. Such paintings as *Poor People Gathering Coal at a Closed Mine, Beast of Burden, Coal Mining. Change of Shifts* were executed in the Donbass, where the artist repeatedly traveled and lived, working from nature. Many other studies were done in peat bogs.

Kasatkin also left paintings showing the everyday life of workers. Among them is *In a Worker's Family*, in which a large family is depicted in an unpretentious and poorly lit room. Most important, though, are the faces of the models, whom the artist has painted with genuine sympathy, warmth and restrained lyricism.

No. 19
*KISELEV, Aleksandr Aleksandrovich*
The Forgotten Mill, *1891*
*oil on canvas, 72 x 122*
*signature lower right: A. Kiselev. 1891*
*Tretiakov Gallery, since 1949*
*Inv. 10955*

During the 1880s the moody landscape genre emerged in Russian painting with I. Levitan as its most talented, accomplished master. Aleksandr Kiselev, following the painting style of I. Shishkin and attempting an objective depiction of nature, was also drawn to its lyrical and poetic character. *The Forgotten Mill* has these qualities, and is one of Kiselev's best known works. The painting enjoyed great popularity and the artist often repeated the motif, changing only minor details in the landscape.

Kiselev's contemporaries noted the bright tone of his landscapes, determined by the artist's own approach to life and his view of nature, and critics wrote of the high quality of execution in his landscapes: "His technique is extremely simple and understandable. Kiselev may be accused of many things, but not of a lack of skill," wrote one reviewer. Understanding that nature has not only an outward, but also, and most importantly, a complex inner life, Kiselev said that only a true painter could convey it. The artist was extremely critical of his own work: "Levitan, in addition to his attractive color scheme, also has a grasp of profound poetic motifs...I merely observe and sometimes depict interesting subjects and motifs for paintings..."

While not an innovator of new trends in painting, Kiselev, through his active creativity, contributed much to the development of landscape painting.

No. 20
*KLODT, Mikhail Konstantinovich*
In the Ploughed Field, *1871*
*oil on canvas, 47.5 x 81.5*
*signature lower left: M:K:Klodt 1871*
*Russian Museum, since 1923*
*Inv. ZH-4111*

The painting *In the Ploughed Field* is central to the art of M.K. Klodt and is his most popular work. Klodt was among the first artists to sign the Charter of Association, and in the 1870s his artistic activities were closely linked to the Wanderers (though later on he would break with them). *In the Ploughed Field*, shown at the first Association exhibit in Moscow, embodies the Wanderers' cardinal principles – use of a subject from the life of the people, and portrayal of the country's natural beauty. In this painting, the limitless expanse is set off by the figure of a peasant woman looking out into the distance, and can be interpreted as a symbol of Russia. Klodt's painting style combines traditions of academic art with methods taken from the new artistic language. Thus, the exactness and even certain crudity of drawing are in the academic manner, while the color scheme testifies to the master's new painting objectives.

Other versions from 1872 and 1879 are in the Tretiakov Gallery and the State Art Museum of the Estonian SSR (Tallin).

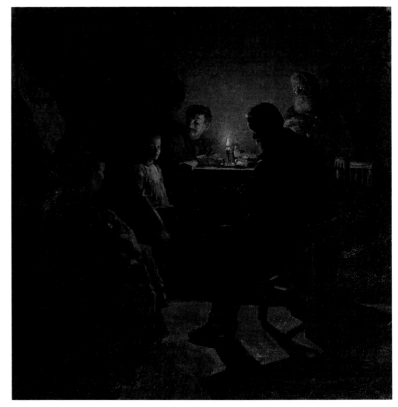

*No. 18*

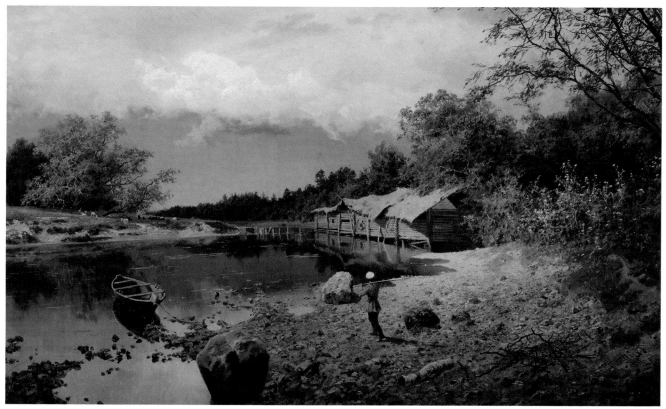

*No. 19*

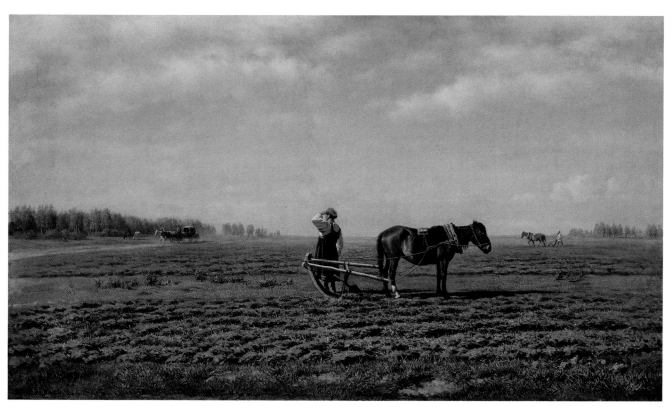

*No. 20*

*No. 21*

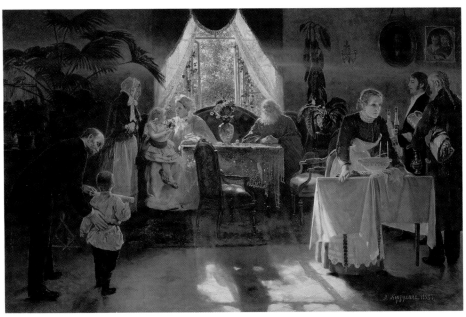

*No. 22*

No. 21
*KORIN, Aleksei Mikhailovich*
The Sick Artist, *1892*
*oil on canvas, 78.2 x 109*
*signature lower right: A. Korin 92*
*Tretiakov Gallery, since 1892*
*Painting acquired by P.M. Tretiakov*
   *from the artist*
*Inv. 1444*

*The Sick Artist* was A.M. Korin's entry for the 20th Traveling exhibit. I. Repin, in a letter to P.M. Tretiakov in which he advised the collector to purchase the painting for his gallery, wrote that Korin's was one of the best paintings in the exhibit, "full of expression, and drawn and painted masterfully." One merit of Korin's genre paintings was that the artist dealt with subjects he knew well from his own experience. As a youth of 19 he had gone to Moscow against his father's will in order to obtain professional artistic training. While studying at the Moscow School of Painting, he lived a life of hardship for five years in a dormitory free of charge to poor students. Deprivation, need, and an obsession with art were a daily reality for many artists, and not just those starting out. This painting exemplifies genre painting of the 1890s, depicting life with its banality and misfortunes.

No. 22
*KORZUKHIN, Aleksei Ivanovich*
Grandmother's Holiday, *1893*
*oil on canvas, 99.7 x 152.5*
*signature lower right: A. Korzukhin 1893*
*Russian Museum, since 1899*
*Inv. ZH-2527*

Because Korzukhin did not submit any works to the first Traveling Exhibit, he was excluded from the Association under the terms of its Charter. Nevertheless, he remained faithful to the Wanderers' ideals, interested in everyday themes, the life of the peasants, poor city dwellers, and the middle class. Inherent in Korzukhin's work is his constant awareness of the surrounding world and his simple and spontaneous presentation of the typical nature of the subject. *Grandmother's Holiday* was the master's last major work. As one critic wrote in the nineteenth century, "He has somehow expressed himself in it. The bright and peaceful mood conveyed in this painting has always been characteristic of Aleksei Ivanovich Korzukhin." The attempt to convey bright effects indoors as well as out in the open, characteristic of Russian painting in the last quarter of the 19th century, can be seen in this painting. The sun shines through a wide-open window, and the play of light on the leaves of the trees and on the faces of the figures, creates a richness of color, providing an overall picturesque effect.

No. 23

No. 23
*KRAMSKOY, Ivan Nikolaevich*
Reading. A Portrait of the Artist's Wife,
   *1866-1869*
*oil on canvas, 64.5 x 56*
*Tretiakov Gallery, since 1929*
*Inv. 11085*

The painting portrays Sofia Nikolaevna Kramskaya, née Prokhorova (1840-1919), Kramskoy's wife, true friend and helper in his many activities.

Sofia served repeatedly as a sitter for Kramskoy throughout his life, and the many portraits are characterized by great tenderness, warmth, love and respect.

As a painter, insightful critic, and remarkable public figure, who headed the Association of Traveling Art Exhibits and was virtually its ideologue, Kramskoy created a wide ranging portrait gallery of his contemporaries. His artistic aspirations stemmed from the overall logical development of Russian Realism, and led him to discover complex psychological aspects of the human condition.

The artist created various kinds of portraits, from studies to formal compositions, and *Reading* is one of his most poetic and lyrical images.

*No. 24*

No. 24
*KRAMSKOY, Ivan Nikolaevich*
Water Nymphs, *1871*
*oil on canvas, 88 x 132*
*signature lower right: I. Kramskoy 1871*
*Tretiakov Gallery, since 1871*
*Painting acquired by P.M. Tretiakov from the artist.*
*Inv. ZH-647*

Lyrical-poetic paintings are an important part of Kramskoy's artistic legacy. One such composition is the painting *Water Nymphs*, a subject which Kramskoy borrowed from a story by Nikolai Gogol. Attracted by the story's folklore origins, the artist chose not so much to illustrate the subject as to use it to express the dream of a life "full of meaning," a secret, mysterious moon-lit "tale." Kramskoy wrote: "I am glad that I did not break my neck over this subject, and even if I may not have caught the moon, something fantastic still has resulted."

No. 25
*KRAMSKOY, Ivan Nikolaevich*
Portrait of Aleksandr Sergeevich
   Griboedov, *1873*
*oil on canvas, 66 x 57*
*signature lower left: I Kramskoy 1873*
*Tretiakov Gallery, since 1873*
*Portrait commissioned by P.M. Tretiakov*
*Inv. 660*

Aleksandr Sergeevich Griboedov (1795-1829) was a famous Russian writer and poet, and the author of the comedy "Woe from Wit," (1822-1824), which helped to establish a Russian realist theater. In 1828 Griboedov was named ambassador to Persia, where he died tragically as a result of a government plot. Because Kramskoy's portrait was done 40 years after Griboedov's death, the artist found it difficult to convey convincingly the appearance and inner feelings of a poet whom he had never seen. In producing the portrait Kramskoy was greatly assisted by the actor P.A. Karatygin, who had known Griboedov well and who had himself done a watercolor portrait of the poet in miniature. In Kramskoy's portrait there is a sense of the subject's reserve, nobility, and intelligence – qualities which had been observed in Griboedov by his contemporaries.

Kramskoy left behind a great many portraits that can be called "historical," in that the subjects were painted posthumously, from a photograph or some other source dating from the lifetime of the subject, such as memoirs or accounts of contemporaries. Kramskoy felt it vital to not only achieve accuracy in appearance but, most importantly, to convey the very essence of the individual. These people, as they appear in Kramskoy's portraits, are preserved in the historical memory of Russian culture.

No. 26
*KRAMSKOY, Ivan Nikolaevich*
The Forester, *1874*
*oil on canvas, 84 x 62*
*signature lower left: I Kramskoy 1874*
*Tretiakov Gallery, since 1875*
*Portrait acquired by P.M. Tretiakov from the artist*
*Inv. 659*

Peasant portraits have a special place in Kramskoy's work, and his treatment of them reveals the Wanderers' overall interest in the everyday life of common people, and the artists' attempt to understand their nature, psychology, thoughts and feelings. To a large extent, Russian literature dealt with these same issues at the time. "For three years we have heard nothing but talk about the *muzhik* (peasant)," wrote the famous Russian satirist M.E. Saltykov-Shchedrin. "If we all need this *muzhik* so much, then we have to find out what he is, what he really looks like…What are his customs, mores, habits, and from what angle to approach him."

Kramskoy expressed the purpose of his work as follows: "My study…has been intended to portray one of those types – and they do exist among the Russian people – who have grasped social and political aspects of peasant life with their mind, and who have lived with a deep feeling of distrust bordering on hatred. During hard times Stenka Razins and Pugachevs recruit such people for their gangs. During ordinary times, they are simply loners. However, they are never reconciled."

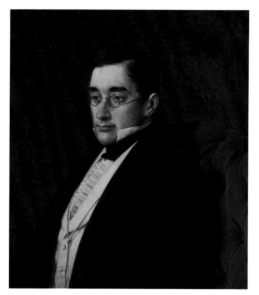

*No. 25*

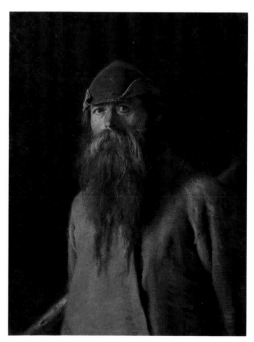

*No. 26*

No. 27
*KRAMSKOY, Ivan Nikolaevich*
Portrait of the Sculptor M.M.
    Antokolsky, *1876*
*oil on canvas, 75 x 63.5*
*signature lower left center: I Kramskoy*
    *1876 Roma (Letters I and K intertwined)*
*Russian Museum, since 1913*
*Inv. 2990*

Kramskoy considered Mark Matveevich Antokolsky (1843-1902), the prominent realist sculptor, to be a kindred spirit of the Wanderers and a "great master." His quest for the humanitarian ideal of truth and justice, clearly reflected in his *Christ Before the People* (1874) was especially appreciated by Kramskoy, who had thought of painting the same subject. After arriving in Rome to gather materials for the painting, Kramskoy painted a portrait of Antokolsky, who was also in the city.

The pale, lively face with the attentive look is full of tense inner vitality. An impression of anxiety in the figure enhances the emotional tone of the color. The dark red background can be interpreted as a sort of symbolic essence of the person depicted. Antokolsky, in a letter to the critic V.V. Stasov, reported that Kramskoy had painted a portrait of him marvelous for its style, liveliness, expression and color. It later occupied a prominent place in the gallery of portraits of outstanding figures in Russian culture created by the artist. The work reflected Kramskoy's new approach to the portrait as a form of art affirming first and foremost the intellectual and moral qualities of the sitter. As in all his portraits, the artist's imprint is evident in spite of the objective portrayal of the model. A kind of "dialogue" between the sitter and artist on the one hand, and the viewer, on the other, expressed in Antokolsky's "passionate" glance, gives the portrait the heightened psychological effect especially distinctive of Kramskoy's art.

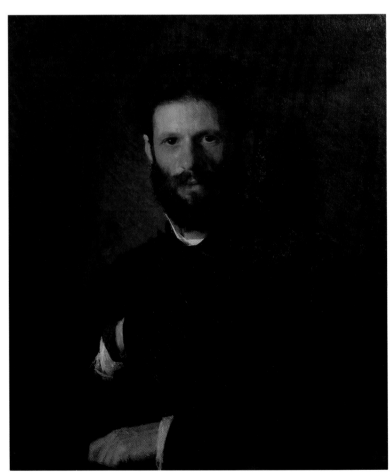

*No. 27*

No. 28
*KRAMSKOY, Ivan Nikolaevich*
Portrait of the Artist's Daughter,
  S.I. Kramskoy, *1882*
*oil on canvas, 118 x 70.1*
*signature lower left: SPG I Kramskoy 1882*
  *(Letters I and K intertwined)*
*Russian Museum, since 1897*
*Inv. 2983*

Among Kramskoy's most poetic works are his portrayals of children. Often, he painted portraits of his daughter, Sofia Ivanovna Kramskaya (1866-1933), married name Yunker, who later became an artist. There were deep bonds of friendship between them. Kramskoy began painting her from her childhood, and followed her growth as a young girl, highlighting the special features of her face and character. In this 1882 portrait, Sofia was a sixteen year old girl in the full flower of youth, wearing a graceful, highly refined dress which draped her figure. Kramskoy marvelously conveys the charm of youth, which can be felt in the entire figure, in her delicate complexion, in the almost child-like puffed lips, and in her relaxed posture. Though far from idealizing her, Kramskoy's portrait of Sophia is executed with a sensitive understanding of the psychology of the subject. In her facial expression, in her glance, and in the gesture of her hand, Kramskoy has conveyed her restraint, seriousness, and delicate shyness.

The painting, with its highly nuanced colors, is painted boldly and solidly, and the color scheme, the gentleness and simultaneous clarity of the forms, and the freedom and conviction of execution all testify to Kramskoy's growing mastery in the 1880s.

This sensitive and inspired portrait was especially prized by its author, and used to hang in his home. After his death it was sold to the Academy of Arts Museum, and from there it entered the newly founded Russian Museum. In the 19th century it was shown not only in Russia, but at international exhibitions in Munich (1883) and Chicago (1893).

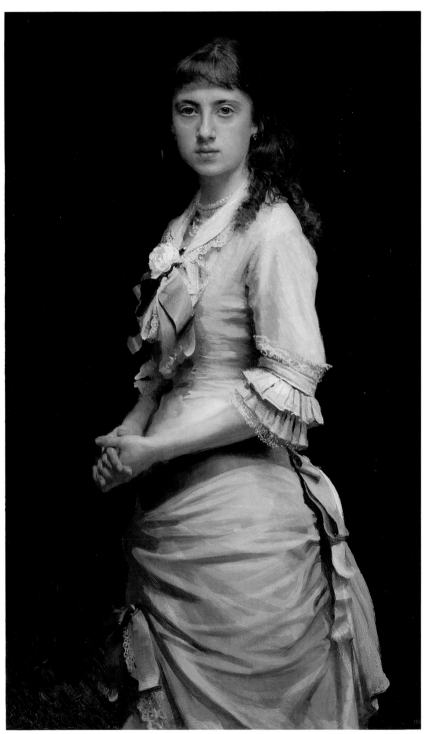

*No. 28*

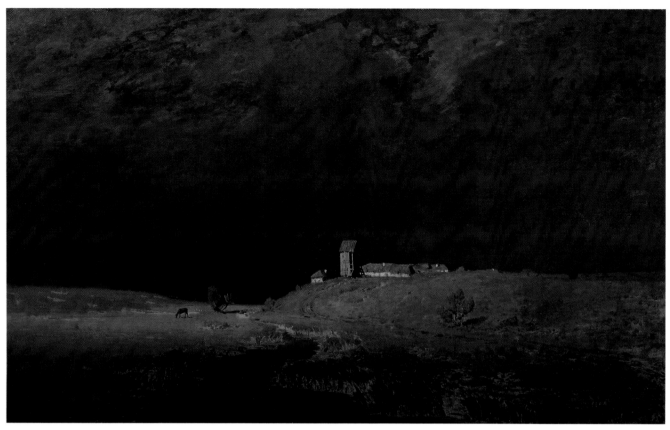

*No. 29*

No. 29
*KUINDZHI, Arkhip Ivanovich*
After the Rain, *1879*
*oil on canvas, 102 x 159*
*signature lower right: A. Kuindzhi 1879*
*Tretiakov Gallery, since 1879*
*Painting acquired by P.M. Tretiakov from the artist*
*Inv. 883*

Kuindzhi is one of the best representatives of Russian landscape painting. He viewed nature as a source of noble human feeling, and he sought to portray it at moments of triumph. *After the Rain*, through its emotional design, and its contrast of lights and darks, is close to romantic landscape painting. But unlike the Romantics, Kuindzhi eschewed any exaggeration or hyperbole in nature. The tension in the scene is due to the actual state of nature itself. The painting was an enormous success when shown at the Wanderers Exhibit.

Kuindzhi was an artist of remarkable talent; he was boldly experimental and often used unexpected color schemes. One of the more innovative painters, his traditions were carried on in the art of his pupils and successors, talented landscape painters of the early 20th century such as N. Roerich, A. Rylov, K. Bogaevsky and others.

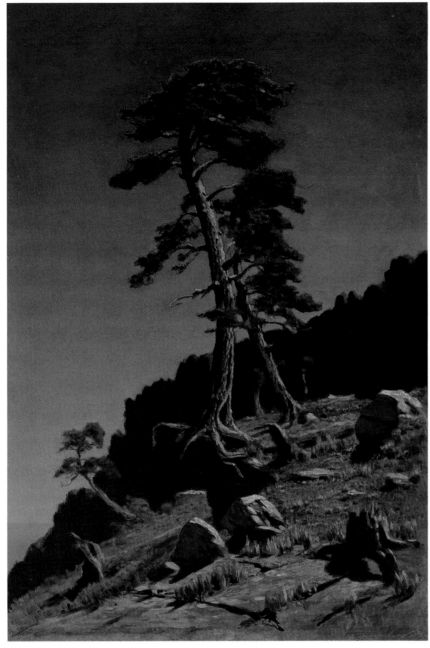

*No. 31*

No. 30
*KUINDZHI, Arkhip Ivanovich*
The Sea. Crimea, *1885-1890*
*oil on canvas, 40 x 54*
*Tretiakov Gallery, since 1930*
*Inv. 1516*
*(Photo not available)*

This painting was executed in the artist's later period, when Kuindzhi declined to show his works and was seeking special means of expression for conveying the reality of nature. What interested him, in particular, was the salient feature or sharp contrast in the landscape, the fullness of color observed in nature, and the contrast in tone between sky, land and water. After having played a great role in the formation of a national school of Russian landscape painting in the 19th century, exemplifying its romantic tendencies, Kuindzhi strove to create significant and lofty landscape images which emphasized form and color, and could give his works a certain decorative and picturesque quality. Small sketches were the basis for the artist's work at the time, and they became famous only after his death. This landscape study became part of the collection at the A.I. Kuindzhi Society.

No. 31
*KUINDZHI, Arkhip Ivanovich*
Pines, *c. 1885*
*oil on paper on cardboard, 55 x 36.5*
*Kalinin Regional Picture Gallery, since 1937*
*Inv. ZH-1029*

Kuindzhi experimented with landscape painting, but the spirit of romanticism is always inherent in his work as is clearly manifest in *Pines*. By building his description on color contrasts, giving the colors a decorative tone and, at the same time, an inner tension, Kuindzhi here created a picture of nature full of force and life. The dynamic compositional framework of the picture gives it special expression. The work was executed in Crimea, where Kuindzhi lived in the mid-1880s. The nature of Crimea – the rocky slopes of the mountains, the quaint forms of the pine trees, the yellow sand and dark blue sea, and the unusual light effects – were all basic elements in his work at that time.

No. 32
*KUINDZHI, Arkhip Ivanovich*
On Valaam, *1873*
*oil on canvas, 110 x 75*
*signature lower right: Kuindzhi*
*Tula Art Museum, since 1966*
*Inv. 683-ZH*

The image of a northern, barely inhabited land-
scape, with the rocky shore of the Lake of Ladoga,
clearly emerges in *On Valaam* painted by Kuindzhi
in the early years of his career. The careful
approach to detail, the delineation of all the ele-
ments in the composition, and the ascetic palette
all help to convey the harshness of nature and its
austere beauty.

The island of Valaam in the Lake of Ladoga was,
throughout the 19th century, a kind of mecca for
Russian artists. Its unusual natural beauty attracted
many landscape painters, especially those inclined
toward romantic leanings. Kuindzhi's landscape
shows an original combination of a realistic view of
nature, the influence of the Barbizon School and a
romantic pathos of his own.

No. 33
*KUZNETSOV, Nikolai Dmitrievich*
Going on Holiday, *1882*
*oil on canvas, 66 x 94*
*signature lower right: N. Kuznetsov 1882*
*Russian Museum, since 1932*
*Inv. 4189*

Kuznetsov, as a member of the Association of
Traveling Art Exhibits, was also one of the founders
and active members of the Association of South
Russian Artists, which was a Ukrainian version of
the Wanderers. Kuznetsov did not often work in
landscape. The combination of landscape and
genre motifs is characteristic of the Wanderers'
concept of landscape painting. The art of South
Russia in the late 19th century showed a special
interest in problems of tone and color scheme
which were reflected in the work of this painter.
One can feel these new trends in his work, and the
beginnings in Russian art of the 1880s of a new type
of landscape, one more in the Impressionist mood.
We can see this first of all in the bright color
scheme which seems to be bathed in sunlight. The
painting was exhibited in 1883 at the 11th
Traveling Exhibit and was highly praised.
Association official P.A. Ivachev wrote to the promi-
nent collector, P.M. Tretiakov, that "Every single
expert without exception has liked Kuznetsov's
painting," and that many found it to be the best
canvas at the exhibit.

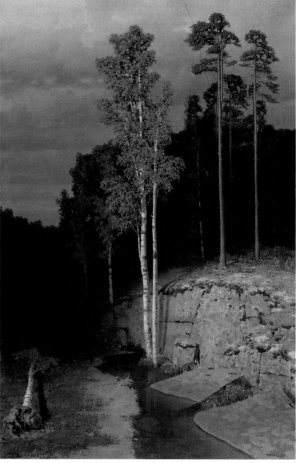

*No. 32*

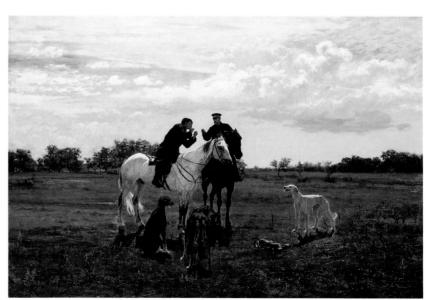

*No. 33*

No. 34
*KUZNETSOV, Nikolai Dmitrievich*
Housekeeper, *1887*
*oil on canvas, 141 x 95*
*signature lower right: N. Kuznetsov 1887*
*Tretiakov Gallery, since the 1880s*
*Portrait acquired by P.M. Tretiakov from the artist*
*Inv. 954*

*Housekeeper* is a portrait of the artist's wife Anna
Grigorievna Kuznetsova, and among the painter's
best works. Joy, enthusiasm, and a love of life suf-
fuse this attractive female figure, who is depicted as
an energetic, competent and knowledgeable house-
keeper for a large landowner's home. The work is
executed in the finest tradition of portrait art. "His
*Housekeeper* nearly moves and speaks," wrote one
critic.

Towards the mid-1880s Kuznetsov's gifts reached
their height, and he became a master of landscape,
of typical genre compositions from peasant and
gentry life, and of marvelous portraits. Kuznetsov's
portraits appeared on exhibit along with the works
of I. Repin and I. Kramskoy. It would, at first, seem
impossible to begin to compare him with these
masters, but Kuznetsov's individuality is clearly evi-
dent in each portrait.

Contemporaries liked Kuznetsov's canvases
because of his ability to convey, simply and vigor-
ously, individual traits of character, and his mastery
at expressing the complexity and diversity of the
human personality.

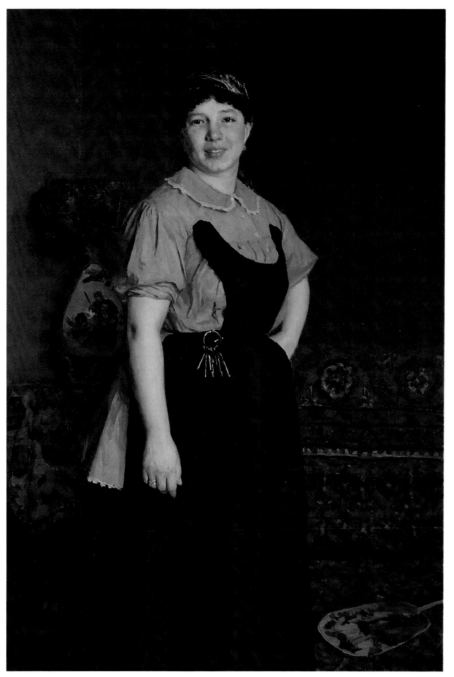

*No. 34*

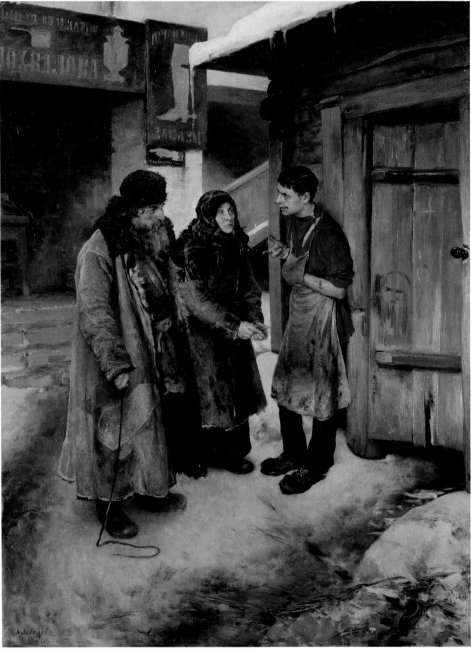

No. 35

No. 35
*LEBEDEV, Klavdii Vasilevich*
Visiting their Son, *1894*
*oil on canvas, 87 x 65.7*
*signature lower left: K. Lebedev 1894*
*Tretiakov Gallery, since 1895*
*Painting acquired by P.M. Tretiakov from the artist*
*Inv. 960*

In addition to historical painting, by which Lebedev first earned his reputation, the artist was prominent in contemporary genre, a field in which he maintained the best traditions of the Wanderers of the 1870s and 1880s. The subject of *Visiting their Son* is a very simple one: some old peasants – a husband and wife – have arrived in the city to visit their son, who is an apprentice. The subject embodies a major social problem at that time – when movement from the countryside into the city was breaking down age-old bonds among people, and the new urban life was having a cruel effect on the first generation of rural immigrants. For Lebedev, the moral ideal was personified in the Russian peasant – with his strong ethics, his sense of dignity, and respect for work. The artist's sympathies were always to lie with the people of the rural countryside.

*No. 36*

No. 36
*LEVITAN, Isaak Ilich*
First Greenery. *May, 1888*
*oil on canvas, 42 x 58.7*
*signature lower right: I. Levitan*
*Tretiakov Gallery, since 1888*
*Painting acquired by P.M. Tretiakov from the artist*
*Inv. 1476*

Levitan was a central figure in Russian landscape painting in the 1880s and 1890s. In his work he developed traditions in lyrical landscape which had been initiated in Russian art by his teachers, A. Savrasov and V. Polenov. Levitan, however, created a special type of landscape – the mood landscape – which echoed the sensitivity of the human soul. After completing the Moscow School of Painting, the young artist spent many summers working enthusiastically on landscapes in the Moscow region. It is no accident that the name Levitan is often mentioned along with that of the writer Chekhov, with whom the artist was friendly until the end of his life. Their friendship was nurtured by a similarity in work and a profound love of man and of nature.

With the keen artistic attention inherent in his powers of observation, Levitan conveyed his living impressions in an enormous number of studies and small paintings. The artist's youth and a fresh feeling of early spring emerge from this small canvas, *First Greenery. May.* It was done on the basis of an earlier study executed in 1883, but it retains its spontaneous view of nature, which the artist achieved by working directly from the subject.

No. 37
*LEVITAN, Isaak Ilich*
Portrait of Nikolai Pavlovich Panafidin, *1891*
*oil on canvas, 88.5 x 71*
*signature upper right: Levitan 1891*
*Kalinin Regional Picture Gallery, since 1937*
*Inv. ZH-741*

Nikolai Pavlovich Panafidin (1819-1895) was a landowner on whose estate, Pokrovskoye near Tver (now Kalinin), the artist was a guest in the summer and autumn of 1891.

Levitan did not often work in the portrait genre, painting portraits only on those rare occasions when he especially liked the subject. As a rule, these were renderings of his closest friends. The artist invested this portrait of Panafidin with a great deal of sympathy, preserving in this rather large painting a feeling of intimacy and enthusiasm for the model.

"The Panafidin family became close to Levitan because of the consideration and respect they showed towards the artist and towards all who painted for them," recalled the artist S. Kivshinnnikova, a close friend of Levitan. "The entire household looked after Levitan." In the Panafidin house, music echoed almost every evening, along with readings from Chekhov's stories and lively arguments about art – all this created a special atmosphere and sustained the artist's creative work.

The portrait of the head of this hospitable household was done by Levitan as a token of gratitude for the warmth and understanding shown him at their home.

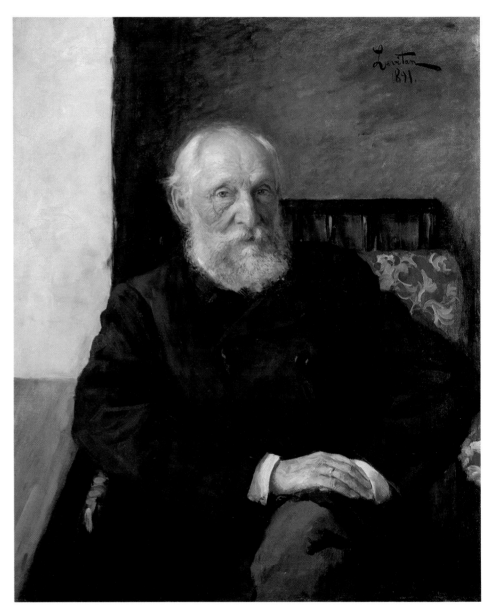

*No. 37*

*No. 38*

No. 38
*LEVITAN, Isaak Ilich*
Silence, *1898*
*oil on canvas, 96 x 128*
*signature lower right: I. Levitan*
*Russian Museum, since 1927*
*Inv. 4276*

This completely tranquil and poetic work was done in the artist's late period, when he continued the traditions of Realist landscape of the late nineteenth century, while still seeking other ways to devise a new type of lyrical-epic landscape, one that would achieve greater consistency and clarity of form and allow for clearer expression in depiction. In treating the simplest, most unpretentious theme of rural nature, Levitan, in the words of M.V. Nesterov, demonstrated "what is humble and innermost in the Russian landscape – its soul, its charm." The dark shimmer of the silent river, bordered by a steep, sloping bank, with a small wooden house in the forest, and a cloudy sky with a fading moon – the entire setting seems steeped in silence, engulfed in a mood of contemplation. The painting is constructed on broad surfaces, with large patches of color which enhance its monumental aspect. Trying to achieve a greater sweep of form, Levitan also filled the work with characteristic details – the bright path along the river bank, the fragile birch tree with its gentle white trunk, and the plowed fields in the distance. Nature is basked in human warmth, and inspired with human feeling and mood. The deep, restrained tones give the impression of dusk falling. At the same time, the bright yellow patch of the sandy river bank, the moonlit green of the grass, the yellow sandbar and the nearly black ring of forest enhance the emotional tone of the highly nuanced, complex color scheme of the landscape. The expressiveness of the image is enhanced by the melodiousness of the soft, flowing lines in the composition, strengthening the feeling of broad expanse, and enabling the artist to succeed in achieving a collective image of the typical Russian scene.

Levitan often liked to use the theme of dusk. The charm of this silent state of nature, when nothing seems to stir, is especially evident in his later years.

*No. 39*

No. 39
*LEVITAN, Isaak Ilich*
Golden Autumn, *1896*
*oil on canvas, 52 x 84.6*
*signature lower left: I Levitan*
*Tretiakov Gallery, since 1917*
*Inv. 5635*

In the 1890s the artist produced paintings in which he tried to capture the beauty so generously displayed in nature. One such landscape is *Golden Autumn.* The painting is an example of the artist's aspirations in the last years of his life. Whereas his earlier works had been tonal paintings, he now strove to depict an independent resonance for each color and its decorative expression.

*No. 40*

No. 40
*LEVITAN, Isaak Ilich*
Lake, *1898-1899*
*oil on canvas, 27 x 36.5*
*Tretiakov Gallery, since 1968*
*Inv. 552*

This work is the first version of Levitan's last great painting, *Lake* (Leningrad, Russian Museum) which the artist began in 1898, but never completed due to his untimely death. Levitan dreamed of expressing his idea, his view, of Russia, so he took care to subtitle it *Russia*. All of the artist's previous experience, all the skill he had accumulated are embodied in this landscape.

Levitan raised the significance of landscape painting to that of the historical and portrait genres. In his landscapes, the most important aspects of Russian spiritual life in the late 19th century are reflected.

No. 41
*LEVITAN, Isaak Ilich*
Village. Winter, *1880s*
*oil on canvas, 23.5 x 34.5*
*signature lower right: I. Levitan*
*Tula Art Museum, since 1962*
*Inv. 613-ZH*

Levitan's small studies and paintings, done in the 1880s, exemplify the artist's remarkable mastery of tonal painting. The refined silver-gray palette conveys the inherent hues of nature in a typical Russian scene. The simple theme of a gray, winter day is interpreted intimately, poetically. Despite the painting's small size, it is fairly monumental in impact.

*No. 41*

No. 42
*LEVITAN, Isaak Ilich*
Spring. Khotkovo, *1880s*
*oil on canvas, 15 x 23*
*signature lower left: Levitan*
*Tula Art Museum, since 1962*
*Inv. 586-ZH*

*Spring. Khotkovo* is a typical Levitan landscape, with its portrayal of a cozy, calm and lyrical corner of Russian nature. The subtle colors of the landscape reflect a mood of poetic sorrow.

No. 43
*MAKOVSKY, Vladimir Egorovich*
Anticipation, *1875*
*oil on canvas, 83 x 122*
*signature lower right: V. Makovsky 1875 Moskva*
*Tretiakov Gallery, since the late 1870s*
*Painting acquired by P.M. Tretiakov from the artist*
*Inv. 597*

Makovsky was a remarkable master of paintings that depicted everyday life. He found the protagonists for his works in the midst of daily life. Inquisitive, sensitive and observant, Makovsky often focused on the more minor episodes of unusual events recounting anecdotal details about the little man, petty bureaucrats, poor city dwellers, peasants, the intelligentsia, and the nobility. In short, representatives of all classes and strata of society inhabit his works.

A native of Moscow, he graduated from a Moscow art school. P. Fedotov, V. Perov, N. Nevrev, and I. Prianishnikov were some of the artists to whom Makovsky was closest. Along with tranquil accounts of banal events, Makovsky often dealt with subjects and themes having strong social content. *Anticipation* is one such work. Near the walls of the "Moscow Deportation Fortress" – as indicated by the inscription on the archway of the Moscow Prison gates – people have gathered to wait for the prisoners to come out. This motley group is united by grief and fatigue. The artist does not show us the prisoners, but the tone of the picture demonstrates that to him these are not criminals, but victims of social circumstances.

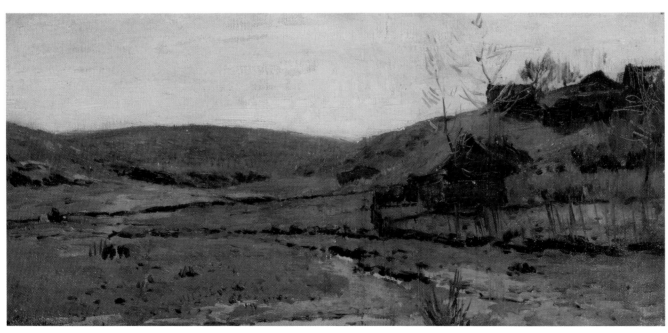

*No. 42*

*No. 43*

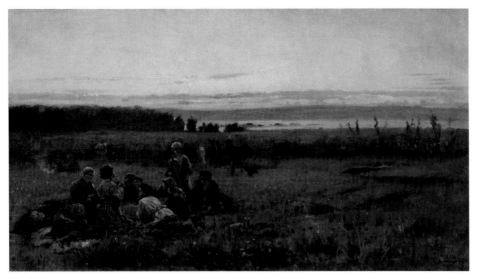

No. 44

No. 44
*MAKOVSKY, Vladimir Egorovich*
Night Watch, *1879*
*oil on canvas, 40.5 x 71.5*
*signature lower right: V. Makovsky 1879*
*Kalinin Regional Picture Gallery, since 1937*
*Inv. ZH-142*

The painting *Night Watch* contains V. Makovsky's characteristic qualities: subtle powers of observation and an ability to identify different characters and convey their interrelationship. The simple subject from the life of village children, guarding horses at night, is conveyed naturally and convincingly. Makovsky depicted the figures with sincere warmth and sympathy, and the subject of this painting was one of the artist's favorites, as he used it more than once, making both reproductions and different versions of this painting.

No. 45
*MAKOVSKY, Vladimir Egorovich*
Off to Get Medicine, *1884*
*oil on canvas, 64.6 x 47*
*signature lower right: V. Makovsky 1884*
*Tretiakov Gallery, since the 1880s*
*Painting acquired by P. M. Tretiakov from the artist*
*Inv. 626*

It was with warmth and heartfelt sympathy that Makovsky depicted the grim life and cruel fate of the underprivileged. The silent scene in this small painting, *Off to Get Medicine*, reveals a great deal about typical aspects of old Russian life. The dramatic subject here is toned down by its lyrical treatment, and the warm image of the peasant boy nestling his head so trustfully in the arm of his father. The peasant type is one of the images of common people constantly portrayed by such Wanderers as V. Perov, N. Kramskoy, I. Repin, N. Ge, each of whom depicted peasant types with his own imprint.

The soft, sincere tone of Makovsky's painting is also revealed in its color scheme, in which the modest, even restrained hues of the poor surroundings and of peasant dress are unified through the artist's use of color.

No. 45

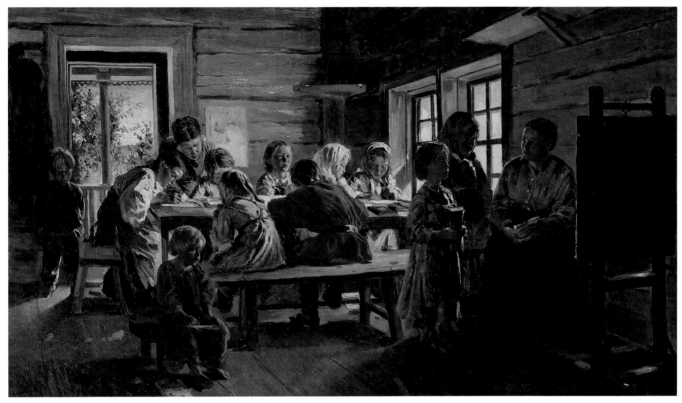

*No. 46*

No. 46
*MAKOVSKY, Vladimir Egorovich*
In a Country School, *1883*
*oil on canvas, 42.5 x 66*
*signature lower left: V. Makovsky 1883*
*Tula Regional Art Museum, since 1963*
*Inv. 617-ZH*

The artist often treated the subject of peasant life in the 1880s. In one of his best works *In a Country School*, Makovsky portrayed a typical scene of peasant children. Everything here is real and convincing, from the simple decor to the children themselves. The feeling of naturalness is enhanced by the light shining through the window, enriching the color scheme of the painting, and it is part of the mastery of execution, freshness and sincerity expressed in this work.

No. 47
*MAKSIMOV, Vasilii Maksimovich*
The Blind Host, *1884*
*oil on canvas, 52 x 61*
*signature lower left: V. Maksimov 1884*
*Russian Museum, since 1907*
*Inv. 4165*

Maksimov was of peasant origin and maintained an organic link with the countryside, which he knew so well. Among the Wanderers he was an acknowledged master of peasant themes. The artist was not drawn to social criticism in depicting events, but his sincere, truthful art sometimes reflects the complex processes of change underway in the countryside. In spirit, Maksimov's realism is generally close to psychological drama, with lyrical overtones. He loved and deeply respected his subjects – their hard peasant lot, their staunch spirit and their attractive human qualities.

In *The Blind Host*, the subject is not very individualized and is akin to the "prototypes" of people often used by the Wanderers in their art. The peasant sitting in the holy corner by the icons is still youthful, but his blank face shows his resignation to fate. The artist portrays the poverty of the scene simply and naturally, and against this background the helplessness of the host, unable to feed his family, becomes especially heartrending. Only the careful gesture of the man as he holds the child to feed it has a lyrical, optimistic note to it, which eases the drama of the situation and lends the work a warmth typical of Maksimov.

No. 47

*No. 48*

No. 48
*MALIAVIN, Filipp Andreevich*
Portrait of K. A. Somov, *1895*
*oil on canvas, 169 x 92.5*
*lower right unintelligible: ...5*
*Russian Museum, since 1920*
*Inv. 4364*

Maliavin began to work in portraiture while still studying at the Academy, and it was then that he painted works of great psychological breadth. Among them is this portrait of Konstantin Andreevich Somov, a fellow student in the studio of I.E. Repin. In his mature years, Somov also became a first-rate portrait artist and a master of retrospective compositions.

Somov is here portrayed in his studio in the white smock in which he normally worked in front of the easel. His looks are carefully captured, and his character revealed in a subtle manner. Somov impressed all he knew with his modesty, inner intensity, idealism, and even temper, and these individual traits of the model are revealed in the subject's facial expression and also in the interpretation of gesture and pose.

Although the portrait is from an early period in the artist's work, it stands out nonetheless for its masterful composition and color scheme. It is not without interest that this work was done in one sitting, and quite quickly, in the studio while people were watching. The portrait was duly appreciated by other professionals, and was shown at an exhibit of the Moscow Society of Art Lovers where it was awarded a first prize.

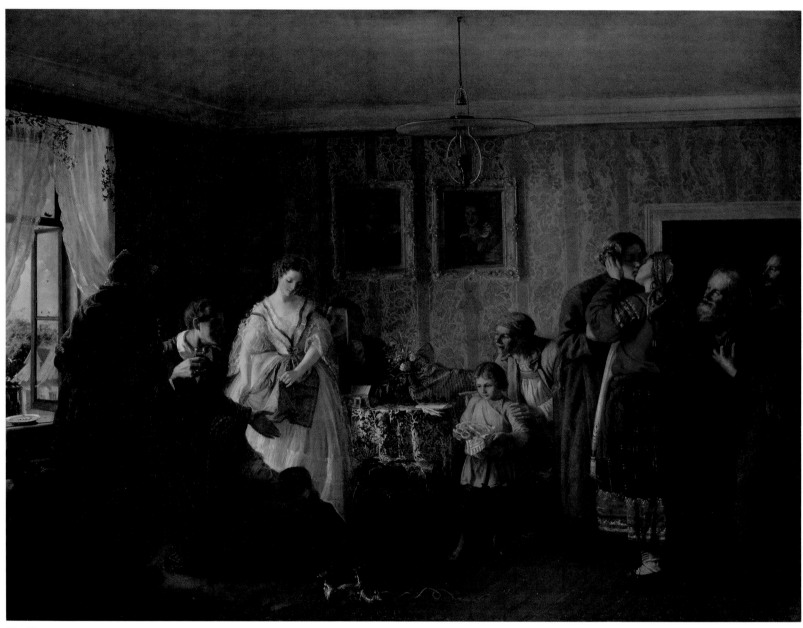

No. 49

No. 49
*MIASOEDOV, Grigorii Grigorievich*
Congratulating the Young at the Landowner's
    House, *1861*
*oil on canvas, 96 x 123.5*
*signature lower right: GR. Miasoedov*
*Russian Museum, since 1897*
*Inv. 2511*

A talented genre painter, Miasoedov expressed in his best paintings the basic, burning issues of the rural areas in his time, and created lively, truthful portrayals of peasants. The creative individuality of this intelligent and profound expert on rural life was fully expressed only in the 1870s. His student work, such as the idyllic painting *Congratulating the Young at the Landowner's House*, is typical of his early period, with its roots in the academic "democratic" genre. There is not the criticism here that charac-terized the leading genrists of the sixties, but instead an attempt at truthfulness in depicting the real world with clarity and simplicity. The ability to understand the grouping, to place it in space, to emphasize the contours of lines, the local color – all reveal the artist's academic training, but the artist applied them here to a subject deemed unac-ceptable by the Academy at that time, and with less constraint. The storytelling aspect of the painting, the psychological mimicry, the poses, gestures are like a lovingly portrayed interior, with each object a reflection of the traditions of the founder of critical realism, P.A. Fedotov. One has the feeling that everything shown here is familiar and close to the artist. One of Miasodov's gifts was his ability to work from life, and the prototype for the landowner's daughter was the artist's fiancée, E.M. Krivtsova, who later became his wife. For this painting, which demonstrated fully his professional skills, he was awarded a Second Gold Medal.

No. 50

No. 50
*NESTEROV, Mikhail Vasilevich*
The Hermit, *1888*
*oil on canvas, 91 x 84*
*signature lower right: M. Nesterov 90*
*Russian Museum, since 1909*
*Inv. 4337*

Nesterov in his early years created works similar to those of the Wanderers. From the late 1880s he began to take interest in religious ethical problems and his search for spiritual ideals led him to depict people who had rejected worldly cares and plea-sures. The heroes of his works are monks, hermits and recluses.

One of the first paintings in this cycle was *The Hermit*. The figure of the old hermit in the sur-rounding scene is permeated with a feeling of silent sadness. The work was, no doubt, done from nature, and in it the artist reaffirmed the subtle spiritual beauty of man, his contemplative nature, and tranquility. We find a similar emotional mood in such later works by the artist as: *Ringing of the Church Bells* (1895), *The Cropping of Hair* (1898), *St. Sergius of Radonezh* (1899) and others.

*No. 51*

*No. 52*

No. 51
*NESTEROV, Mikhail Vasilevich*
Head of a Young Mordvinian, *1880s*
*oil on canvas, 44 x 33.5*
*signature upper right: Nester...*
*Tula Regional Picture Gallery, since 1945*
*Inv. ZH-380*

This picture of a young man with an energetic look, done by Nesterov in the early years of his work, is proof of the artist's sharp powers of observation and his ability to emphasize characteristic traits of the individual and traits of national pride.

No. 52
*NEVREV, Nikolai Vasilevich*
Moscow Caretaker, *1880s*
*oil on canvas, 70 X 57*
*signature right: N. Nevrev*
*Tula Art Museum, since 1986*
*Inv. 1287-ZH*

The depiction of simple individuals from the common people was an important aspect of the Wanderers' art, and Nevrev made use of similar themes quite often in his work. *Moscow Caretaker* is one of these typical common types, portrayed by Nevrev with a sensitive understanding of the individuality and spirit of the subject.

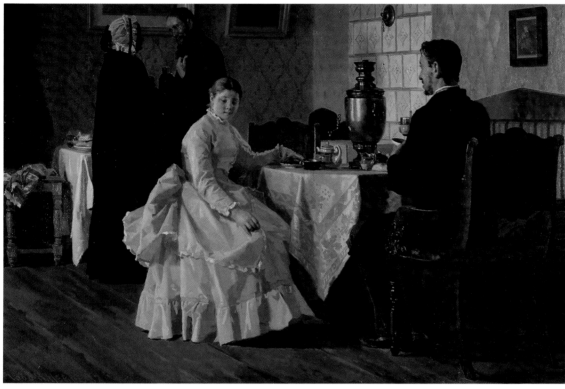

No. 53

No. 53
NEVREV, Nikolai Vasilevich
Smotriny (Inspection of the Bride), 1888
oil on canvas, 89 X 106.7
signature lower left: 1888 N. Nevrev
Tretiakov Gallery, since 1889
Painting acquired by P.M. Tretiakov from the artist
Inv. 519

Nevrev, who was born in Moscow and spent his entire life there, was well acquainted with the life and customs of the various strata of the population in the ancient Russian capital. Family disputes, match-making, funeral banquets – the most diverse aspects of life are depicted in the many and varied subjects of Nevrev's paintings. The artist was a marvelous master of subject narrative, and he ably developed it in his works.

Smotriny is one of his most successful works. The young girl, the daughter of a priest about to inherit his property, is being matched with a young seminarian, a sturdy youth. The picture demonstrates the artist's ability to sketch characters accurately and to present a typical situation in a typical setting.

Interior details always play an important role in the genre paintings of Nevrev, who did not think of interiors as simply a backdrop or scenery. Every detail in the setting is part of the overall characterization and enhances our understanding of the subject. This tradition, in the art of the Wanderers and of N. Nevrev, in particular, was inherited from the early nineteenth century painters A. Venetsianov and P. Fedotov, though it was to undergo significant change in the next half century.

No. 54
*PEROV, Vasilii Gregorievich*
Portrait of Apollon Nikolaevich Maikov, *1872*
*oil on canvas, 103.5 X 80.8*
*signature lower left: V. Perov, 1872*
*Tretiakov Gallery, since 1872*
*Portrait commissioned by P.M. Tretiakov*
*Inv. 387*

Apollon Nikolaevich Maikov (1821-1897) was a well-known Russian poet who began to publish in 1835. In his verse he dealt with Russian history and art, and he especially loved ancient culture, in which he saw the ideal of perfection. Maikov's best poems are devoted to Russian nature, and many of them were set to music by Tchaikovsky and Rachmaninov.

V.G. Perov first worked as a portrait artist in the late 1860s and early 1870s. An acknowledged genre specialist with an accomplished style of painting, the artist used portraits not just as a manifestation of his interest in the human psychology prevalent at the time, but as an attempt to understand reality through the knowledge and comprehension of the human individual. Most often Perov did portraits of representatives of Russian culture - writers, musician and scholars. The artist did Maikov's portrait at the same time he was doing his famous portrait of Dostoevsky. In a letter to P.M. Tretiakov, who had commissioned the portraits, Perov wrote: "How well they are painted, that is, how good they are, I do not know, but as to whether they are portraits or not, it seems to me clear that they express even the character of the writer and the poet."

Perov was striving for the total absence of cliches in his approach to representing people. Perov's best portraits were unique in their content, scope and the force of intensity in reaching deep into the human soul, and they had a remarkable impact on portraiture in Russia.

*No. 54*

No. 55
*PEROV, Vasilii Grigorievich*
Portrait of the Writer I.S. Turgenev, *1872*
*oil on canvas, 102 X 80*
*signature lower right: V. Perov*
*Russian Museum, since 1930*
*Inv. ZH-4090*

In the late 1860s and early 1870s Perov turned with his usual seriousness to portraiture, eventually becoming a preeminent master of it. His achievements in this sphere were especially appreciated by his contemporaries, since portrait painting was undergoing a kind of crisis at the time: its great achievements were in the past or would be painted in the near future.

Perov's portraits are quite characteristic of the realism of the Wanderers. They are not at all ceremonial, although they lack a friendly intimacy. In his affirmation of the human individual, the artist presents the subject with a serious and objective gaze. The model's individual traits were chosen at the moment of creation, and the pose and the position of the hands frequently give Perov's portrayals a sense of spontaneity. This portrait of the famous writer Ivan Sergeevich Turgenev (1818-1883) is one such work. Like several other portrayals of famous cultural figures, it was commissioned by P.M. Tretiakov. The restraint of the picture's color scheme is typical of the artist: it is in keeping with the programmatic scheme of many of the democratic painters, who toned down the external effect of the portrait for the sake of a deeper interest in the spiritual life of the individual subject.

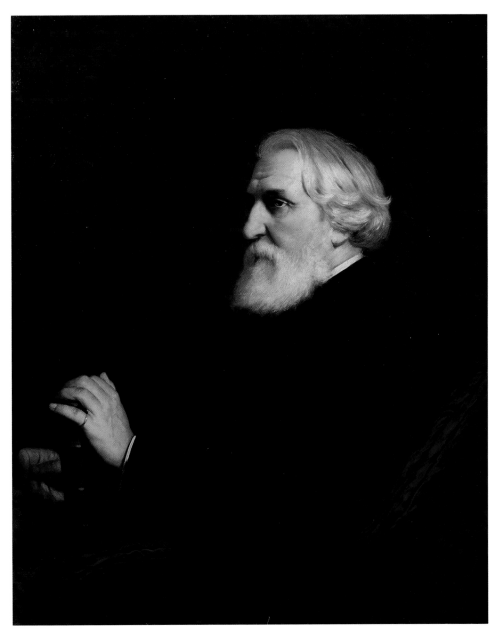

*No. 55*

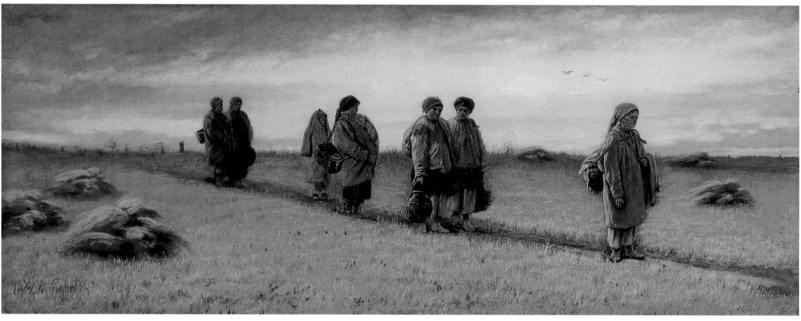

*No. 56*

No. 56
*PEROV, Vasilii Grigorievich*
Reapers Returning from the Fields in Riazan
    Province, *1874*
*oil on canvas, 25.8 X 65*
*signature lower left: 1874 V. Perov*
*Tretiakov Gallery, since 1939*
*Inv. 24786*

This painting is one of Perov's works dealing with the daily life of the working man. It shows sympathy and complete respect on the part of the artist for the life and labors of the Russian peasant. The subjects and images in Perov's paintings often reveal his social sympathies. The plaintive melody of this small painting – the grim landscape, the grey-brown color scheme, the drawing and rhythm of the peasant figures, returning tired from the fields, recreate a sorrowful truth, a kind of poetry of sadness in national life.

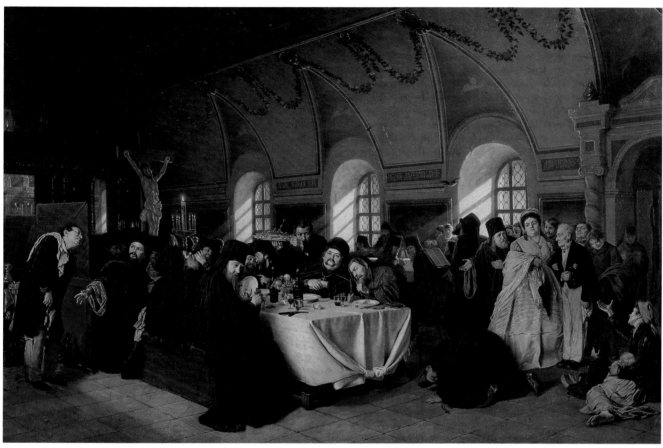

No. 57

No. 57
*PEROV, Vasilii Grigorievich*
The Refectory, *1865-1876*
*oil on canvas, 84 X 126*
*signature lower right: V. Per*
*Russian Museum, since 1906*
*Inv. 3000*

The painting *The Refectory* clearly characterizes one of Perov's main qualities as a genre painter – his heightened awareness of social and moral problems in society. With the revolutionary upsurge in Russia in the late 1850s and early 1860s, he was the first to produce "denunciatory" works on contemporary themes. Anticlerical subjects such as this were central to the artist's work. A man of strict high standards and sincere religious beliefs, Perov could not tolerate the failings of the priesthood, "the spiritual pastors" of the people, who had forgotten Christian teachings. *The Refectory* was begun

in 1865 and completed eleven years later. In its artistic structure, it maintains Perov's special features from his pre-Wanderers period – the narrative aspect, the clear exposition of the author's idea. The artist exposes the contemptible mores of the monastery inhabitants: the inequality among themselves, their greed, gluttony, indifference to the poor, their servility to the rich. In highlighting these traits, Perov pays attention not only to their faces, but to their gestures and poses. The monks' hands are especially expressive. Many of the inanimate objects in the composition are also significantly juxtaposed. For example, the large crucifixion above the table, against the background of which the refectory meal takes place, contrasts with a large plate of food brought in by a lackey.

In terms of technique the painting is not Perov's finest work, since its style is somewhat over simplified, but it is an outstanding example of critical realism in Russian painting.

*No. 58*

No. 58
*PEROV, Vasilii Gregorievich*
Christ in the Garden at Gethsemane, *1879*
*oil on canvas, 151.5 x 238*
*signature lower right: V. Perov 1878*
*Tretiakov Gallery, since 1883*
*Painting acquired by P.M. Tretiakov*
*Inv. 398*

The treatment of religious themes in Russian art and their philosophical and moral interpretation has its own special history and an extremely rich tradition. It begins with A. Ivanov in his painting *Christ Appearing Before the People,* continues with I. Kramskoy in the painting *Christ in the Desert,* and in the lengthy cycle of religious paintings done by the artist N. Ge. Other Russian painters of the 19th century joined in this tradition as well. Such eternal themes as goodness, self-sacrifice, humanity, serving higher ideals, moral strength and spiritual purity were treated in various ways by the artists in their works.

Perov dealt with religious themes in the final years of his life. *Christ in Gethsemane* has great penetrating force. One expert on the work of the artist has written that in this painting Perov achieved the fruition of his constant striving for psychological expression, and that here "religion is taken as a personal drama of the individual...as an expression of the greatest suffering of the soul."

No. 59
*POLENOV, Vasilii Dmitrievich*
Caesar's Entertainment, *1879*
*oil on canvas, 136 X 93.4*
*Tretiakov Gallery, since 1962*
*Inv. 262*

Polenov has entered the annals of the history of Russian painting primarily as a landscape artist who painted canvases of the countryside full of harmony, poetry and beauty. At the same time, however, he also worked in other genres. He was interested in historical and religious subjects, painted portraits and worked as a scenic designer for the theater.

The subject of *Caesar's Entertainment* is taken from a story of ancient Rome, involving grandeur and cruelty, beauty and inhumanity, great enlightenment and barbarism. The artist was not so much concerned with the historical subject of the painting as with its use as a statement against ignorance and violence.

The work was done during the year in which such works as Polenov's *Moscow Courtyard*, *Grandmother's Garden* and *The Overgrown Pond* were being exhibited, and it was these paintings that were to determine the basic lyrical tendency in the artist's work. Yet during these years, Polenov never lost interest in historical subjects, and they led him to create an important series of paintings, *From the Life of Christ*. In them the artist attempted to express his lofty ideas of humanity and justice.

*No. 59*

*No. 60*

No. 60
*POLENOV, Vasilii Dmitrievich*
In Nazareth, *1880s*
*oil on cardboard on canvas, 49.5 X 73*
*signature lower right: V. Polenov*
*Tula Art Museum, since 1962*
*Inv. 612-ZH*

This work, like the study for *Temple of Omar,* was
done as a result of a trip the artist took to the Near
East and in preparation for the landscape and
architectural motifs for his major painting *Christ
and the Sinner.*

No. 61

No. 62

No. 61
*POLENOV, Vasilii Dmitrievich*
The Parthenon. Temple of Athena-Parthenos, *1882*
*oil on canvas, 29.8 X 43.3*
*Tretiakov Gallery, since 1885. Study acquired by P.M.*
   *Tretiakov from the artist*
*Inv. 2788*

*The Parthenon* is among V. Polenov's finest studies, done by the artist during his travels through the Near East and Greece. The nobility of the fragile silvery tone, and the refinement of the brush strokes corresponds to the architectural perfection of the subject.

Polenov made his trip to the Near East in order to work on his idea for the painting *Christ and the Sinner.* Many of the studies are not directly related to the painting. Done in Egypt, Syria, Greece, they were conceived of as completely new works of painting. "Polenov revealed the secret of new visual strength to the Russian artist in these studies and awakened in him a use of color about which he had never dreamed," wrote the artist I. Ostroukhov on this series of works.

Polenov's *plein air* painting and his view of nature played a most important role in training the younger generation of artists, including pupils of his such as I. Levitan and K. Korovin.

The studies were shown by the artist at the Wanderers exhibit. P.M. Tretiakov acquired most of them, and they are now part of the collection at the Tretiakov Gallery.

No. 62
*POLENOV, Vasilii Dmitrievich*
The Temple of Omar, *1882*
*oil on cardboard on canvas, 30.5 X 48.5*
*signature lower right: V. Polenov 1882*
*Tula Art Museum*
*Inv. 860-ZH*

This work, painted also during Polenov's travels in the Middle East, represents his full mastery of light and color working directly in nature. These *plein air* studies were preparatory works for the artist's plan to create a group of gospel paintings. Polenov recognized their integrity as independent works of art, however, and exhibited them as such at the Wanderers exhibitions. According to Sarabianov, this ushered in a new appreciation for the sketch in Russian art, a "cult of the study," among other artists and collectors in Moscow.

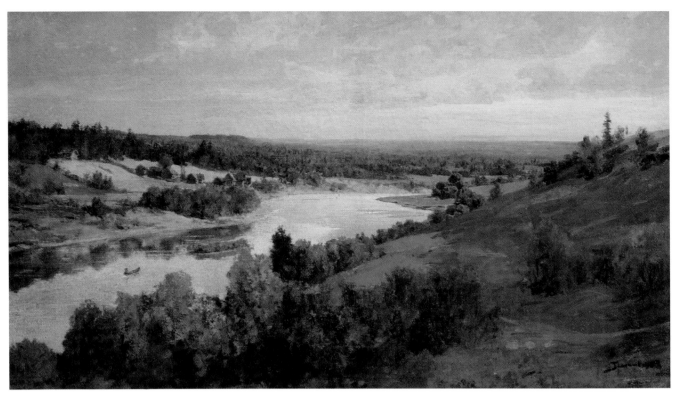

*No. 63*

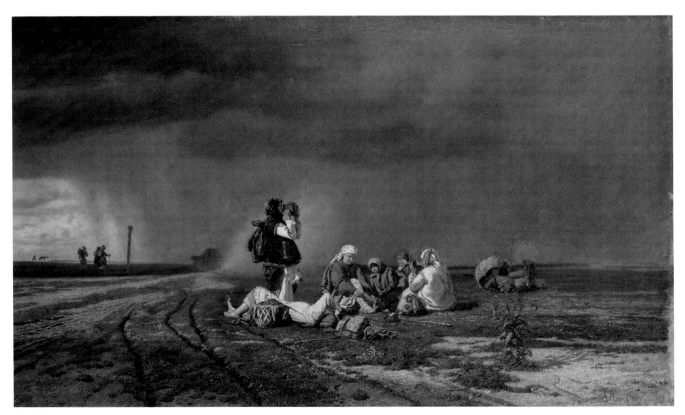

*No. 64*

No. 63
*POLENOV, Vasilii Dmitrievich*
The Oyat River, *1890*
*oil on canvas, 51 X 88*
*signature lower right: Polenov 90*
*Tula Art Museum, since 1966*
*Inv. 666-ZH*

The small river Oyat flows through the north of Russia in the Arkhangelsk region, where the Polenov family estate was located. This is where he spent his youth, and where he returned once he had become an artist. He loved these northern places for their silent beauty. The tranquil flow of the river, the broad horizon, and the breathtaking harmony of nature are here conveyed in subtle green hues, in a compact and clear composition.

No. 64
*POPOV, Andrei Andreevich*
Pilgrims, *1861*
*oil on canvas, 56 X 93*
*signature lower right: A. Popov 1861*
*Tula Regional Art Museum, since 1967*
*Inv. ZH-686*

Popov's work is typical of the "pre-Wanderer" Russian social genre of the 1860s, with its awakened interest by artists in popular scenes and characteristic national types. Although Popov had a great deal in common with the normative art of the Academy, which is evident in *Pilgrims*, this painting nevertheless shows the artist's sincere sympathy for simple people. The poignant scene is one of distinctive poetry steeped in sadness.

No. 65
*PRIANISHNIKOV, Illarion Mikhailovich*
Returning from the Fair, *1883*
*oil on canvas, 48.5 X 71.5*
*signature lower left: 1883 I. Prianishnikov*
*Russian Museum, since 1898*
*Inv. 4167*

I. M. Prianishnikov was one of the prominent masters of genre painting in the late nineteenth century. A major theme of his was life in the Russian countryside, where he returned often in the 1880s, and everyday life is at the basis of nearly all of Prianishnikov's paintings; it was easy to narrate and create, and this narrative, literary quality, when emphasized, sometimes diminished the painter's impact. Nevertheless his works convey in remarkable fashion the typical attributes of the middle class and of peasants. *Returning from the Fair*, shown at the 11th Wanderers Exhibit, reveals the festive side of life in the country. The slow procession of people, exhausted by their day of trading, unfolds against a tranquil, slightly hilly landscape. From their manner of dress one can guess that the scene is occurring in the remote Vologda Province. The color scheme of the landscape is rendered faithfully, with cold silver-green tones prevailing, reflecting the mood of the northern landscape. Prianishnikov's landscape style is characterized by lightness and facility, but he does not, however, manage to integrate all the elements of the composition into a harmonious whole. The figures are given a dry interpretation as compared with the landscape.

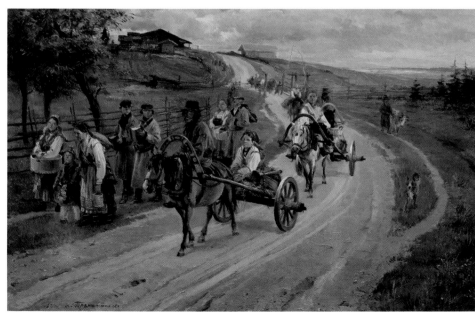

*No. 65*

*No. 66*

No. 66
*REPIN, Ilya Efimovich*
Portrait of the Historian Ivan Egorovich Zabelin,
   *1877*
*oil on canvas, 113 X 86*
*signature lower right: I.Repin 1877 Moscow*
*Tretiakov Gallery, since 1877*
*Portrait commissioned by P. M. Tretiakov*
*Inv. 713*

Ivan Egorovich Zabelin (1820-1909) was a historian
and archaeologist, a respected member of the
Russian Academy of Sciences, Chairman of the
Society for History and Russian Antiquity (1879-
1886), and one of the founders and head of the
Historical Museum in Moscow. His most important
publications were documents and studies on the
history of Russian life in the 16th-18th centuries
and on the ancient history of Moscow. Repin was a
close acquaintance of I. Zabelin and benefitted
from this scholar's advice while working on his his-
torical compositions.

The broad manner, the marvelous composition,
and the masterfully handled detail all demonstrate
that Repin completed this painting without relying
on previous conventions of portraiture. This paint-
ing occupies a place of honor among his great por-
traits of contemporaries, through whose likenesses
the artist memorialized the high-mindedness of his
subjects. This inspired work, which Repin executed
with great enthusiasm, helped bring the portrait
genre to the forefront of Russian painting in the
1870s and 1880s.

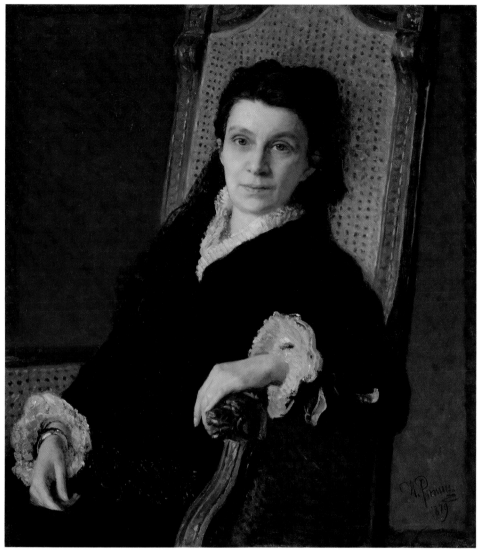

*No. 67*

No. 67
*REPIN, Ilya Efimovich*
Portrait of P.S. Stasova, née Kuznetsova, *1879*
*oil on canvas, 74.5 X 66*
*signature lower right: I. REPIN 1879*
*Russian Museum*
*Inv. 4044*

Poliksena Stepanovna Stasova, née Kuznetsova (1839-1918), was active in the field of women's education. In the 1860s she taught at the Woman's Sunday School in St. Petersburg. On marrying the well known lawyer Dmitrii Vasilevich Stasov she entered a family of remarkable figures in Russian culture, many of whom were friends with Repin for many years. D.V. Stasov's brother, the art and music critic Vladimir Vasilevich Stasov, was a proponent of realist art, and especially close to Repin. Elena Vasilevna Stasova, whom he painted several times, was active in the women's emancipation movement. Later on, the Stasovs' daughter, Elena Dmitrievna became a famous Russian revolutionary and companion of Lenin.

A frequent guest of P.S. Stasova and her husband, Repin attended the family "Thursdays," and it was at their home that he did this portrait. Writing about Repin's great artistic talent, one of his contemporaries recalled how he met Poliksena Stepanovna: "...the first thing I noticed were the youthful, always honest, open, straightforward eyes and the genuine, welcoming tone of voice..." Repin indeed captured the openness and simplicity of this outstanding, spiritually sensitive woman, and this portrait gives us an idea of the master's great skill as a portraitist; he was truly versatile in his choice of compositional methods and color schemes, shaping them to suit the features of each individual model.

No. 68
*REPIN, Ilya Efimovich*
Portrait of the Composer Anton Grigorievich
 Rubinshtein, *1881*
*oil on canvas, 80 X 62.3*
*signature upper right: 1881. I. REPIN*
*Tretiakov Gallery, since 1881*
*Portrait commissioned by P. M. Tretiakov*
*Inv. 729*

Anton Grigorievich Rubinshtein (1829-1894) was a famous pianist, conductor and composer ("Demon" and "Nero"), and was a major figure in the world of Russian music. He founded the Petersburg Conservatory in 1862 and was a professor there.

This portrait is one of Repin's most consummate works. The conviction, skill, and freedom of movement, along with the artist's insight into the individuality of the subject make this one of Repin's most inspiring portraits.

Rubinshtein in the mid-1880s was at the height of his glory as a conductor and pianist, and Repin was pleased to do his portrait since he admired the musician's talent and eloquence. "I am now painting a portrait of Anton Rubinshtein for P.M. Tretiakov. An interesting head, resembling that of a lion," wrote Repin to Stasov.

No. 69
*REPIN, Ilya Efimovich*
Evening Gathering, *1881*
*oil on canvas, 116 X 186*
*signature lower right: I. Repin 1881*
*Tretiakov Gallery, since 1881*
*Painting acquired by P. M. Tretiakov from the artist*
*Inv. 727*

Repin worked with great enthusiasm on this painting, and in it expressed his devotion to the Ukraine and interest in various aspects of their life.

In the summer of 1880 the artist took a long trip to the south of Russia and to the Ukraine, the purpose of which was to gather material for a painting he was planning to make, *The Cossacks.* Repin painted many studies of Cossacks on small canvases, or did sketches of them in his travel notebooks. Later, these preparatory works were used by him in both *The Zaporozhe Cossacks* and *Evening Gathering,* which he painted simultaneously.

One of Repin's special talents was his ability to work on several different paintings at the same time. One might find on easels in his studio the first draft for *The Zaporozhe Cossacks,* a portrait of the composer A. Rubinshtein and another of the actress P. Strepetova, *The Propagandist's Arrest,* and *Evening Gathering.* And he would already be contemplating and starting new projects.

*Evening Gathering* is part of a larger series of paintings and portraits done by Repin on peasant themes. These many diverse works helped prepare the artist for his major accomplishment, *Religious Procession in Kursk Province* (1880-1883). Repin's interest in folk culture and customs is clearly manifest in *Evening Gathering.* When Tolstoy saw the still unfinished painting in Repin's Moscow studio and expressed his approval of it, Repin reported it joyously, in a letter to his friend, the art critic V.V. Stasov.

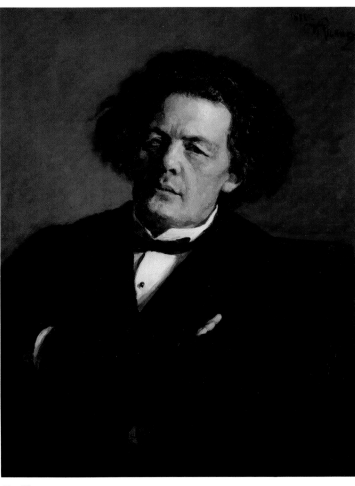

*No. 68*

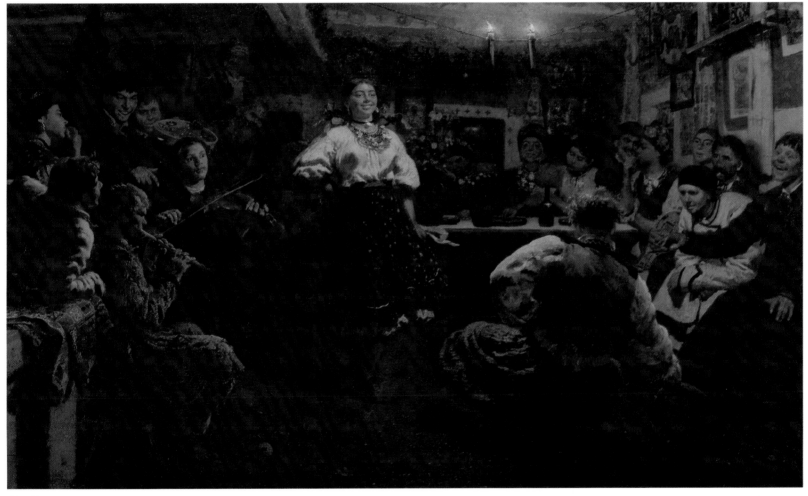

*No. 69*

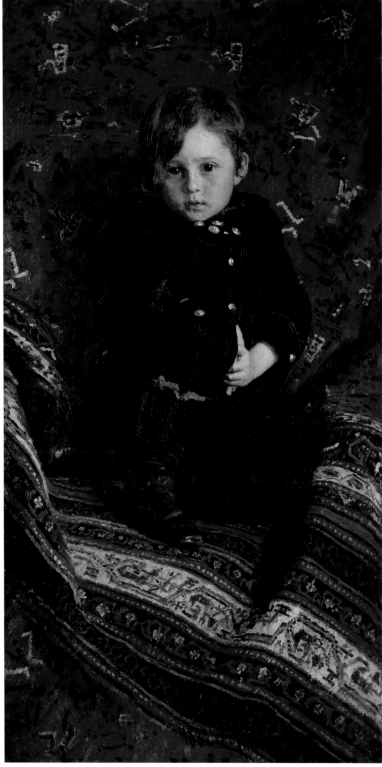

No. 70

No. 70
*REPIN, Ilya Efimovich*
Portrait of Yurii Ilich Repin, the Artist's Son, *1882*
*oil on canvas, 110 X 55.5*
*signature lower middle: 1882 I. Repin*
*Tretiakov Gallery, since 1930*
*Inv. 10559*

Yurii Ilich Repin (1877-1954) graduated from the Petersburg Academy of Arts, studied with his father, and later worked under his direct influence.

Repin did this portrait of five-year-old Yurii when he was at the height of his creative gifts, when he dealt easily with the most difficult and subtle of artistic tasks. While revealing the fragile world of the child, Repin also conveys with his usual genius the beauty, design and texture of the rug, the shining gold of the buttons against the black garments, and the silky softness of the child's hair.

Unlike the Wanderers of his generation, who rarely dealt with portrayals of children, Repin did a great many such portraits. The artist often painted his daughters and son at various ages with great technical skill.

Kramskoy wrote in a letter to Repin: "You are a realist, one of the most unyielding...and all of a sudden you appear capable of such tender notes..." Kramskoy's words are quite applicable to Repin's portraits of children.

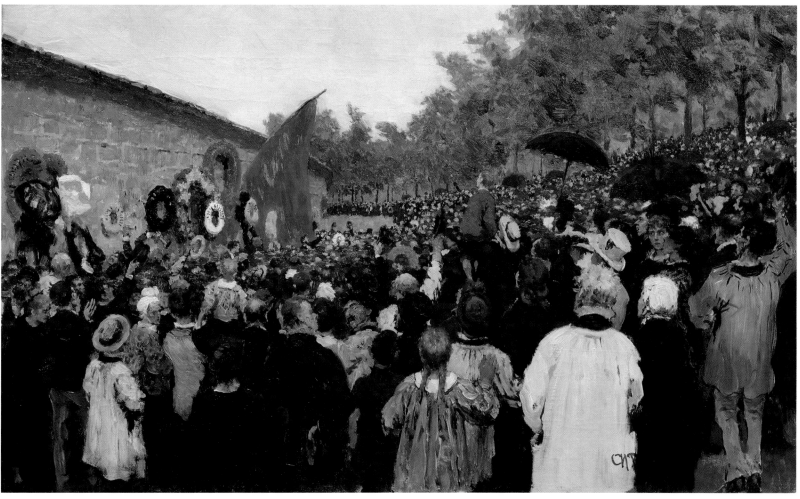

*No. 71*

No. 71
*REPIN, Ilya Efimovich*
Annual Meeting in Memory of the French
    Communards at Père Lachaise Cemetery in
    Paris, *1883*
*oil on canvas, 36.8 X 59.8*
*signature lower right: 1883 I. Repin*
*Tretiakov Gallery, since 1929*
*Inv. 11163*

In 1883, while on a long trip through Europe with V. Stasov, Repin was present at the traditional meeting of Paris workers at Père Lachaise Cemetery in memory of the Communards who had been executed there in 1871.

This small finished painting appears to be a study taken from nature. Lush, temperamental and vibrant, it shows the remarkable originality of Repin's style of painting. Although the painting is small in size, the artist skillfully conveyed an impression of broad space and of the enormous throng of people moved by one event. In a letter to his friend, the artist V. Polenov, Repin wrote from Paris, right after the event: "Where else would I have been able to see all at once hundreds of popular speakers if not at Père Lachaise... There were tens of thousands of people, they were carrying wreaths, and proceeding solemnly, in groups...Each group first went up to the tomb of Louis Blanc, and from there to the tombs of brothers, sons, and fathers, and here is where one speaker after another excited the crowd, where passionate applause rang out, and where hats were thrown in the air with cries of 'Vive la revolution sociale!'"

Here we see yet another important aspect of Repin's work – his interest in revolutionary subjects. *Refusal to Make Confession, The Propagandist's Arrest, They Did Not Expect Him, The Gathering* and this small painting, done in Paris, comprise the diverse revolutionary series in Repin's paintings. They are all different, executed over a period of more than twenty years, but are united by a passionate interest in the provocative issues of the time.

No. 72

No. 72
*REPIN, Ilya Efimovich*
Woman with a Dagger, *1874-1876. Study*
*oil on canvas, 80 X 64*
*Tula Art Museum, since 1926*
*Inv. 363-ZH*

This portrait of the Oriental beauty, Zarema (*Woman with a Dagger*) is a study for the painting *Sadko* to be found in the Russian Museum in Leningrad. The artist worked on both the painting and studies while he was an Academy of Arts fellowship student in Paris. Typical characteristics of Repin are already evident in this early work: strength of form, temperament of execution, and freedom from established academic norms and rules with regard to the model. The proud woman is portrayed freely, broadly and clearly, with a feeling of enthusiasm for the subject.

*No. 73*

No. 73
*REPIN, Ilya Efimovich*
At the Academy Dacha, *1898*
*oil on canvas, 64 X 106*
*Russian Museum, since 1931*
*Inv. ZH-4075*

The rapprochement between the Association of Travelling Art Exhibitions and the Imperial Academy in the 1890s was one of the most dramatic events of the Wanderer's history – erasing the cherished distinction between official and free art, and producing great controversy within the Association. However, Repin and many of the other Wanderers joined the move to reform the outdated Academy. From the time in 1894 when Repin took up his duties as professor and studio head at the Higher Art School of the Academy of Arts, he would often travel with his pupils to the Academy dacha located near the town of Vyshnii Volochek in the Kalinin region. This painting was executed with great speed, in the free Impressionist manner, and gives us insight into the artist's aspirations during those years. In the nineties, Repin was more than ever interested in the theme of human figures in a landscape background. This was in part due to his private life, for he had just acquired and moved to an estate in Vitebsk Province on the banks of the Western Dvina River, but primarily because of his growing interest in the problems of painting. Russian painting as a whole was trying to achieve a new emotion, color and composition scheme at the time, and not only Repin, but many other Russian artists became interested in depicting man and nature. A.A. Fyodorov-Davidov, the well known Soviet art historian, quite rightly called the late 19th century the most important landscape period in the development of Russia's national art.

The fresh style and bright color scheme in Repin's work, essentially a large study from nature, is built upon carefully harmonized shades of green and white. The artist skillfully combines the two into one tone. The broad, dynamic brush strokes give one a feeling of immediacy in the surrounding world, and of movement in the outdoor air where the pupils work at their studies. Air and light unite the picture, giving it a sense of wholeness.

No. 74

No. 74
*REPIN, Ilya Efimovich*
Portrait of the Vice-President of the Academy of
    Arts I.I. Tolstoy, *1899*
*oil on canvas, 120 X 87*
*signature upper right: 1899 I. Repin*
    *lower left: I. Repin 1899*
*Russian Museum, since 1918*
*Inv. 4042*

Count Ivan Ivanovich Tolstoy (1858-1916) was a
scholar, archaeologist and numismatist, who in
1893 became Vice-President of the reformed
Academy of Arts. Thanks to a reorganization of the
Academy, realist artists who had earlier voiced
fierce opposition to it, were able to take up profes-
sorships there. In his desire to breathe new life into
the Academy, Tolstoy relied especially on Repin,
with whom he had begun to negotiate as early as
1892. This provoked a long period of estrangement
between the artist and the Wanderer apologist, the
critic V.V. Stasov, who saw only hypocrisy and
treachery in Repin's desire to help renew the
Russian Academy.

Repin's fondness for Tolstoy, whom he described
as kind and sensible, intelligent and honest, and
capable of doing Russian art a great deal of good, is
evident in the portraits: in the vigorous likeness done
of Tolstoy in 1893 and in the large canvas dating
from 1899, where the official nature of a commis-
sioned portrait supplanted the more informal, inti-
mate nature of the first. This portrait shows a new
stage in Repin's work, as the artist gave increasing
attention to characteristic gesture, outline and espe-
cially the relationship of the subject to the surround-
ing space. The objects, more spiritual and aesthetic
than before, have become an integral part of the life
of the sitter. Brush stroke technique is not lost and
dissolved in detail, but, rather, is distinct and emphat-
ic, one of the components of the painting's structure.

In highlighting the artistic nature and inner
freedom of Tolstoy, evident in the subject's relaxed,
unpretentious pose, Repin chose a foreshortened
body movement to give a feeling of perspective.
The gesture of the hands holding a book consti-
tutes an essential point in space: the artist takes us
into the spiritual world of the sitter who has just fin-
ished reading a book, and his eyes show a keen
intellect. Drawn in a subtle and delicate manner,
the portrait has its decorative side, as expressed in
the gracious form and in the broad movement of
brush strokes which bestow large patches of color.
While working on this portrait, Repin wrote to
Stasov: " I am still the same as I have always been.
And in spite of the fact that, thanks to your assis-
tance, many people have either praised me or
buried me... I am still the same as in my early
youth, I love the play of light, I love truth, good
and beauty, for they are the best that life has to
give. And especially art!"

No. 75

*RIABUSHKIN, Andrei Petrovich*

Waiting for the Newlyweds in the Novgorod
    Province, *1891*

*oil on canvas, 51 X 98*

*signature lower right: A. Riabushkin*
    *18/III 28 91*

*Russian Museum, since 1923*

*Inv. 4353*

Riabushkin turned down a fellowship to study abroad after finishing his studies at the Academy of Arts, and took up traveling around Russia instead. As a result he accumulated a great deal of material on the festive, traditional aspects of peasant life. This material served as the basis for a number of his works.

The painting *Waiting for the Newlyweds in the Novgorod Province* is interesting for its accuracy and for its profound knowledge of local customs. The artist lovingly portrayed typical peasants from a Novgorod village, their festive dress, the decor of the peasant hut and much more. The internal dynamics of the composition and the subdued colors help convey a feeling of the solemn silence which prevailed among guests as they waited for the arrival of the newlyweds after the ceremony.

The painting was done in the hamlet of Korodynia in Novgorod Province. A patriarchal way of life survived in places such as this well into the end of the nineteenth century, when an old-fashioned wedding ceremony was still the custom.

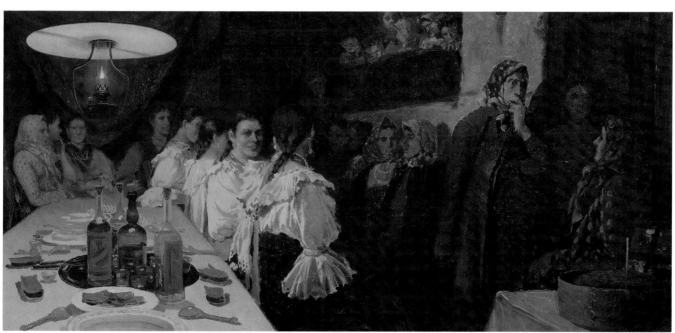

No. 75

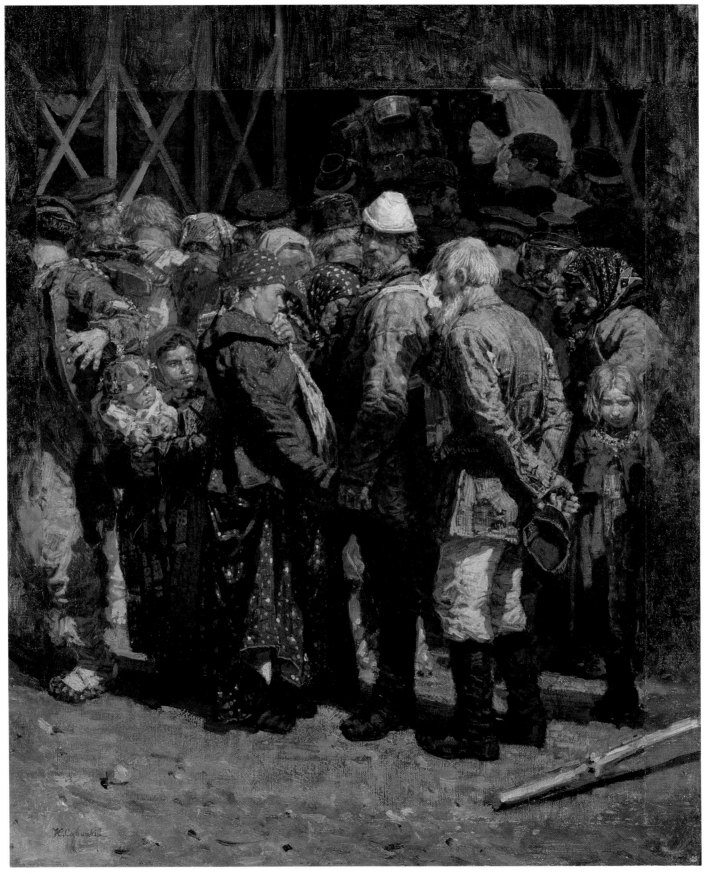

*No. 76*

No. 76
*SAVITSKY, Konstantin Apollonovich*
A Group Saying Farewell, *1880*
*oil on cardboard on canvas, 70 X 56*
*signature lower left: K. Savitsky*
*Russian Museum, since 1908*
*Inv. 1420*

As one of the leading genre painters and a master of complex multifigured compositions, Savitsky devoted his work to depicting typical, yet dramatic events in the life of the people. Emotional intensity and a profound interest in the inner psyche of the subject distinguish this artist's work. Savitsky's interest in realist art was greatly influenced when he met I.N. Kramskoy, who became his friend and mentor. While continuing the committed course in art of the "men of the sixties," Savitsky attempted to create positive peasant images. This important trend in the development of critical realism of the 1870s and 1880s was clearly reflected in one of the master's most crucial works *Off to War*. The idea for it came from impressions of the Russo-Turkish War of 1877-1878. The artist worked feverishly on this theme for almost ten years. The first version of the painting was completed after two years of work in 1880 and then was shown at the Eighth Traveling Wanderers Exhibit. This work, however, with too many figures and scenes, and insufficient composition, did not satisfy its author. In 1888 he completed the second – and definitive – version of the painting, which was acquired by Alexander III; meanwhile the fate of the 1880 version was long unknown.

*A Group Saying Farewell* was considered to be a study for the 1888 painting, but in 1955 it was established that it is a fragment from the initial 1880 canvas, which the artist had cut into several parts. It conveys a peasant's sad, silent moment of farewell with his family, which took place during the general commotion before his departure. The figure of this middle-aged, humble recruit is interesting for its convincing psychological aspect. The facial expressions and poses of the various characters are quite eloquent: sad resignation on the face of the soldier's wife, and the old mother's grief as she leans against her son's breast. Also memorable is the concerned expression of the young girl with the child in her arms. The work is a solid, confident one that demonstrates drawing skill and expressive treatment of form.

No. 77
*SAVRASOV, Aleksei Kondratevich*
The Road into the Forest, *1871*
*oil on canvas, 138.5 X 109*
*signature lower left: 1871 A. Savrasov*
*Russian Museum, since 1905*
*Inv. ZH-2842*

A.K. Savrasov was a founder of the so-called lyrical trend in landscape painting of the late 19th century. After surmounting the traditions of Academic Romanticism, he created a new type of landscape based on the artist's first-hand observation of nature. Savrasov's work laid the foundations for new trends in landscape art in the 1890s which, according to the well known artist and art historian A.N. Benois, were "guided" by Savrasov's landmark painting *The Rooks Have Come* (1871). The 1870s, especially in the first half, marked the height of the master's strength. In *The Road into the Forest*, as in other works of the period, Savrasov interpreted nature in an emotional manner. The theme of a road disappearing into the distance, which is the basis of the composition, and the moving picturesqueness of form, are trademarks of Savrasov, and give what first appears to be an ordinary scene a special expressiveness and poetry.

The 1871 study *The Road into the Forest at Sokolniki* can be found at the Tretiakov Gallery.

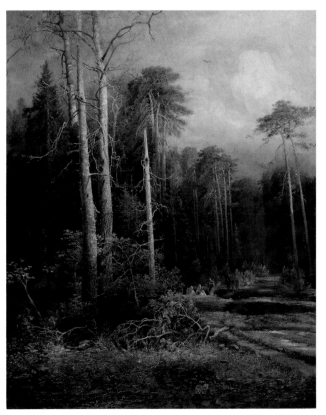

*No. 77*

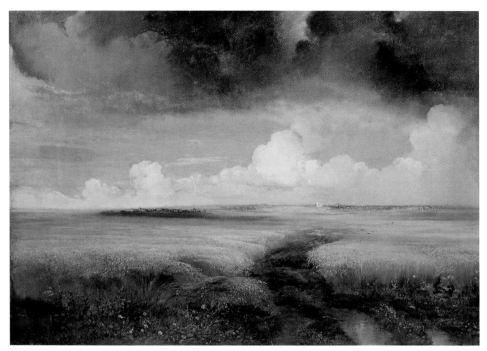

No. 78

No. 78
SAVRASOV, Aleksei Kondratevich
Rye, *1881*
*oil on canvas, 45.4 X 64*
*signature lower left: 1881 A Savrasov*
*Tretiakov Gallery, since 1948*
*Inv. 26783*

Savrasov, in addition to lyrical-poetic interpretations of nature, also pursued another important path – epic landscape. These works give us a better idea of the artist's skills and help us to understand him as a person living in a difficult, often tragic era. One of his best late paintings, *Rye*, is an example. The artist did not normally present his interpretations of nature on large canvases.

In these works, the broad expanses of Russia are seen from a bird's eye view. There is a sense of relaxation here, and an enthusiasm for the beauty of the land as well as some concern expressed by the waving fields of rye and the gathering dark clouds. This painting was the last one shown by Savrasov, at a Wanderers Exhibition in 1881. And although Savrasov was to live more than another decade, they were tragic years of instability, weariness, serious illness, and artistic failure amid brief bursts of artistic activity.

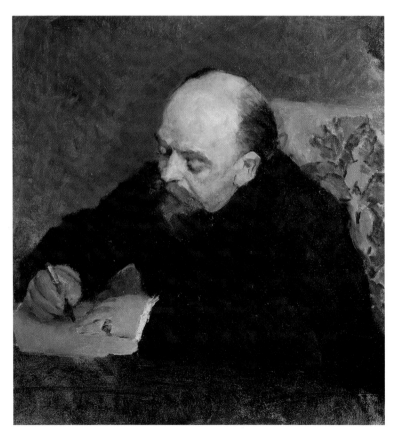

No. 79

No. 79
SEROV, Valentin Aleksandrovich
Portrait of Savva Ivanovich Mamontov, *1891*
*oil on canvas, 62 X 52.5*
*Tula Art Museum, since 1965*
*Inv. 670-ZH*

Savva Ivanovich Mamontov (1841-1914) was a major industrialist in Moscow, a builder of railroads in Russia, a famous patron of the arts and founder of a private opera company.

V. Serov recreates the rich emotional and spiritual atmosphere of S. Mamontov's inner world in this portrait, executed in an airy, unpretentious manner. As a portraitist Serov occupied a special place in Russian art at the turn of the century, since he carried the best qualities of the Wanderers' psychological portrait art into early twentieth-century portraits. Serov joins a subtle psychology with sharply observed character traits.

Serov was a close friend of the Mamontov family and with Savva Ivanovich himself. He lived a long time on Mamontov's estate near Moscow, Abramtsevo, which from the 1870s to the 1900s was one of the most important cultural and spiritual centers in Russia. Artists who stayed and worked at the Mamontov home formed an informal association, which later became known in the history of Russian art as the Abramtsevo (or Mamontov) Circle. The heart and soul of that artistic community was Savva Mamontov himself.

*No. 80*

No. 80
*SHISHKIN, Ivan Ivanovich*
Forest Swamp, *1873*
*oil on canvas, 80 X 120.5*
*signature lower left: Shishkin. 1873*
*Kiev Museum of Russian Art, since the 1920s*
*Inv. ZH-534*

Shishkin was born and raised in Vyatka Province, in a region of magnificent forests that greatly determined later the contents of his landscapes. A major figure in late nineteenth century landscape painting, Shishkin painted the majestic features of the Russian countryside with a feeling for their beauty, power and richness. A rational analytical approach to nature inspired his creative work. It was employed in an effort to produce a grandiose picture, and, despite its objectivity, did not exclude emotion.

In the 1870s the artist reached his creative maturity, and *Forest Swamp* dates from that time. The accurate draftsmanship helps convey the form and texture of the diverse forest growth, and an impression of clear, tranquil beauty is enhanced by the light of the subtly rendered sunset.

No. 81
*SHISHKIN, Ivan Ivanovich*
Dawn, *1883*
*oil on canvas, 118 X 75.6*
*signature lower right: I. Shishkin 1883*
*Kiev Museum of Russian Art, since 1948*
*Inv. ZH-538*

In the 1870s Shishkin dealt not only with the bright, fixed state of nature in bloom on sunny summer days, but with changing nature in transition as well. He was especially interested in depicting a grove of trees in autumn, against the background of a dawning sun breaking on the horizon, and he did many versions of such themes in the 1880s. In *Dawn* the image of nature takes on an air of urgency and tension, but not without the graceful presentation so characteristic of the artist's previous works.

*No. 81*

*No. 82*

No. 82
*SHISHKIN, Ivan Ivanovich*
Corner of an Overgrown Garden, *1884*
*oil on canvas, 54.3 X 41.7*
*signature lower left: 1884 Pargolovo I. Sh.*
*Tretiakov Gallery, since 1917*
*Inv. 5559*

No. 83
*SHISHKIN, Ivan Ivanovich*
Mixed Forest (Shmetsk near Narva), *1888*
*oil on canvas, 83 X 101*
*signature lower right: I. Shishkin*
*Russian Museum, since 1898*
*Inv. 4123*

Shishkin is one of the most prominent representatives of landscape painting in the late 19th century. His creative methods were based on an analytical study of nature and emphasis on its exacting portrayal. A marvelous master of forest landscape, the artist pioneered not only a scientific approach to nature, but also a grandiose interpretation of it. The landscape *Mixed Forest* was produced during Shishkin's best period, when he worked on creating monumental images. He also worked on studies, many of which are no less impressive for their content and their clear presentation. *Mixed Forest* shows the master's inherent feeling for nature, his ability to depict it with an almost illusory precision, and his talent for finding beauty in the most ordinary of scenes. Shishkin, who had settled in Shmetsk for the summer months, in a little wooden house on the Gulf of Finland, wrote to a friend: "The forest here is wonderful, and what is more, right close by my dacha. I have begun two large studies. A forest of pine, fir, birch trees, aspen. A wonderful swamp... And the surroundings are spectacular." The artist's choice of a forest glade as his subject with a young sapling forcing its way up among the older trees, a trunk lying in the vegetation, and tree stumps and tussocks, was to be repeated numerous times. Drawn with free-flowing assurance, the landscape is an affectionate reproduction of the various forms of vegetation. The carefully chosen and accurately rendered color in combination with the detailed draftsmanship yield an unerring depiction of nature's special features. This work, with its cheerful mood, gives us a feeling of tranquility and contemplation, which is characteristic of many of Shishkin's landscapes.

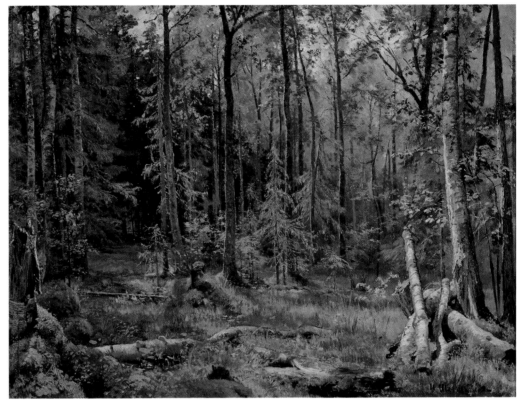

*No. 83*

*No. 84*

No. 84
*SHISHKIN, Ivan Ivanovich*
Thickets, *1881*
*oil on canvas, 44 X 34*
*signature lower right: I. Shishkin*
*Tula Art Museum, since 1962*
*Inv. 672-ZH*

Shishkin's usual methods of work emerge quite clearly in his many nature studies. There we find an expression of his first impressions and the painstaking, thorough study based on them. It would be impossible to imagine how Shishkin arrived at his more monumental landscapes without these nature studies.

"The main thing a landscape artist has to do," wrote the famous painter, "is to study nature diligently, and the painting done from nature will be without fantasy as a result." In this regard the artist took a view of nature somewhat like that of a botanist, and it made him a man of his time – a time of rational study of the world around us.

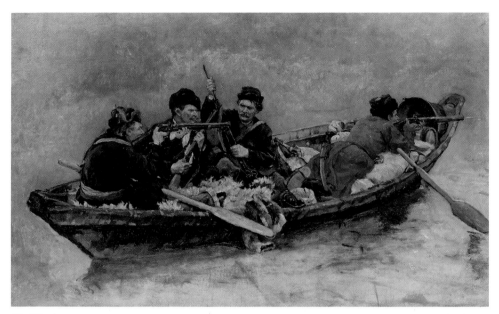

No. 85

No. 85
*SURIKOV, Vasilii Ivanovich*
Cossacks in a Boat, *c. 1893*
*oil on canvas, 65.5 X 99*
*Russian Museum, since 1937*
*Inv. 4244*

This work is a study for the painting *Yermak's Conquest of Siberia*, 1895, which can also be found at the Russian Museum. Work on this canvas was begun by the artist in 1891 and lasted five years.

The scene in the picture takes place during the 16th century, when the Cossacks under Yermak's leadership conquered the realm of the Tatar Khan of Kuchum. Surikov gathered historical material with great care, and traveled for long periods of time to Siberia and the Don region, studying the location where the battle took place; he did research in the Armory Museum in Moscow, and in the museums of Tobolsk and Minusinsk he studied the collections of old weaponry and costume. The difficult preparatory work done by the artist is reflected in a variety of sketches and studies. They enable us to follow the development of the final composition, and of its various portrait components. *Cossacks in a Boat* is a group study, and was subsequently included with some changes in the foreground of the final painting. By revealing the individuality of each protagonist, Surikov executed a finished work full of inner dynamics.

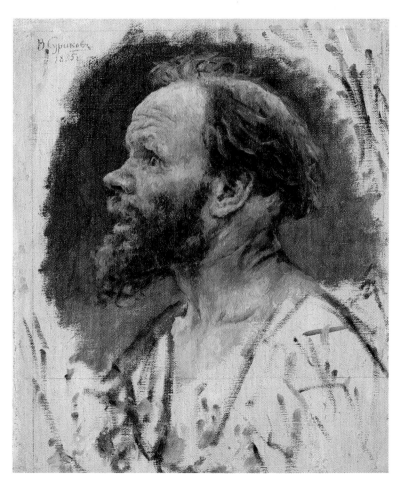

No. 86

No. 86
*SURIKOV, Vasilii Ivanovich*
Head of a Fool, *1885*
*Study for the painting* Boyarina Morozova
*oil on canvas, 44 X 36*
*signature lower left: V. Surikov 1885*
*Tretiakov Gallery, since 1965*
*Inv. 381*

Surikov attached special importance to the image of the fool in his painting. He is not only a witness to tragedy, but someone who deeply sympathizes with Boyarina Morozova as she is taken away in disgrace.

*Startsi*, or "Holy Fools," in Russia were religious ascetics and adepts always perceived among the simple people as defenders of truth. Because of their acceptance of great physical deprivation, they were regarded as seers and prophets. The Fool in this painting incarnates the essential characteristics of the era as portrayed by the artist: disorder, nationalism and tragedy. This image is one of a marvelous series of peasant portraits done by many Russian artists of that decade with attachment, care and deep respect for the common man.

No. 87
*SURIKOV, Vasilii Ivanovich*
Nun with Hands to Her Face, *1884*
*Study for the painting* Boyarina Morozova
*oil on canvas, 34.5 X 26.5*
*Tretiakov Gallery, since 1929*
*Inv. 11180*
(Photo not available)

Included in this exhibition are several studies for Surikov's major historical painting, *Boyarina Morozova* (1887), the artist's finest work. The subject for the painting is taken from a tragic episode of the Russian religious schism in the mid-17th century. The heroine of the painting *Boyarina Morozova*, after being tortured, is taken away to be imprisoned in a monastery. In dealing with this tragic confrontation, the artist presents a study of a profound development in Russian history, in which a grass-roots movement was a powerful force. The painting was preceded by a great deal of preparatory work, including sketches and several hundred drawings and studies, many of which are completed works and true masterpieces.

This study of a nun was an important stage in Surikov's attempt to portray one of the key characters in the painting. The psychological expressiveness and color scheme of the study are a part of the compositional framework for the larger painting.

The female figures in the painting have a special emotional impact – they show the immediate reaction of the crowd to Boyarina Morozova's appeal. A broad spectrum of diverse feelings – surprise, fright, respect for the fanatic inflexibility of the main heroine, covert pain and sympathy – are all expressed with exquisite subtlety by Surikov in the female figures of this historic epic. Each face is an inimitable character expressing the artist's view of the ideal of woman's beauty and character, her sensitivity and responsiveness to another's pain, as well as her determined self-sacrifice.

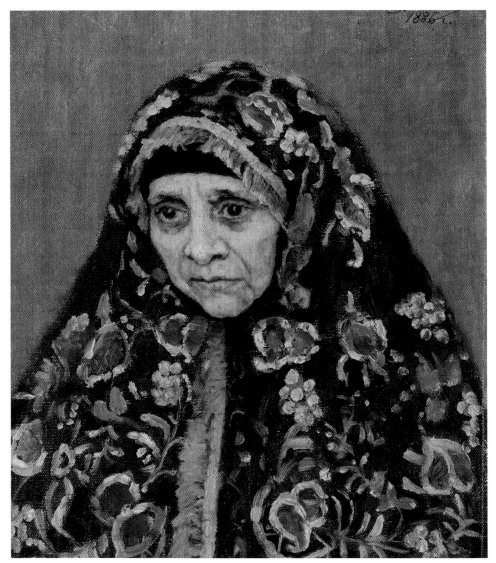

*No. 88*

No. 88
*SURIKOV, Vasilii Ivanovich*
Old Woman in a Patterned Dress, *1886*
*Study for the painting* Boyarina Morozova
*oil on canvas, 43.7 X 36*
*signature upper right: V. Surikov 1886*
*Tretiakov Gallery, since 1924*
*Inv. 10320*

In this depiction of an old woman, the artist was primarily interested in her facial expression. Lined with deep wrinkles, the face appears to be stamped from leather. The dark brown dress, sewn with golden thread, was drawn by the artist with exceptional attention to the rare beauty of that ancient fabric. Such studies made it possible for the artist to express his enthusiasm for the decorative richness and variety of old national costume, and takes the viewer into the bygone era of 17th-century Russia.

Born in Siberia, where in the late 19th century the everyday ways, customs and even dress of the 16th and 17th centuries were still preserved, Surikov knew well and loved these historical artifacts, and they were a natural part of his painting. "Siberia imbued me with historical ideals from childhood; it gave me my spirit, strength and health," wrote the artist.

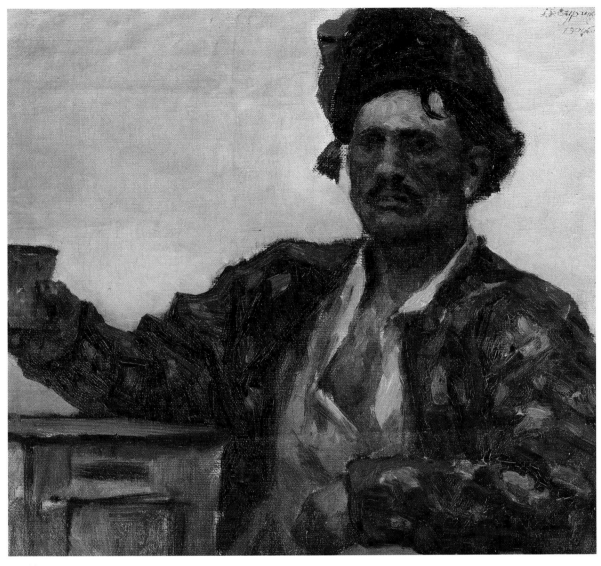

*No. 89*

No. 89
*SURIKOV, Vasilii Ivanovich*
Haydamak, *1904*
*oil on canvas, 38 X 59*
*signature lower right: V. Surikov 1904*
*Tula Art Museum, since 1919*
*Inv. 328-ZH*

The image of a Cossack of stubborn courage clearly emerges from this study, *Haydamak*, one of many preparatory works Surikov produced for the painting *Stepan Razin* (1907-1910), which is to be found in the Russian Museum in Leningrad. When he began this painting in the 1890s, Surikov traveled several times to the Volga, doing landscape studies and sketching typical Cossacks. These studies, done in a colorful, bright palette, determined the color scheme for the final painting.

*No. 90*

No. 90
*SVETOSLAVSKY, Sergei Ivanovich*
Spring Approaches, *1887*
*oil on canvas, 82 X 158*
*signature lower left: S. Sviatoslavsky 87*
*Tretiakov Gallery, since 1888. Painting acquired by*
  *P.M. Tretiakov from the artist*
*Inv. 978*

Svetoslavsky's marvelous painting shows his clear, artistic individuality, and originality as well as faith in the best traditions of his teachers, Savrasov and Perov. In it, everyday life in the Russian countryside is observed through the curious eyes of the artist and is raised to the level of a poetic image.

The lyrical interpretation of this everyday theme is expressed through the emotional, subtle landscape of the painting. Adhering to Savrasov's style of lyrical landscape painting, Svetoslavsky documented in this work his own understanding of the interrelationship of man and nature. Pride of place in this relationship is given to the unity of landscape and genre subject. In its presentation, *Spring Approaches* lies somewhere in between a genuine landscape and a genre painting "without an event," quite characteristic in painting of the 1890s.

From his renowned teachers, the artist inherited a love for a yellow-gold color scheme, which he developed here in rich and subtle hues. The painting, drawn with great skill, appears to be basked in a soft, sunny glow.

No. 91
*VASNETSOV, Apollinarii Mikhailovich*
17th Century Moscow. At Dawn. The Voskresensky
  Gates, *1900*
*oil on canvas, 136 X 122*
*signature lower left: Apollinarii Vasnetsov 1900*
*Tretiakov Gallery, since 1900*
*Inv. 974*

Apollinarii Vasnetsov's historical landscapes of Moscow in the 16th and 17th centuries occupy a unique place in Russian painting.

A landscape artist by vocation, he became known in the 1890s for his epic renderings of the Urals, Siberia and the North. Later he dealt with architectural landscapes of the ancient capital, because, as he himself said, "I love everything of ours, and old Moscow is our national creation from the life of the past." With archaeological precision, Vasnetsov reconstructed in his canvases a face of Moscow which had long been relegated to the distant past. His reference not only to historical documents – old maps, archaeology, accounts and descriptions of people of that time – but also his artistic imagination helped Vasnetsov create living portraits of old Moscow.

Towards the end of the 19th century a serious interest in Russia's historical past became characteristic of society. It was expressed in the active development of historical scholarship, and for many artists history became the main theme in their work. The works of V. Surikov, S. Riabushkin, V. Vasnetsov, and I. Roerich revealed the country's past through national tragedy or the beauty of folk customs, the poetry of old traditions, or images of pagan Russia. A. Vasnetsov's historical landscapes originated in this same overall interest. A man of diverse talents, he was both artist and scholar, and wrote works on art theory and archaeology. As an artist he was a member of many historical societies and commissions, and through his artistic and other regular activities he promoted the study of Moscow's historical past.

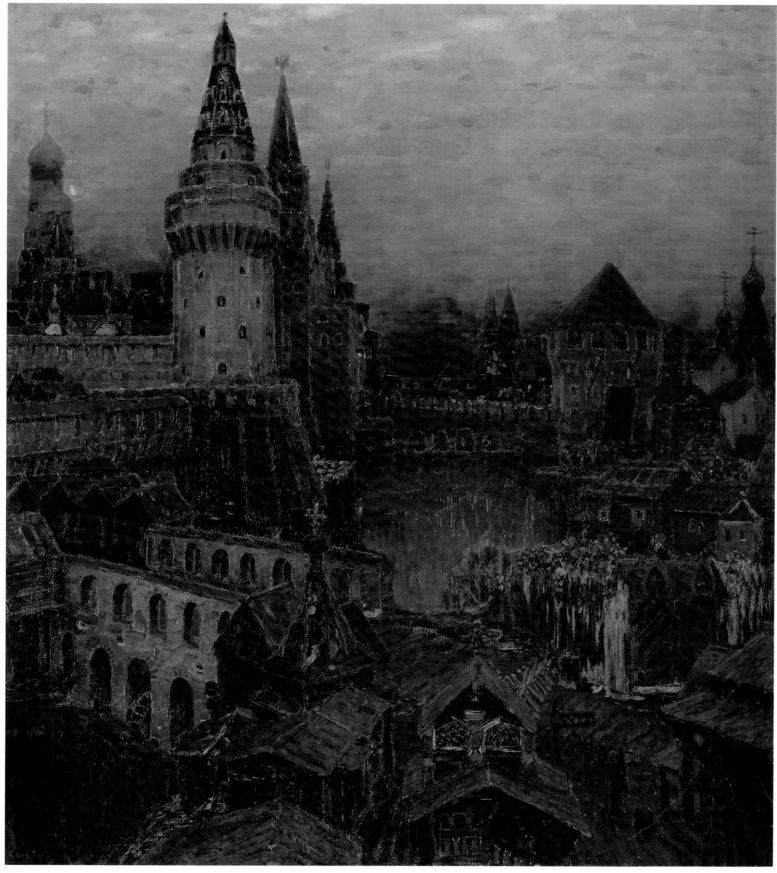

*No. 91*

No. 92

No. 92
*VASNETSOV, Viktor Mikhailovich*
The Vorya River, *1880*
*oil on cardboard, 33 X 24*
*signature lower right: V. Vasnetsov*
   *Notation on reverse: River Vorya, Study by my father*
   *Viktor Mikhailovich done in village of Akhtyrka in*
   *1880, A. Vasnetsov*
*Tula Regional Art Museum, since 1962*
*Inv. 589-ZH*

Here we see a quiet, intimate corner of the Russian
countryside in which a small river flows and there is
soft lighting and the artist's subtle working of
nature's forms.

The landscapes so lovingly painted by the artist
were, as a rule, studies for his larger paintings on
folk tales or national customs. They expressed
Vasnetsov's inherent poetic view of Russian history,
and thanks to this aspect of his art in particular,
Vasnetsov has become one of the best known and
most loved Russian artists.

NOTE: Because of the forthcoming one man show
of Vasnetsov's works, to be held first in Moscow and
then in Leningrad, it has not been possible to prop-
erly represent this artist in the current exhibition.

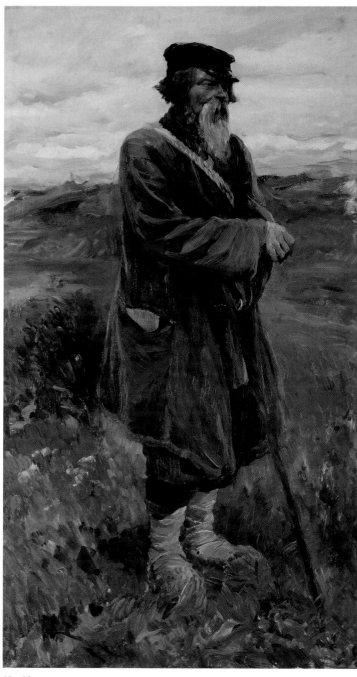

No. 93
*VINOGRADOV, Sergei Arsenevich*
Shepherd, *c. 1900*
*oil on canvas, 100 X 57*
*Tretiakov Gallery, since 1935*
*Inv. 15073*

This work is a study for the artist's painting *After the Harvest* (1900). Vinogradov's main interest, especially during his first decade of work, was in depicting the daily life of the rural peasant. The Wanderers' traditions were, no doubt, a strong influence on him. But, for the younger generation of Wanderers, to whom Vinogradov belonged, emotional impact was more important than social commentary. The artist painted peasants eating in the fields, old women resting from a hard day's work, and shepherds tending their flocks. Through these simple portrayals, he opened up a whole world of poetic, inspiring images. Work on each of these paintings was preceded by a large number of studies. In them the master attempted to preserve the vitality of the original in his effort to reveal human character and its yearnings.

For the younger generation of artists, the study was not only a preparation for a painting, but took on its own independent significance. For this reason exhibitions of studies in the 1880s began to open more and more frequently in Moscow and in St. Petersburg. Studies from life showed an increasing interest in nature as seen through the human eye, and in the possibilities for color in *plein-air* painting. One such work is Vinogradov's study *Shepherd*.

*No. 94*

No. 94
VOLKOV, Efim Efimovich
October, 1883
oil on canvas, 38.2 X 55
signature lower left: E. Volkov S Pburg
lower right author's notation: October 1883 Siversky
   Station
Tretiakov Gallery, since 1884
Painting acquired by P. M. Tretiakov from the artist
Inv. 935

Volkov was an artist whose work underwent favor-
able transformations through his contact with the
Wanderers Association. Having acquired artistic
training as early as the 1860s, he began to exhibit
actively in the early 1870s. Reviewers at that time
noted a certain dryness in his landscapes and some-
what monotonous themes. He became a member
in the Association of Traveling Art Exhibits in 1879,
and thenceforth all his future activity was connect-
ed with it. The fact that his paintings would hang at
Wanderers exhibits alongside those of Shishkin,
Polenov, and later Levitan forced Volkov to take
special care in his work. The artist did his best work
in the 1880s.

   The famous art critic Stasov quite rightly said of
the painting *October*: "...This is one of the best, if
not the best work by Volkov, so good are the reliefs
of the thick trees grown bare with autumn, so fine
the perspective through the sparse forest, and so
strong the feeling of the air and of autumn's fading
light."

No. 95
YAROSHENKO, Nikolai Aleksandrovich
In Warm Country, 1890
oil on canvas, 107 X 81
signature lower left: N. Yaroshenko 1893
Russian Museum, since 1898
Inv. 2500

Developments in Russian art in the 1890s – the
interest of many artists in color, beauty, and in
*plein-air* art – inevitably had an effect on the leading
Wanderers, even such orthodox followers of their
program as Yaroshenko, who had become the head
of the Association. During the nineties his works
lost some of the social pathos and immediacy of the
1870s and 1880s. Still a pensive psychologist, and
still keen on one figure compositions, the artist
paid ever greater attention to landscape painting –
how to convey sunlight and the change of color in
the air. The elegiac mood of his painting *In Warm
Country* makes it one of the most penetrating works
of the artist's late period. Great attention was given
to portraying the pale gaunt face of the sad woman,
and, as always with Yaroshenko, the position of the
subject's hands is essential. The artist's great exper-
tise can be felt in his landscape composition. By

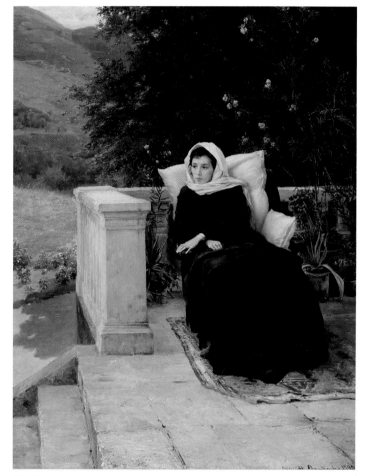

No. 95

painting in the open air, Yaroshenko expanded his
palette, and the blossoming beauty of the early
greenery is stronger here than a feeling of sadness
and loneliness. The nuanced tones of green, gray
and yellow, in contrast with the black of her dress,
strengthens the minor key. Anna Konstantinovna
Dideriks, the wife of Tolstoy's companion G.V.
Chertkov, and fellow student of Yaroshenko's wife,
posed for this picture, and often served as a model
for the artist.

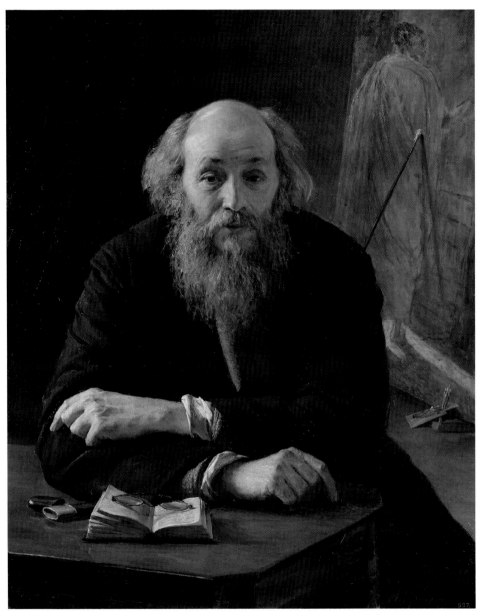

*No. 96*

No. 96
*YAROSHENKO, Nikolai Aleksandrovich*
Portrait of the Artist N. Ge, *1890*
*oil on canvas, 92.5 X 73.5*
*signature lower right: N. Yaroshenko*
*lower left: 1890*
*Russian Museum, since 1899*
*Inv. 4156*

An artist of revolutionary themes, Yaroshenko reacted strongly to the issues of his time and devoted many of his works to young students. He has entered the history of Russian art not only as a painter on social issues, but also as an accomplished portraitist, and as pupil and successor to I.N. Kramskoy. Yaroshenko was by nature a gifted psychologist, therefore the portrait genre was important in his work. According to his wife, he was incapable of painting people who did not interest him, despite the fact that he needed the money. The portrait of N. Ge clearly shows his special attention to innermost human feeling. In it the artist created an extremely complex composition, in which the setting is the main component. Ge is portrayed seated in his studio, deep in thought before an open Bible in his studio, with his work *What Is Truth?* in progress in the background. This painting, which shows a tortured and humiliated Christ standing before Pilate, was withdrawn from the 1890 Wanderers Exhibit on orders from Alexander III, for being un-Christian in its presentation.

In that same year Yaroshenko did his portrait of Ge, the innovative artist and propagator of lofty moral ideals, in which he expressed not only his sympathy and respect for Ge, but his opposition to those official circles that had attacked Ge. In the portrait Ge appears as a gray-haired man of wisdom. The critic Stasov wrote of the portrait: "Here we see before us all the unusual meekness, kindness, and good nature of the original – an exceptional likeness."

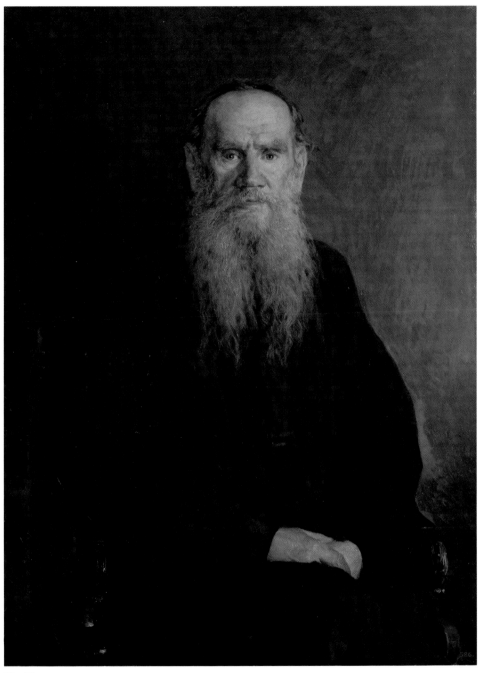

No. 97

No. 97
*YAROSHENKO, Nikolai Aleksandrovich*
Portrait of the Writer L.N. Tolstoy, *1894*
*oil on canvas, 112 X 81*
*signature and date lower left: N. Yaroshenko 1894*
*Russian Museum, since 1899*
*Inv. ZH-6345*

The portrait of Lev Nikolaevich Tolstoy (1823-1910), shown in St. Petersburg at the 23rd Traveling Exhibit, was not appreciated by contemporaries. One critic wrote that there was no "great writer or great moralist" to be seen in it. The extensive iconography of Tolstoy, who had been painted and drawn by Repin, Kramskoy and many other Russian masters, had prompted preconceived notions of how he should be portrayed. Obviously Yaroshenko had something special in mind, and his Tolstoy is not the powerful thinker who overwhelmed people with his personality, but rather a wise, withdrawn old man, ridden by his inner doubts and moral aspirations. The refusal to generalize, and the artist's attraction to simple human images, so characteristic of his work in the 1890s, is reflected in this portrait.

*No. 98*

No. 98
*YAROSHENKO, Nikolai Aleksandrovich*
The Stoker, *1878*
*oil on canvas, 124 X 89*
*signature lower left: N. Yaroshenko. 1878*
*Tretiakov Gallery since 1878. The painting was acquired*
*by P.M. Tretiakov from the artist.*
*Inv. 687*

Nikolai Aleksandrovich Yaroshenko's fame began with this canvas, *The Stoker,* which the artist exhibited at the Itinerants' Sixth Exhibition in 1878. The painting makes a strong impression on the viewer due to its uncomfortable portrayal of truth. The artist was convinced that through the strength of art he could, and must arouse compassion for oppressed people. V.M. Garshin, who was one of the most perceptive Russian writers between 1870 and 1880, wrote a short story titled, "The Artist" under the influence of this particular painting.

In the story the protagonist is an artist named Ryabinin, who, like Yaroshenko, astounded others with his creations by using the subject of a worker to protest conditions:

> "I, I myself, created you so that you could terrify this pure and hateful crowd with your presence. Come, the power of my strength is bound to the linen, and look upon the dress coats and gowns, and shout at them: I am the one who taunts and stings! Strike them in the heart, deprive them of sleep, stand before their eyes as an apparition! Destroy their peace of mind – as you destroyed mine..."

Beginning with *The Stoker,* Yaroshenko created a series of works portraying various social types of his time. The series also includes such important paintings as *The Student* and *The Coed.*

# Artist Biographies

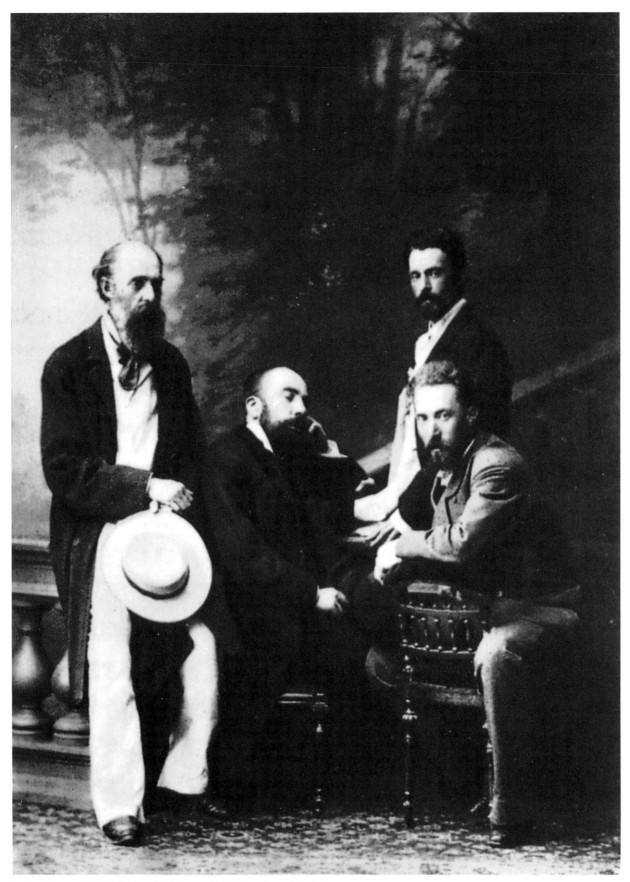

Artists (from left) N.E. Makovsky, Polenov, V.E. Makovsky and Savitsky

# The Wanderers

---

## ABRAM EFIMOVICH ARKHIPOV

*1862, village of Egorovo in Riazan Province - 1930, Moscow.*
*Painter. Genre, landscapes.*

Studied at Moscow School of Painting, Sculpture and Architecture (1877-1883, 1886-1887) with V. Perov, I. Prianishnikov, V. Makovsky, V. Polenov. Studied at the Academy of Arts (1884-1885). Taught at Moscow School of Painting, Sculpture and Architecture (1894-1918).

Active member Association of Traveling Art Exhibits (1889-1901). Founding member Union of Russian Artists (1903). Named People's Artist in 1927.

Also participated in exhibitions of Moscow Society of Art Lovers, and "World of Art" association.

*Authors and Editors of Biographies of Individual Painters and Annotations:*
Yekaterina Vladimirovna Vinogradova   *State Russian Museum*
Valentina Fedorovna Gershfeld   *Kalinin Regional Picture Gallery*
Valentina Pavlovna Kniazeva   *State Russian Museum*
Galina Sergeevna Churak   *State Tretiakov Gallery,*
   *Kalinin Regional Picture Gallery, Tula Art Museum*
Marina Nikolaevna Kuzina   *Tula Art Museum*
Mikhail Davydovich Fantorovich   *Kiev Museum of Russian Art*
Irina Nikolaevna Shuvalova   *State Russian Museum*
Marina Nikolaevna Shumova   *State Russian Museum*

## VASILII NIKOLAEVICH BAKSHEEV

*1862, Moscow - 1958, Moscow.*
*Painter. Landscape artist, genre paintings and portraits.*

Studied at Moscow School of Painting, Sculpture and Architecture (1878-1881) with A. Savrasov, V. Polenov, V. Makovsky. Received title of Academician in 1913. Taught at Moscow School of Painting, Sculpture and Architecture (1894-1918). Member Association of Traveling Art Exhibits from 1896, included in Association exhibitions from 1891.

After October Revolution 1918-1919 worked in Commission for the Preservation of Monuments and Antiquities. Member Association of Artists of Revolutionary Russia (1925-1927); member Society of Russian Artists (1927-1931). From 1933 to the end of his life active in teaching at Moscow art schools. From 1941, professor; from 1947, full member of the Academy of Arts; from 1956, People's Artist of the USSR.

## NIKOLAI PETROVICH BOGDANOV-BELSKY

*1868, village of Shitiki in Smolensk Province -
1945, Latvia.*
*Painter. Genre, portraits.*

Studied at icon workshop of the Troitse-
Sergeev Lavra near Moscow; at Moscow
School of Painting, Sculpture and Architec-
ture (1884-1889) with V.E. Makovsky, V.D. Polenov, I.M.
Prianishnikov; at Academy of Arts in St. Petersburg (1890s)
with Repin, in Paris with F. Cormon and F. Colarossi. Received
title of Academician (1903). Full member Academy of Arts
(1914). Lived and worked in St. Petersburg, in the village of
Tateve, in Latvia (from 1921). Chairman of A.I. Kuindzhi
Society (1911-1921). Participant in exhibitions: Moscow
Society of Art Lovers, in Paris (1900), in New York (1924),
Association of Traveling Art Exhibits (displayed from 1890;
member from 1895).

## ALEKSEI PETROVICH BOGOLIUBOV

*1824, village of Pomeranie in Novgorod Province -
1896, Paris.*
*Painter, watercolor artist. Landscape, seascape.*

Prepared for career as naval officer, educated
at Naval Officers School (1833-1841). Audited
classes at Academy of Arts in St. Petersburg
(1850-1853), studied with B.P. Villevalde and M. N. Vorobyov.
Academy of Arts fellowship holder abroad (1854-1860),
worked in Paris, Geneva, Düsseldorf. Received title of
Academician, 1858; of Professor, 1861. Lived in St. Petersburg,
after 1873 in Paris, traveling to Russia every year. Traveled
repeatedly to countries of Europe. Founder 1885 and lifetime
trustee of the Saratov Radishchev Museum (now The Saratov
Radishchev Art Museum).

Member Association of Traveling Art Exhibits from 1872
and participant in Association exhibitions. Also took part in
exhibitions of Academy of Arts, All-Russian, Universal and
International exhibitions in Paris, London, Vienna, Berlin.

## NIKOLAI VASILEVICH DOSEKIN

*1863, Kharkov - 1935, Moscow.*
*Painter. Landscapes, portraits.*

In 1870s – 1880s active in private studios of Kharkov, Moscow,
Paris. One of Dosekin's teachers was the landscape artist A.A.
Kiselev.

Lived primarily in Paris, then in Moscow between 1896-1914.
From 1900 member Association of Traveling Art Exhibits;
shown at Association exhibits since 1888. From 1903 member
Union of Russian Artists. Also participated in exhibitions of
Moscow Association of Artists, All-Russian Exhibition (1896)
and "World of Art" association, international shows in Paris,
Berlin and Munich.

## NIKOLAI NIKANOROVICH DUBOVSKOY

*1859, Novocherkassk - 1918, Petrograd.*
*Painter. Landscapes.*

Studied at Petersburg Academy of Arts with M.K. Klodt (1877-1881), in 1881 left the Academy, refusing to participate in a competition. Obtained right to teach drawing and sketching (1892). Frequently traveled abroad – Greece, Italy, France, Switzerland, Germany (1893, 1895, 1898, 1908, 1912, 1916). Received title of Academician (1898); full member of Academy of Arts (1900); received title of Professor (1911). Taught at Petersburg Academy of Arts (from 1909). Participated in exhibitions of Society for the Promotion of Art, the Association of Traveling Art Exhibits, All-Russian Exhibition in Nizhni Novgorod, Moscow Society of Art Lovers, in Düsseldorf, Paris, Universal Exhibitions in Rome and Munich. Lived and worked in St. Petersburg. Member Association of Traveling Art Exhibits (from 1886). Leading member of the Association; member of the Board. Bequeathed his collection of works by Russian artists and a large number of his own paintings and studies to Novocherkassk.

## NIKOLAI NIKOLAEVICH GE

*1831, Voronezh - 1894, village of Ivanovsky in Chernigov Province.*
*Painter. Primarily religious subjects and historical themes in the 1870s. Portraits.*

Studied mathematics at Kiev, later Petersburg University (1847-1850), at Academy of Arts in St. Petersburg (1850-1857). Academy fellowship holder in Italy (1857-1863). In 1863 received title of Professor. Lived in St. Petersburg, in 1876 moved to village of Ivanovsky in Chernigov Province. Follower of Leo Tolstoy's religious and moral teachings. Founding member Association of Traveling Art Exhibits in 1870, participant in Association exhibits, beginning with the first one in 1871. Also took part in exhibitions of Academy of Arts, All-Russian exhibitions, and International exhibitions in Paris, London, Vienna, Chicago.

## NIKOLAI ALEKSEEVICH KASATKIN

*1859, Moscow - 1930, Moscow.*
*Painter. Genre.*

Studied at Moscow School of Painting, Sculpture and Architecture (1873-1883) with V. Perov and I. Prianishnikov (1892-1899) made several visits to Donbass in the Urals which inspired a cycle of paintings on the mines. Taught at Moscow School of Painting, Sculpture and Architecture (1894-1917). Member Association of Traveling Art Exhibits from 1891. Member Association of Artists of Revolutionary Russia (1922-1926). Member Association of Realist Artists from 1927. Organized art studies for workers, designed revolutionary celebrations in Moscow. Named People's Artist in 1923.

## ALEKSANDR ALEKSANDROVICH KISELEV

*1838, Sveaborg (now Suomenlinna, Finland) -*
*1911, St. Petersburg.*
*Painter, watercolor artist. Landscapes. Art critic.*

Studied history and philosophy at Petersburg University (1858-1861). Before completing university, enrolled at Academy of Arts in St. Petersburg (1862-1864), studied with S. Vorobyov. Full member of Academy of Arts from 1898; received title of Academician 1899. Professor and head of landscape studio at Higher Art School of Academy of Arts in St. Petersburg (1897-1911). During the 1880s and 1890s was frequently in the Caucasus. Also traveled to Germany, France and Italy during those years.

Member Association of Traveling Art Exhibits from 1876, participating in exhibitions from 1875.

Also took part in exhibitions of Academy of Arts, All-Russian, Universal and International exhibitions in Paris, Venice.

## MIKHAIL KONSTANTINOVICH KLODT

*1832, Zegevolde, Courland Province (near Riga) -*
*1902, St. Petersburg.*
*Painter. Landscapes.*

Studied at Officers School of Mining with I.T. Khrutsky, at Petersburg Academy of Arts with M.N. and S.M. Vorobyov (1851-1858). Fellowship holder Academy of Arts in France and Switzerland (1858-1861), returned home before completion of studies and continued travels in native country (1862). Received title of Academician (1862); of Professor (1864). One of the founders and head of landscape class of Academy of Arts, taught at Academy of Arts (1871-1886). Participant in Academy exhibitions, Association of Traveling Arts Exhibits, Universal Exhibitions in Paris, London, Vienna, Philadelphia, Antwerp, All-Russian in Moscow. Lived and worked in St. Petersburg. One of founding members Association of Traveling Art Exhibits (1870). Member of the Board.

## ALEKSEI MIKHAILOVICH KORIN

*1865, village of Palekh in Vladimir Province -*
*1923 Klin.*
*Painter. Genre, portraits, landscapes.*

Studied at icon painting workshop in village of Palekh (1876-1884), then at Moscow School of Painting, Sculpture and Architecture (1884-1889) with I.M. Prianishnikov, V.E. Makovsky, V.D. Polenov.

Lived and worked in Moscow. Taught at Moscow School of Painting, Sculpture and Architecture (1894-1917). Member Association of Traveling Art Exhibits from 1895, participated in Association exhibitions from 1891. Took part in exhibitions of Moscow Association of Artists, All-Russian (1896), as well as International Exhibitions in Berlin, Paris, Munich.

## ALEKSEI IVANOVICH KORZUKHIN

---

*1835, Uktussky Zavod in Perm Province - 1894, St. Petersburg.*
*Painter. Genre, portraits.*

Studied at Petersburg Academy of Arts with A.T. Markov (1858-1863). In 1863 refused to comply with program for gold medal, left the Academy of Arts ("protest of the fourteen"), an organizer of the Petersburg Artists' Cooperative Workshop. Received title Academician (1868); Founding member of Association of Traveling Art Exhibits (1870); Full member Academy of Arts (1893). Participant in academic exhibitions, International exhibitions in London and Vienna. Lived and worked in St. Petersburg.

## IVAN NIKOLAEVICH KRAMSKOY

---

*1837, Ostrogozhsk in Voronezh Province - 1887, St. Petersburg.*
*Painter, graphic artist. Portraits, genre, religious themes.*

Studied at Academy of Arts in St. Petersburg (1857-1863), which he left as one of fourteen artists in protest against strict rules for academic competitions. Leader and initiator of the Petersburg Artists' Cooperative Workshop, first independent organization of artists (1863-1869).

Lived in St. Petersburg. Traveled through France (1869, 1876).

Founding member, virtual theorist for the Association of Traveling Art Exhibits in 1870, participant in Association exhibitions, beginning with first one in 1871. Participant in exhibitions of Academy of Arts, All-Russian (1882), as well as Universal and International Exhibitions in Paris, Vienna, London.

## ARKHIP IVANOVICH KUINDZHI

---

*1842, Mariopol - 1910, St. Petersburg.*
*Painter. Landscapes.*

Received no formal training. Worked in I.K. Aivazovsky's studio in Feodosiya (1865-1866), then attended Petersburg Academy of Arts for a while. Received title of Artist (1878). Full member Academy of Arts (1893). Professor and head of landscape studio at Higher Art School of the Academy of Arts (1894-1897). Lived in the Crimea and in St. Petersburg. Founder of a society in his own name (1908) to which he donated substantial funds to support Russian artists and left his own works to it. Member Association of Traveling Art Exhibits (1875-1879). Also showed his works independently – especially in 1880, showing his well-known painting *Moonlight on the Dniepr*.

## NIKOLAI DMITRIEVICH KUZNETSOV

---

*1850, village of Stepanovka in Kherson Province - 1930, Sarajevo, Yugoslavia.*
*Painter. Portraits, landscapes, genre.*

Studied at Petersburg Academy of Arts (1876-1879) with P.P. Chistiakov. Traveled through France and Germany (1880). Received title of Academician (1900). Participant in Association of Traveling Art Exhibits; Association of South Russian Artists; Universal Exhibitions in Brussels, Chicago; International Exhibits in Berlin, Munich, Paris Salon, etc. Lived and worked in the Ukraine. Member of Association of Traveling Art Exhibits (from 1883), Association of South Russian Artists (from 1890).

## KLAVDII VASILEVICH LEBEDEV

---

*1852, (Moscow?) - 1916, Moscow.*
*Painter, illustrator. Author of books on historical, genre subjects.*

Studied in Moscow at Stroganov Industrial Arts School and at Moscow School of Painting, Sculpture and Architecture (1875-1881) with I.S. Sorokin, V.G. Perov. In 1897 received title of Academician. Taught at Moscow School for Painting, Sculpture and Architecture (1890-1894), at Higher Art School of the Academy of Arts in St. Petersburg (1894-1898).

Member Association of Traveling Art Exhibits from 1891. Participated in Association exhibits from 1884. Full member of Academy from 1906.

## ISAAK ILICH LEVITAN

---

*1860, Kibarty station in Kovno Province - 1900, Moscow.*
*Painter, worked in various media – drawing, watercolor, pastels. Landscapes.*

Studied at Moscow School of Painting, Sculpture and Architecture (1873-1885) with A. Savrasov and V. Polenov. Lived in Moscow. Traveled to the Crimea (1886, 1899), Finland (1896), Italy, France, Switzerland (1890s). Made several trips to the Volga (1887-1889, 1891), which played an important role in the artist's creative work. Was interested in the painting of the French Barbizon School, later the Impressionists. In 1898-1900 headed landscape class at Moscow School of Painting, Sculpture and Architecture. In 1898 received title of Academician. Member Association of Traveling Art Exhibits from 1891; participated in its shows from 1884. Also took part in exhibitions of Moscow Artists Association, "World of Art" association, All-Russian Exhibition (1896), International Exhibitions in Paris, Munich, Berlin.

## VLADIMIR EGOROVICH MAKOVSKY

*1846, Moscow - 1920, Petrograd.*
*Painter. Genre, portraits, illustrator.*

Studied at Moscow School of Painting, Sculpture and Architecture (1858-1866) with E.S. Sorokin, S.K. Zaryanko.
   Received title of Academician (1873); full member of Academy of Arts from 1893. Lived and worked in Moscow, from 1894 in St. Petersburg. Taught at Moscow School of Painting, Sculpture and Architecture (1882-1884); (1894-1918) Professor and Studio Head of Higher Art School of the Academy of Arts in St. Petersburg; Rector from 1895.
   Member Association of Traveling Art Exhibits from 1872 and active in its exhibits. Also took part in All-Russian (1882, 1896), Universal and International Exhibitions in Paris, Vienna, London, Berlin.

## VASILII MAKSIMOVICH MAKSIMOV

*1844, village of Lopino in Petersburg Province -*
*1911, St. Petersburg.*
*Painter. Genre, portraits, landscapes.*

Served as master's apprentice in an icon studio in St. Petersburg from 1855. Studied at Academy of Arts (1863-1866). Received title of Academician (1878). Lived and worked in St. Petersburg and in Petersburg Province, as well as in Tver Province, in Kiev, on the Volga. Participated in exhibits of Academy of Arts, Society for the Promotion of Art, Universal Exhibition in Paris (1878), and others. Member Association of Traveling Art Exhibits from 1872; exhibitions shown from 1871 on.

## FILIPP ANDREEVICH MALIAVIN

*1869, village of Kazanka in Orenburg Province -*
*1940, Brussels.*
*Painter, draftsman. Genre paintings, portraits.*

Studied at the monastery icon workshop in Ion-Oros (Greece, 1885-1891), at Academy of Arts in St. Petersburg (1892-1899) with P. P. Chistiakov and I. E. Repin. Received title of Academician (1906). Participant in exhibitions: Association of Traveling Art Exhibits, Moscow Society of Art Lovers, "World of Art" association, 36 Artists, Union of Russian Artists and others. In 1900 traveled to Paris. Lived and worked in St. Petersburg and in villages near Riazan; from 1922, abroad. Member Union of Russian Artists (from 1903). Displayed at Association of Traveling Art Exhibits from 1895.

## GRIGORII GRIGORIEVICH MIASOEDOV

*1834, village of Pankovo in Tula Province - 1911, Poltava.*
*Painter. Genre, historical works, landscapes, portraits.*

Studied in St. Petersburg at Academy of Arts (1853-1862), primarily with A.T. Markov. As an Academy fellow visited Germany, France, Italy and Spain. Lived in Paris, Rome and Florence (1863-1869). Received title of Academician (1870). Full member Academy of Arts (1893). Made several trips to Western Europe. Took part in Academy, Wanderers, and All-Russian exhibitions (1882, 1896), Universal in Paris (1878, 1900), International in Chicago (1893) and Copenhagen (1897) and others. Lived and worked in St. Petersburg, Moscow, Kharkov, Poltava (late 1880s). Member Petersburg Society for the Promotion of Artists (1862).

Initiator, founding member and leading figure of Association of Traveling Art Exhibits, for many years one of its leaders. Participant in forty Wanderers exhibits.

## MIKHAIL VASILEVICH NESTEROV

*1862, Ufa - 1942, Moscow.*
*Painter. Portraits, genre, landscapes, religious painting.*

Studied at Moscow School of Painting, Sculpture and Architecture (1877-1881 and 1884-1888) with V.G. Perov, A.K. Savrasov, I.M. Prianishnikov, at Petersburg Academy of Arts (1881-1884) with P.P. Chistiakov. Received title of Academician (1898). Honored Art Worker of the RSFSR (1942). Participant in exhibits: Association of Traveling Art Exhibits, "World of Art" association, 36 Artists, Union of Russian Artists (founding member) and others. Visited Italy, France, Austria, Germany, Greece, Turkey. Lived in Moscow, in Kiev 1890-1910. Member Association of Traveling Art Exhibits (from 1896, first shown 1889).

## NIKOLAI VASILEVICH NEVREV

*1830, Moscow - 1904, Moscow.*
*Painter. Genre, historical themes, portraits.*

Studied at Moscow School of Painting, Sculpture and Architecture (1851-1856) with M.M. Skotti. In 1859 received title of Artist. Lived and worked in Moscow. Taught at Moscow School of Painting, Sculpture and Architecture (1887-1890).

Member Association of Traveling Art Exhibits from 1881, active participant in Association exhibits. Took part in exhibitions of Academy of Arts, Moscow Society of Art Lovers, All-Russian (1882, 1896).

## VASILII GRIGORIEVICH PEROV

*1834, Tobolsk - 1882, Moscow.*
*Painter, draftsman. Genre, portraits, historical*
*themes.*

Studied at Arzamas School of Painting with A.V. Stupin (1846-1849), then at Moscow School of Painting, Sculpture and Architecture (1853-1861) with E.Ya. Vasiliev, M.I. Skotti, A.N. Mokritsky, S.K. Zarianko. Academy of Arts fellowship holder in France (1862-1864). Received title of Academician in 1866; Professor in 1870. Lived and worked in Moscow. Traveled to the Urals and the Lower Volga in 1873. Taught at Moscow School of Painting, Sculpture and Architecture (1871-1882). Founding member (1870) of Association of Traveling Art Exhibits, participating in exhibits until 1878.

Took part as well in Exhibitions of Moscow Society of Art Lovers, Academy of Arts, All-Russian (1882) and Universal and International Exhibitions in Paris, Vienna, London.

## VASILII DMITRIEVICH POLENOV

*1844, St. Petersburg - 1927, Borok estate*
*(now Polenovo) in Tula Region.*
*Painter, draftsman, watercolor artist.*
*Landscape, genre, historical and religious subjects.*

Studied at Academy of Arts in St. Petersburg (1863-1871) and simultaneously at Law Faculty of Petersburg University. Academy of Arts fellowship holder in Italy, France (1872-1876). Lived in St. Petersburg (1863-1871), and on Borok estate in Tula Province (from 1892). Traveled three times to the Near East and to Greece, (1881-1882, 1899, 1909). Visited France (1867,1889), Italy (1888-1884, 1894-1895).

In 1876 received title of Academician; Professor in 1892; full member of Academy of Arts in 1893. Taught at Moscow School of Painting, Sculpture and Architecture (1882-1895), Member Association of Traveling Art Exhibits. People's Artist of the Republic (1926).

Took part in exhibitions of Academy of Arts, Moscow Society of Art Lovers (1882, 1896), Universal and International Exhibitions in Paris, Berlin, Munich.

## ANDREI ANDREEVICH POPOV

*1832, Tula - 1896, Nizhnii Novgorod*
*(now Gorky).*
*Painter. Genre, portraits.*

Studied at Academy of Arts in St. Petersburg intermittently (1846-1860) with M. Vorobyov, B. Villevalde. Academy fellowship holder in Germany, Belgium, France, Italy, (1863-1868). Took part in many exhibits in the 1860s and 1870s. In late 1860s was close to I.N. Kramskoy and his Artists' Cooperative Workshop. Was not a member of the Association of Traveling Exhibits. Took part in exhibits of the Academy of Arts.

## ILLARION MIKHAILOVICH PRIANISHNIKOV

---

*1840, village of Timashovo in Kaluga Province - 1894, Moscow.*
*Painter. Genre.*

Studied at Moscow School of Painting, Sculpture and Architecture with S.K. Zarianko and E.S. Sorokin (1856-1866). Taught at Moscow School of Painting, Sculpture and Architecture (1873-1894). Full member Academy of Arts (from 1893). Participated in exhibits of Academy of Arts, Association of Traveling Art Exhibits, Universal Exhibitions in Vienna and Paris.

Lived and worked in Moscow. Founding member of Association of Traveling Art Exhibits (1870), member of Board in Moscow branch of Association. Member Moscow Society of Art Lovers.

## ILYA EFIMOVICH REPIN

---

*1844, Town of Chuguyev in Kharkov Province - 1930, Kuokkala (now Repino, near Leningrad), Finland.*
*Painter, master draftsman, watercolor artist, illustrator, etcher, lithographer. Portraits, genre, historical subjects.*

Studied at Academy of Arts in St. Petersburg (1864-1871). Academy of Arts fellowship holder in Italy, France (1872-1876). In 1876 received title of Academician. Lived in Chuguyev (1876-1877), Moscow (1877-1882), St. Petersburg (1882-1900), after 1900 in Kuokkala. Made many trips throughout Russia and Europe (1883, 1889, 1900, 1911).

Professor and Head of Studio at Higher Art School of Academy of Arts (1894-1897), rector (1898-1899), also taught at private school-studio of Princess M.K. Tenisheva in St. Petersburg. Member Association of Traveling Art Exhibits from 1878-1891, 1897. Shown at Association exhibits from 1874. Took part in exhibits of the "World of Art" association; in exhibits of Academy of Arts, Moscow Artists Society, All-Russian (1882,1896), Universal and International Exhibitions in Paris, Vienna, London, Berlin, Munich, Venice, Chicago, Rome.

## ANDREI PETROVICH RIABUSHKIN

---

*1861, village of Stanichnaya Sloboda in Voronezh Province - 1904, Divdino estate near Lyuban station in Petersburg Province.*
*Painter. Historical subjects, genre.*

Studied at the Moscow School of Painting, Sculpture and Architecture (1875-1882) with V.G. Perov and I.M. Prianishnikov and at Petersburg Academy of Arts (1882-1890). Participant in exhibitions: Association of Traveling Art Exhibits, 36 Artists, "World of Art" association and others. Traveled a great deal to old Russian cities. Lived in St. Petersburg. Shown at Association of Traveling Art Exhibits since 1891.

## KONSTANTIN APOLLONOVICH SAVITSKY

---

*1844, Taganrog - 1905, Penza.*
*Painter, draftsman, engraver, illustrator. Genre.*

Studied at Petersburg Academy of Arts (1862, 1867-1873), with L.F. Lagorio and A.E. Beideman as mentors (1863-1867). Lived and worked in Paris; summered in Auverny and village of Veules in Normandy (1874-1875); full member Academy of Arts (1895), received title of Academician (1897). Taught in St. Petersburg at Baron Stieglitz' School for Technical Drafting (1883-1889), at Moscow School of Painting, Sculpture and Architecture (1889-1891) and at Penza Art School (1897-1905). Founder and director of that school (1897) and creator of Penza Art Museum (1898). Participated in exhibits of the Academy, the Wanderers, the Society of Russian Watercolor Artists, the All-Russian Exhibits (1892,1896) the Universal in Paris (1878). Lived in Dinaburg (Latvia), St. Petersburg, Moscow (from 1891) and Penza (from 1897).

Member Association of Traveling Art Exhibits (1878, shown from 1872).

## ALEKSEI KONDRATEVICH SAVRASOV

---

*1830, Moscow - 1897, Moscow.*
*Painter. Landscape artist.*

Studied at Moscow School of Painting, Sculpture and Architecture (1844, 1848-1857) with K. Rabus. Received title of Academician in 1854. Taught at Moscow School of Painting, Sculpture and Architecture (1857-1882). Lived in Moscow. Visited London, France, Switzerland and Germany in 1882.

Founding member Association of Traveling Art Exhibits in 1870. Took part in Association exhibits from 1881.

Participated as well in exhibitions of Moscow Society of Art Lovers, All-Russian exhibition and Universal Exhibition in Paris (1878).

## VALENTIN ALEKSANDROVICH SEROV

---

*1865, St. Petersburg - 1911, Moscow.*
*Painter, draftsman. Landscapes, portraits.*

First studied painting with I. Repin, at various times between 1874 and 1880. Studied at Academy of Arts (1880-1885) with P. Chistiakov. Traveled to Germany, Holland, Belgium in 1885. Lived in Moscow. Taught at Moscow School of Painting, Sculpture and Architecture (1897-1908). Member Association of Traveling Art Exhibits from 1894, participated in Association exhibits from 1889. After 1889, participated in exhibits of "World of Art" association.

Also took part in exhibitions of Moscow Society of Art Lovers, Moscow Artists Association, All-Russian Exhibition (1896) and International Exhibitions in Berlin and Rome.

## IVAN IVANOVICH SHISHKIN

*1832, Elabuga in Viatka Province -
1898, St. Petersburg.
Painter, draftsman, engraver. Landscapes.*

Studied at Moscow School of Painting, Sculpture and Architecture (1852-1855) with A.M. Mokritsky and at Petersburg Academy of Arts (1856-1860), which he completed with a gold medal award. As an Academy fellowship holder, traveled abroad (1862-1865) and lived in Germany and Switzerland. Worked in Zurich at the studio of P. Koller (1863), did studies in the Teutoburg Forest (1864), lived one year in Düsseldorf (1864-1865). Received title of Academician (1865); of Professor (1873). Full member Academy of Arts (1893). Headed landscape studio at Academy's Higher Art School (1894-1895, 1897). In addition to many exhibits at home, took part in Universal Exhibitions in Paris (1867, 1878), London (1872), Vienna (1873) and others. Lived in St. Petersburg.

Founder and active member Association of Traveling Art Exhibits. Member Society of Russian Watercolor Artists (1871). Member Moscow Society of Art Lovers (1866).

## VASILII IVANOVICH SURIKOV

*1848, Krasnoyarsk - 1916, Moscow.
Painter, watercolor artist. Historical works, portraits.*

Studied at Academy of Arts in St. Petersburg (1869-1875) with P.P. Chistiakov. Lived and worked until 1876 in St. Petersburg, then in Moscow. Traveled regularly to his home in Siberia. Traveled to the Don, Volga, Crimea in the 1890s. Visited Germany, France, Italy, Austria (1883-1884), Switzerland (1897), Italy (1900), Spain (1910).

Member Association of Traveling Art Exhibits from 1881, left Association in 1907. Participated in exhibitions of Union of Russian Artists (1908-1915), Academy of Arts, Moscow Artists Association, and All-Russian Exhibitions (1882, 1896).

## SERGEI IVANOVICH SVETOSLAVSKY

*1857, Kiev - 1931, Kiev.
Painter. Landscapes, genre.*

Studied at Moscow School of Painting, Sculpture and Architecture (1875-1883) with V.G. Perov, A.K. Savrasov, V.D. Polenov. Lived and worked in Moscow (1875-1883, 1890-1893) and Kiev (1884-1889, 1894-1931). Late 1890s and early 1900s as well as in 1910, traveled to Central Asia, visiting Bukhara, Samarkand, Ashkhabad and the Altai Mountains.

Member Association of Traveling Art Exhibits from 1891, participated in Association exhibits from 1884. Shown at "World of Art" exhibits.

Also took part in exhibitions of Moscow Artists Society, All-Russian Exhibition (1896), International Exhibitions in Berlin, Munich and Venice.

## APOLLINARII MIKHAILOVICH VASNETSOV

*1856, village of Ryabovo in Vyatka Province - 1933, Moscow.*
*Landscape artist, historical painter, scenic designer. Author of works on the history of Moscow and on art theory.*

No formal art studies. Engaged in painting independently and under the guidance of his brother, V.M. Vasnetsov (1872-1875), consulted I. Repin, V. Polenov. Received title of Academician (1900).

Taught at Moscow School of Painting, Sculpture and Architecture (1901-1918). Lived in Moscow.

Member Abramtsevo art circle, Association of Traveling Art Exhibits (from 1888), participant in "World of Art" association (1899), founding member Union of Russian Artists (1903), also took part in exhibitions of Moscow Society of Art Lovers.

## VIKTOR MIKHAILOVICH VASNETSOV

*1848, village of Riabovo in Viatka Province - 1926, Moscow.*
*Painter, graphic artist. Historical, genre subjects, and Russian folk tales. Worked in monumental genre, scenic design, decorative applied art, and in a number of architectural projects.*

Studied at Academy of Arts in St. Petersburg (1868-1874). Visited France (1876), Italy (1885). Received title of Professor in 1862. Full member Academy of Arts from 1893, left Academy 1905. Took part in restoring frescoes at St. Vladimir Cathedral in Kiev (1885-1896).

Member Association of Traveling Art Exhibits from 1878, participated in Association exhibits from 1874. Participated in exhibitions of Academy of Arts, All-Russian Exhibition, Universal and International Exhibitions in Paris, Vienna, Berlin.

## SERGEI ARSENEVICH VINOGRADOV

*1869, village of Bolshiye Soni in Yaroslavl Province - 1938, Riga.*
*Painter, book illustrations. Landscapes, genre, portraits.*

Studied at Moscow School of Painting, Sculpture and Architecture (1880-1889) with V.D. Polenov, V.E. Makovsky, I.M. Prianishnikov, E.S. Sorokin. Studied at Academy of Arts with B.P. Villevalde and K.B. Venig in 1889. Taught at Stroganov Industrial Arts School in Moscow from 1896-1913. Received title of Academician 1912; from 1916 on full member Academy of Arts. Member Association of Traveling Art Exhibits 1899-1903; member Union of Russian Artists 1903-1924.

Took part in exhibitions of Academy of Arts, Moscow Society of Art Lovers, "World of Art" association.

## EFIM EFIMOVICH VOLKOV

---

*1844, St. Petersburg -1920, Petrograd.*
*Painter, draftsman. Landscape artist.*

Auditor Academy of Arts in St. Petersburg (1867-1870). Received title of Academician in 1899; full member Academy of Arts from 1895. Lived and worked primarily in St. Petersburg.

Member Association of Traveling Art Exhibits from 1879. Took part in Association Exhibits from 1878. Also participated in exhibitions of Academy of Arts, Moscow Society of Art Lovers, All-Russian Exhibitions, Universal Exhibition (Paris, 1900).

## NIKOLAI ALEKSANDROVICH YAROSHENKO

---

*1846, Poltava - 1898, Kislovodsk.*
*Painter. Genre, portraits, landscapes.*

Born to a military family. Studied drafting at Poltava Officers School with I.K. Zaitsev. In St. Petersburg studied with A.M. Volkov, at Drawing School of the Society for the Promotion of Artists with I.N. Kramskoy (1868) and at Academy of Arts (1868-1874). Graduated Mikhailov Artillery Academy (1870), appointed army engineer. Traveled to Western Europe, Near East, to the Urals, the Volga, the Caucasus and the Crimea. Retired with rank of major-general in 1892. Lived and worked in St. Petersburg and Kislovodsk during the 1880s.

Member Association of Traveling Art Exhibits (1876), became its head after death of I.N. Kramskoy.

# Art Criticism

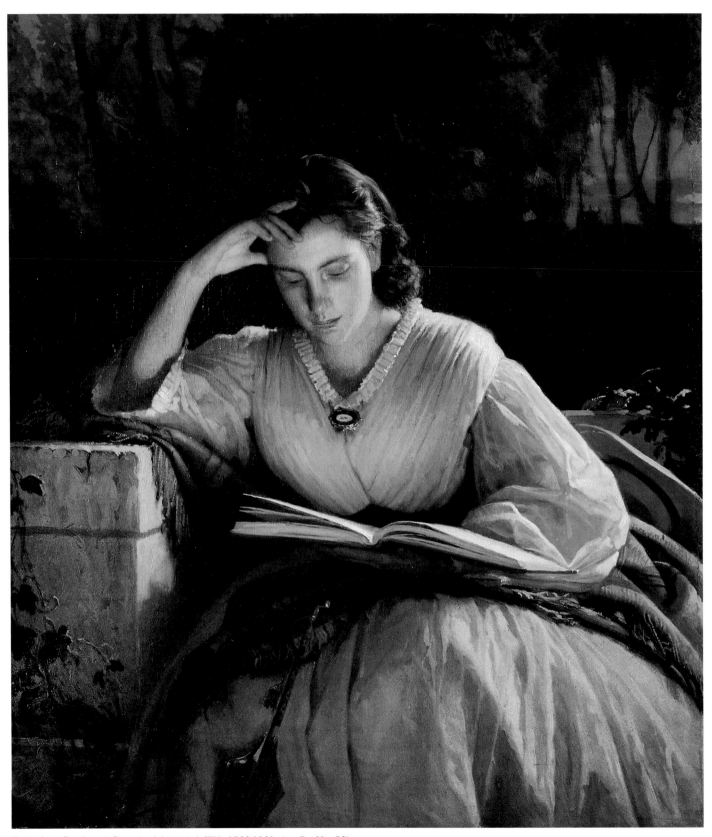

Kramskoy, *Reading. A Portrait of the Artist's Wife,* 1866-1869. (*see* Cat No. 23)

# Russian Art Criticism
## of Ideological Realism

BY IRINA SHUVALOVA

The second half of the nineteenth century saw the development and widespread acceptance of a new kind of art criticism; its foremost proponent was Vladimir Stasov, an ardent spokesman for ideological-realist art. Just as Russian painting, in striving for a deeper psychological realism, came to be acknowledged as the expression of high democratic ideals in the period from the 1860s through the 1880s, so did the criticism it inspired acquire a unique form and social importance.

Brought to life by the new art and in turn exerting an undeniable influence on it, this new criticism gained great authority, forcing advocates and detractors alike to take notice. For, despite being basically descriptive, dryly expository, and insufficiently analytical of art's technical aspects, this criticism made its impact felt in the art community because of its combative spirit, programmatic content and ideological conviction.

The writings of well-known contemporaneous critics, men of letters and the artists themselves, excerpted below, are meant to give a general idea of the *new* criticism of that period. When ordered chronologically, these excerpts give us a sense of the art discourse of the time as a journalistic genre, as a way of looking at pictures through their content or ideas, and as activist, aggressive polemics. All this was dictated by the fierce, relentless struggle of two cultures – the one democratic in outlook and aspiration, the other conservative, supported by the official circles that favored academic Salon art.

It is only natural that Vladimir Stasov should figure so prominently here. A talented and erudite critic in the truest sense of the work, his name is inseparably bound up with the Wanderers, whose tireless advocate he was for so many years. Already in the 1860s, his vigorously expressed opinions on Realist art in its first sharp clashes with academic art, and his unceasing controversy with all those who stood in its way, proved formative for the subsequent development of Russian painting.

From Stasov's voluminous writings we have chosen extracts in which he expresses a major theme of all his criticism – the ideas of populism in art and realism – and encapsulates his views on the art of the times. No less interesting is his own distinctive manner of writing: it is lively and spirited and engages the reader directly in Stasov's position as he hotly contests those who disagree with him. In his reviews of the Wanderers' exhibitions, this apologist and ideologue of the new Russian school of painting gives us impassioned and consistent impressions of the major and minor events in the country's artistic culture over a period of more than three decades. Excerpts are provided as well from two of Stasov's major essays written in the 1880s: "Twenty-five Years of Russian Art" and "Obstacles to New Russian Art." By then the Wanderers had gained wide renown and their largest following. But their success had also aroused fierce counterattacks in the conservative press in support of the Academy of Arts, which was trying to undermine the Wanderers' popularity by various means, including its own rival traveling exhibits. Hence, it was all the more important to defend the new style of painting against obtuse, uninformed and often scurrilous misinterpretations that derided

the significance of realism. This Stasov did with great zest and persuasiveness.

Adrian Prakhov was another influential expositor of the new art, especially through his reviews which appeared in the journal, *Pchela (The Bee)*, in the 1870s. A learned art historian and close friend of many of the Wanderers, his perceptive criticism is exceptional for providing a broad view of the development of realism in its several stages and for the serious analysis of the purely artistic worth of individual paintings.

Major Russian authors frequently wrote critical reviews of the Wanderers' exhibitions for periodical publications, thereby contributing their authority and support to the new realist art. We include some reactions to works in the first Wanderers' exhibition by the satirical novelist Mikhail Saltykov-Shchedrin, drawn from an essentially theoretical article in which he formulated what he thought the new Russian art should accomplish. Pride of place in the history of this era's criticism must, however, be given to the views of leading Wanderers themselves. Notable are the occasional remarks of such major painters as Ilya Repin, Vasilii Perov, Nikolai Ge and, foremost, the extensive writings of Ivan Kramskoy, who was acknowledged by his fellow artists for his role as an inspirational teacher and mentor, a sensitive critic, and the creator of the theoretical foundations for the new movement. The writings of these artists are imbued with a heightened feeling of social obligation, which distinguished the best representatives of the democratically-minded intelligentsia of the day. To be sure, the critical talent, insight, and depth of judgment of Repin and other artists were not duly appreciated until later, for it was their own creative work that played the major role in establishing the art of critical realism and supporting the principles of commitment and populism in art.

From later critics we provide some views by S.S. Golgoushev, a doctor by profession, but also a draftsman and art expert, and by the painter A.A. Kiselev, a regular correspondent for the Moscow journal *Artist*, which was popular in the early 1890s. Although their initial concerns rang in unison with Stasov's, both pay increasing attention in their many later articles to matters purely of artistic technique as well as to general aesthetic problems. Even Kiselev, one of the older generation of the Wanderers who always reiterated his devotion to their ideals, nevertheless occasionally betrays a shift from the movement's original ethos. "The naive obviousness of a trend devoid of any artistic element, both in terms of subject and technical execution," he wrote, "only leads to boredom, like an old discarded textbook containing long-known scientific truths..."[1] And N.V. Dosekin went further as he called for "evaluating the artist in an artist, and not the publicist."[2]

Published criticism of this sort in *Artist* reflected the changes that were occurring in the Wanderers' movement. The 1890s were a difficult period for the Association of Traveling Art Exhibits, characterized by crises in the creative work of many members of the older generation, a marked decline in the overall quality of the shows, and serious internal discord due to the restive assertiveness of younger members chafing under the by-now traditional outlook of the group.

Moreover, a group of young artists of more radical leanings in St. Petersburg gathered around the journal *Mir Iskusstva (World of Art)*. It put forward a new artistic program, declaring its rejection of the Wanderers as an outdated historical stage. While welcoming the "release from the chains of the Wanderer movement,"[3] Alexandr Benois, in his polemical fervor, was not always fair in his judgments. But he does pay tribute to the talent of the famous masters: Repin first and foremost, Vasnetsov, Surikov, and particularly such younger artists as Serov, Nesterov and Levitan, about whose work Benois is especially incisive and perceptive. Benois's writings, it should be noted, demonstrate new qualities that emerged in twentieth-century art criticism. He and others attempted to

1 Artist, *1893, No. 32, p.147*
2 Ibid, *No. 31, p.101*
3 Russian School of Painting, *1904, p. 86*

penetrate the artist's world, to discover the artist by analyzing his means of expression, evaluating his innovative features and relating them to both tradition and the present. Although discernible in Kramskoy and Prakhov, this approach blossomed in *World of Art*, which cultivated the critic-as-creator with his subjective evaluations and broad knowledge of European art.

Needless to say, the processes underway in art criticism at the turn of the century, affected as they were both by radically new departures in art and by the fierceness of the ideological struggle within the creative intelligentsia, were much more complex than can be shown through the few excerpts provided here. The problems with art criticism in the latter part of the nineteenth century need further investigation; our purpose here has been to indicate the progressive line and its valuable essence.

SELECTED EXCERPTS

*V.V. Stasov 1863*

There are works of art which the crowds approach, not to criticize, not to philosophize, not to challenge, not to prove something, not to remember what they have read twenty years ago and have already forgotten, but rather to greet as a friend, a relative, or a prized personal possession, extending a warm hand and a full heart. I am not talking here about a painter or his art, not about whether he is a great master or how he performs all the various fancy techniques which have to be properly contrived; but quite simply about every individual going up to a canvas and seeing it as something where he is master and judge, where he observes his own world, his own life, and where he can see what he himself knows, thinks and feels.

This alone is genuine art, where people feel comfortable and actively involved; for art should respond only to real feelings and ideas, and should not be served up like some tasty dessert one can well do without. And yes, now we do have such art, authentic, genuine and not trivial; it has arrived, of course, after long years of scarcity, pretense, and imitation...

1863 Academic Exhibition
V.V. Stasov. *Selected Works*, Moscow-Leningrad, 1950
Vol. 1, pp. 45-46.

*V.V. Stasov 1869*

The art of painting in our country now has to take two important steps. As far as technical performance is concerned, we should have more vibrant and warmer colors...As for content, our school of painting now has to accomplish the following: become more serious than before, and delve even more deeply into some subjects while replacing others, sometimes too insignificant, anecdotal, trivial and superficial, with scenes of more substance, in which profound spiritual events and important conflicts involving people, interests and personalities might provide a new meaning never suggested before.

Our artistic affairs
V.V. Stasov, *Collected Works*, St. Petersburg, 1894
Vol. 1, part 2, p. 204.

*I.N. Kramskoy 1875*

The search for reason and for meaning is a means of self-torture; the best thing is to look for neither the former nor the latter. It should be a natural part of one's nature. It should be a note that rings spontaneously, not intentionally, but organically. That is all you have to do, and no more! And that is all I can do. The world is already beautiful enough for me: what is the point of pondering it further? I say that this is part of the Slavic nature. I say that this characteristic appeared in Russian art long before it was launched as a movement. And when it is natural (and it is natural), it bursts forth inevitably, irresistibly. Whether you like it or not, that is how it will be, that is how it has to be. Even if the whole world were to disagree!

Letter to I.E. Repin of May 16, 1875.
*Kramskoy on Art*, 1988, p. 126.

Kramskoy, *Self-Portrait*

*I.N. Kramskoy 1880*

I am for a national art, I think that art can only be national. There has never been any other kind of art anywhere, and if a so-called universal art exists, it is only because it was the expression of a given nation at the forefront of world development. And if some day, in the distant future, Russia is called upon to occupy such a position among nations, then Russian art, deeply national as it is, will become universal.

    Fate of Russian Art. 1880

    *Kramskoy on Art*, 1988, p. 40

*I.N. Kramskoy 1884*

Only a feeling for the public gives an artist the necessary strength and increases his strength ten-fold; only intellectual surroundings he finds familiar and healthy can raise his individuality to the level of pathos and integrity, and only the artist's conviction that his work is essential and cherished by the public can help bring about the exotic growths we call paintings. And only a painting like this will be the pride of the race, of those living today and of their ancestors.

    Letter to V.V. Stasov, April 30,1884

    *Kramskoy on Art*, 1988, p. 119

*I.N. Kramskoy 1886*

I have been thinking about the tendentiousness of art...what I mean by that is the following attitude of the artist towards reality. An artist, as a citizen and a human being, apart from being an artist, living as he does at a particular period of time, inevitably loves some things and hates others. We assume that he loves what is worthwhile, but hates what deserves to be hated. Love and hate are not the essence of logical conclusions, but feelings. Art only has to be sincere, for it to be tendentious.

    Letter to A.S. Suvorin, February 26, 1886

    *Kramskoy on Art*, 1988, p. 44.

*I.E. Repin 1874*

The human being, the soul, the drama of life, the influence of nature, its life and purpose, the meaning of history – these are our subjects in my view; our colors are our tools, they must express our ideas, (and) our color scheme is not made up of graceful brush strokes, but must express the mood of a picture, its soul, it must engross and encompass the viewer entirely, like a chord in music...

    Letter to I.N. Kramskoy, March 31, 1874

    *Repin on Art*, Moscow 1960, p. 140.

I.E. Repin

## I.E. Repin 1877

I greatly enjoyed the Tretiakov gallery. It is of enormous interest for its contents, and for the ideas of its painters. Nowhere, nor in any other school of art, have I been so seriously absorbed by the imagination of each and every artist!... We can definitely say that an enormous future lies ahead for the Russian school. It produces little, but what it does produce is profound and robust, and in this regard we cannot judge by quantity alone – that is for other schools, working mechanically, without interruption...(some of the lack of painting skill only proves that our school is still inexperienced).

Letter to V.V. Stasov, April 9, 1877.
*Russian Art Criticism in the late 19th and early 20th Centuries. A Reader*, Moscow 1977, p. 368.

## I.E. Repin 1883

I cannot achieve my art spontaneously. Making attractive rugs, weaving lace, keeping up with the latest styles – in a word, making an omelet of God's gift, adapting to new trends... No, I am a man of the '60's, old-fashioned, and for me the precepts of Gogol, Belinsky, Turgenev, Tolstoy and the other idealists have not yet died. In all my insignificant, trivial endeavors I try to base my ideas in truth; life around me distresses me too much, gives me no peace, and begs to be put on canvas; reality is too shocking for one calmly to weave out designs – let us leave that to well-bred young ladies...

Letter to I.N. Kramskoy of November 30, 1883
*Repin on Art*, Moscow 1960, p. 26.

## M.E. Saltykov-Shchedrin 1871

This year marks a magnificent event in Russian art: several Moscow and Petersburg artists have formed an association with a view to organizing traveling art exhibitions to cities throughout Russia. This will mean that the works of Russian art, hitherto confined to St. Petersburg alone, within the walls of the Academy of Arts, or buried in private galleries and museums, will become accessible to all the inhabitants of the Russian Empire. Art will no longer be a secret, will no longer separate the initiated from the uninitiated, and it will address everyone and acknowledge the right of all to evaluate its achievements... The first exhibition, which has opened in St. Petersburg in the halls of the Academy of Arts, was indeed a most satisfying one. There are not many paintings, but each of them is a pleasure to stop by and view. One is inevitably reminded of the masses of painted decorations which used to blinding our eye, before one began to seek at least some point on which to rest one's gaze...First of all, we find here a

painting by professor Ge, *Peter the Great Interrogating His Son.* We see before us only two figures and a very simple scene with nothing to assault the eye. Peter the Great is not standing at full height, he is not reaching out, is not waving his arms, is not glaring at us; he is seated in an armchair without even the slightest gesture or threatening manner, and not one muscle of his face is reduced to trembling. The Tsarevich Aleksei is not down on his knees, his face contorted with horror, he is not pleading for mercy, nor is he waving or wringing his hands, but simply, at first glance, is even standing quite calmly before his father, a table between them, with his head somewhat bowed. Nevertheless, anyone who has seen these two simple, modestly depicted figures, would have to confess that he had witnessed one of those horrifying tragedies we never forget. This is where the secret of art lies, in that the drama should be clear in itself, that it should have sufficient content, regardless of the external devices used by the artist, regardless of fallen tree-trunks, broken chairs, scattered papers etc....

Two paintings by Prianishnikov *Victims of a Fire*[4] and especially *Peasants Returning Home from the City Empty-handed*[5] are minor jewels of which the exhibit can be rightly proud. Each painting by this highly gifted artist is a slice of life, so moving that the viewer unwittingly becomes a direct participant in what he sees before him. In spite of the grim, bland background of *The Empty-Handed* (a long wintry road), it is difficult to take your eyes off the picture. Each of us, of course, has on hundreds of occasions passed by scenes exactly like the one depicted in *The Empty-Handed* and each of us, no doubt, has reacted in his own way to such a sight, but these impressions were so fleeting and vague that we remained indifferent. Mr. Prianishnikov makes it possible for us to confirm these impressions. You see before you shabby sleds, bedraggled, small peasant horses, on which

torn harnesses jingle and rustle; you see a seminarian in an overcoat which does not at all protect him from the cold, and who, huddled in the sled, is obviously tormented by one question: will he make it or will he freeze to death along the way? – you see all this, and since the scene does not take you by surprise, you have every opportunity of penetrating that innermost essence which had eluded you until now. This ability to draw the viewer's attention inward shows a talent full of energy, and Mr. Prianishnikov has a great deal of such energy.

The First Russian Traveling Art Exhibit.

*Russian Progressive Art Criticism of the late 19th and early 20th Centuries. A Reader,* Moscow, 1977.

*A.V. Prakhov 1878*

Our social genre has so far been much too close to literature, it said far too much, too earnestly, and portrayed things too inadequately. Like a newcomer just recently allowed full-fledged membership in society, it has itself become somewhat overwhelmed, confined to small-scale, minor themes and forms of expression, trying its utmost to intrigue, amuse or disturb with its modest tale. This trend must come to an end!... The end is here with the appearance of *The Barge Haulers*[6], where simple figures of our time, indeed from a most neglected social class, whom some consider the dregs of society and others, the very roots of that society, have been acknowledged and portrayed with such love, with such seriousness and reverence, that you would think that you were looking at figures from the greatest of religious legends.

Throw off the blindfold of ingrained artistic prejudice, open your eyes to the outside world, and you will be astounded by the untold wealth of all that is beautiful in life and nature. A simple, minor brush stroke which you earlier

4 *Location unknown*
5 *State Tretiakov Gallery*

6 *c.f., I.E. Repin's painting* Barge Haulers on the Volga, *done in 1873. To be found in the Russian State Museum.*

regarded with condescension, or even with disdain, as something for your aesthetic constructs, will turn out to be so grandiose, so perfectly resolved and completed, that you will simply feel guilty and ashamed, and you will be disturbed not by the smallness of the brush stroke you have seen, or the figure from nature, but by a realization of your impotence when faced with the grandiose accomplishment that is this figure before you!...

The Sixth Traveling Art Exhibit at the Society for the Promotion of Art.
*Russian Progressive Art Criticism of the 19th and early 20th Centuries. A Reader*, Moscow, 1977, pp. 363-364.

*A.V. Prakhov 1878*

Truth, truth, truth!...What a magnificent word, and it rings throughout the entire exhibit, from all the nooks and crannies, from all the picture-frames, both large and small; ringing loud and majestically, albeit not entirely convincingly, a fascinating word thunders from these historical pictures, and simply but sincerely, it leaps forth from scenes of everyday life and local landscapes, capturing the very essence of the human heart, and like a mysterious seed, a token of new, better, more liberating relations – rises with each intelligent viewer to a life beyond, beyond the gilded frame of art. Out of the entire wide-ranging exhibition, which includes dozens of artists displaying some two hundred works of art, there is not a single outstanding piece whose author would dare openly lie about it to the viewer: and if anyone is lying, he is inspired by the greatest sincerity: there is just one word on everyone's lips, and, fortunately, on most everyone's mind – truth. Telling the truth in one's own special artistic language, even the naked truth – this is what should be seen as the final, even most important objective of all our Russian artistic forces ...

The aim of the artist who depicts everyday life, of the genrist, to be a historian...of his own time can be defined as follows: to seize upon, amidst the troubling and dizzying whirl of life today, those scenes and figures which by their very nature summarize an entire era. We must give credit to the Russian social genre: it has lived up to its task. With a host of talented painters, it is trying vigorously to enshrine in artistic terms the most important events and aspects of life as they unfold before their very eyes – a living testimony to its profound seriousness, its dedication to life, and the surest proof of its lofty ongoing achievements. As a chronicler of the momentous era of our generation, of a page in our history, on which a great word – liberation – is written large, it will find a wealth of material for the full picture it will have to draw in contemporary Russian art. However much we may describe the subject in all its detail, we will still not have a clear picture of it in our minds until we have seen it with our own eyes: a visual portrayal of the history of our time, presented in the latest Russian social genre, will enable the future historian to peek into every corner observed with such great love and sympathy by today's artist and human being. That historian, of course, will not fail to notice the significant fact that life among the upper classes of our society is totally absent from the current paintings on social themes, that this genre is not even willing to remain among city dwellers, but, in fact, treats the life of the Russian peasant with remarkable passion, and that it has, to use Turgenev's expression, "taken to plain living" down to the smallest detail...

There is no other type of art in Russia which has reached such a level of perfection, which has won such laurels outside Russia, as the landscape genre – this is self-evident. The Russian landscape had taken a decisive step onto the national scene, and the result is – and no one disputes this – that there is now a magnificent flowering of landscape painting of the Russian school.

Exhibition at the Academy of Arts of Russian Works Intended for the Universal Exposition in Paris.
*Pchela* (The Bee) 1878, No. 10, p. 154, No. 12, p. 190 No. 17, p. 262.

Repin, *Portrait of V.V. Stasov*, 1883

*V.V. Stasov 1878*

When the exhibit first opened, I said in *Novoye Vremya* (*New Times*) that, in my view, this was the best of all the exhibits by the Association thus far. Now that this exhibit has been completed, and, it would seem, there is nothing more to be added to it, I should like to document the truth of what I have said with facts.

Things are getting more difficult for the Association of Traveling Art Exhibits every year. Each and every time, something new comes up, which only makes matters worse. Either the Academy refuses to make its halls available for exhibition, thereby publicly demonstrating that it is not at all gratified by the initiative and success of these Russian artists who want to be independent and do what they like; or some special "Exhibition Society" emerges under the aegis of that same Academy, wishing to monopolize things and allocate all the exhibits to itself; or some members leave, with surprising explanations, and without any explanation at all, others die, and yet others – worse still – are still alive, but don't want to do anything. And so what of it! The Association, you see, doesn't care

a straw: it takes up and shakes off one challenge after another, and then stands as tall as before, vibrant, strong, and healthy, as if absolutely nothing had happened. It is, in fact, apparent that all the forces of Russian art are gathered here, each attracting the other, each looking after the other, and that they all know where they are going. And what a noble title all these young people have – an Association. What a fitting name they have chosen for themselves, what generous associates they are, standing shoulder to shoulder.

The current Wanderers exhibit, the sixth one by now, is third in terms of the number of works on display (the 1875 exhibition had 83 works, the 1874, 71, and the current one, 69, the 1871 exhibit had 47, the 1876 had 45, and the 1872, 44).

Furthermore, the current exhibit includes another 232 works by the late Association member K.F. Gun. The caliber and brilliance of the majority of the works now on display are such that every minute you could hear throngs of people expressing regret that this one or that one or yet another picture wasn't being sent to the Paris Universal Exposition as well. Yet the Association has said nothing in reply, but rather, I think, must have thought to itself: "What for? Why? We've already given quite enough to Paris. And what we are sending there is the very best, the greatest, the most important – and all of it ours. So what of it? We had better see to it that here at home, in the various regions of Russia, our own comrades and fellow-countrymen might see the talented and meaningful things we are doing. We have to start with our own people, the others will have their turn soon enough."

The Traveling Art Exhibit of 1878

V.V. Stasov, *Selected Works*, Moscow-Leningrad, 1950

Vol. 1, pp. 88-89.

*V.V. Stasov 1882*

Today's Russian artists are as passionate and selective in their choice of subjects and materials as yesterday's were indifferent in choosing theirs. Even though we could have suggested a hundred for each of them before dwelling on any one, this

one would be, without a doubt, national. For by now today's artists have lost interest in anything else ...One positive result of such honest national realism, which began in our country not as a fashion, but as a real requirement for the artist and society, has been the seriousness of our art...It seems to me that in future all other art forms will fade away and leave the stage, and all that will remain is that art form which is now being labelled "tendentious," but to which artists have so far contributed their best and most valuable efforts, their hearts and souls, and all they have managed to observe, grasp and comprehend.

"Twenty-five Years of Russian Art"–*Russian Progressive Art Criticism of the Late 19th and Early 20th Centuries. A Reader* Moscow, 1977, pp. 307, 310.

*V.V. Stasov 1885*
In our country art criticism has always been one of the most harmful obstacles to new art. It cannot be said that it has, in the final analysis, achieved its purpose – indeed, I hope to demonstrate below that this, fortunately, has not been the case, but that still, most often through its ignorance, lack of taste and narrow conservatism, criticism has managed to restrain, confuse and mislead many, many people. "And what do they say in the press?" – the majority of people normally ask, timidly waiting to be dictated to, and incapable of deciding for themselves. The verdicts of the press, if they are favorable and well publicized, often have a most decisive influence on the masses, but are also capable of leading them down God knows what garden path, when they hesitate or simply do not know what to make of this or that new event.

But the latest generation of artists has disregarded these retrograde sighs, unafraid of violating imaginary "artistic laws" and firmly going its own way. They are totally different from our earlier artists. They no longer felt apathy and squeamishness, they were not indifferent about what to paint, what to portray, or what goal to pursue in their creations.

They had a clear vision of their goal, and that goal did not correspond with their surroundings. They would not agree to draw, with a brush stroke full of lies, only imaginary joys and successes, triumphs and victories, refinement and smiles – they saw that real life, in most cases, was something altogether different, melancholy and painful, with its troubles and absurdities, and they began to depict this bitter truth on canvas. Not just the best and most significant of our new artists, but the majority of modern artists were, by nature, either tragedians or humorists, sometimes both – so it is understandable that they should no longer remain satisfied with the festive or complacent endeavors of their predecessors. Scornfully rejecting false and sham ideals, they sought truthfulness and honesty for their subjects, genuine figures, scenes and expressions with all their soul and talent. The latest generation of artists has been brought up on Gogol, Ostrovsky and Nekrasov, Belinsky, Dobrolyubov and Pisarev; literary and social themes have been replaced by such issues as "Who Is At Fault?" and "What Is To Be Done?" and the majority of compositions of the major European thinkers who were then available in Russian translation. Consequently, since their school days they have felt stifled and uncomfortable within the old school framework of the Academy, with its artificial limitations and guidelines for artistic creation, with its classical trimmings, based on antique statues, paintings by the old masters and assigned, musty subjects...

Naturally, the works of these new Russian artists have, to date, received a great deal of sympathy, good wishes, and even admiration, not only from the public, but also, at times, from critics as well. Hardly anyone has denied the talent of the best and most significant of our painters – for to state the contrary would be too scandalous and provocative. But dissatisfaction with these artists has always prevailed, in both public discourse and in statements by the press.

Today, just like twenty-five years ago, there are still those who accuse our artists of impudence, lack of skill, of indecency

and foolishness, of disdain for the West, a lack of a desire to learn, of choosing base, hideous subject matter, of a stubborn tendency towards subjects which are vile and offensive to "aesthetic tastes," and finally, of that notorious, horrifying "tendentiousness."

Obstacles to New Russian Art.

V.V. Stasov, *Selected Works*, Moscow-Leningrad 1950

Vol. 1, pp. 554, 570, 578

*V.M. Garshin 1887*

..."This one is good, and that one is bad" – we say with the complete conviction that our view of artists is by and large an appraisal of their qualities, and please note, primarily those based on technique. What we fail to understand is that no one is asking us for our views on matters of technique, and that the artist himself always knows where his technique is good, and where it is lacking. He is not asking us to give him grades for drawing skill, brush-strokes, color scheme and perspective. He would like us to look more deeply into our souls and see the reality which we so stubbornly avoid, and the impressions on which he has based his entire work, not bothering about contours and color schemes, but to see him, not as one painter to another, for a painter paints least of all for other painters or for critics, but only for himself (in terms of satisfying his own requirements) and for the public-at-large. What is the public in relation to the painter? How is he different from it? What I wish to express is, of course, a basic truth, but I believe it necessary to express it, if only for the sake of "transition," and I beg the indulgence of those who will say to me: we already know this without your having to tell us. The painter, as compared with the public, is a person who can better see and communicate to others what he sees. How many thousands of people pass by valuable source material for artistic creation every day, without noticing it, or see it without giving it further thought? The first thing which occurs to any person who has read or seen a great work of art is how life-like it is, how true, how familiar, and yet this is the first time I have seen it, become aware of it...Oh how pitiful our range of ideas would be, if we were presented only with our five senses and our brain processed only the food for thought they provided. Often a single powerful artistic image will inspire us more than what we have experienced over a lifetime; we are aware that the best and most precious part of us belongs not to us, but to that spiritual sustenance which the mighty hand of creation brings closer... The Exhibition of "The Association of Traveling Art Exhibits" is somehow an especially good one this year. It is difficult to imagine how an art form just barely out of its diapers, which has existed as an independent school for only thirty years or so, might produce such exhibits from one year to the next. Two fundamental works in this exhibit are the result of more than a year's work by Messrs. Polenov and Surikov [7], and I am not sure whether next year such major works will be brought to us by our other masters. I say this because it is quite possible that the 16th exhibition may present us with less interesting and less valuable intellectual content and that there will then be the inevitable moaning, repeated year in and year out, about the decline in Russian art, similar to the constant refrains sung twenty times a year by our press about the decline in Russian fiction, a refrain which has not ceased since Belinsky's time, a refrain to the sound of which our literature has advanced, flowered and moved to the forefront of European fiction. As in the first case, so in the second: people forget that art lives on not through individual exhibitions and individual books mentioned in the journals, but in entire eras, and that two or three major works are sufficient to brighten five or six years' time...

Notes on Art Exhibits.

*Russian Writers on Art*, Leningrad, 1976, pp. 210-211.

---

[7] *cf.*, V.D. Polenov's work Christ and the Sinner *at the State Russian Museum and V.I. Surikov's* Boyarina Morozova *from the collection of the State Tretiakov Gallery.*

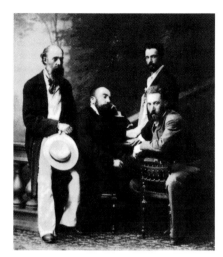

Artists (from left) N.E. Makovsky, Polenov,
V.E. Makovsky and Savitsky

*V.V. Stasov 1888*

They are trying to tell us that the current exhibit is moderately good, a "medium quality" exhibit. What kind of medium quality exhibit is it, with a painting like Savitsky's *Off to War*, several charming small paintings by Vladimir Makovsky and some marvelous works by Repin, and in addition to all this, a few wonderful works?

It is surprising how little value is placed on talent, and simply horrifying to see and hear it! So you stop and think: it is true that these people are not worth showing it to. Pearls before swine. The majority would, no doubt, be satisfied with something a hundred times inferior, as long as it was routinely pretty, graceful and pure, and did not disturb the mind or emotions, but only scratched the surface. Then everybody would be satisfied, not just the "critics," but many, many members of the public as well. All you have to do is listen to what they're saying at the exhibition, and what they write afterwards in the newspapers. All these conversations begin with one and the same thing: how a certain painting is "executed" and "completed" or "unfinished." By this, you are to understand whether the painting is sleek enough, or it is as colorful

as an illustration!... But just give this crowd *Off to War*[8] Savitsky's best creation, and they will remain indifferent to it, as they were once indifferent to that earlier magnificent painting of his *The Procession of the Miraculous Icon*. The fact is that we see here life-like human figures, from our own national experience, psychologically portrayed, it is true; the fact is that we have here tragic, disturbing scenes of farewell, fearless courage, the boisterousness of soldiers, the feminine grace and the beauty of the simple young Russian peasant girl; what naivete and simplicity in the old people and in the children, what movement, life, such varied agitation among the poor people, such irreconcilable interests and what truth in their expression do we see in Savitsky! All this is beyond most people; it goes unnoticed and does not attract attention. But why is this? This is because our "expertise" is too great, and each and every one of us feels it necessary to display it; yet there is essentially nothing to be displayed, inasmuch as all our tastes have been spoiled by so many sugary platitudes and fraudulent illustrations, on which we are being brought up – (illustrations are a veritable plague in modern European society)...

The 16th Traveling Art Exhibit.

V.V. Stasov, *Articles and Notes*, Moscow 1953
Vol.1, pp. 24-25.

*L.N. Tolstoy 1890*

This winter, a painting by N. Ge appeared at the St. Petersburg Wanderers Exhibition: Christ standing before Pilate, entitled *What Is Truth*, John XVIII, 38. Without mentioning the fact that the painting is the work of a great master (with a title of Professor from the Academy), an artist renowned for his paintings – the most marvelous one being *The Last Supper* – this painting, apart from its technical mastery, drew everyone's particular attention because of the forceful expression of its main theme and the innovative, honest manner in which the subject is treated. I believe it was Swift who once so rightly said that

8 *To be found in the State Russian Museum.*

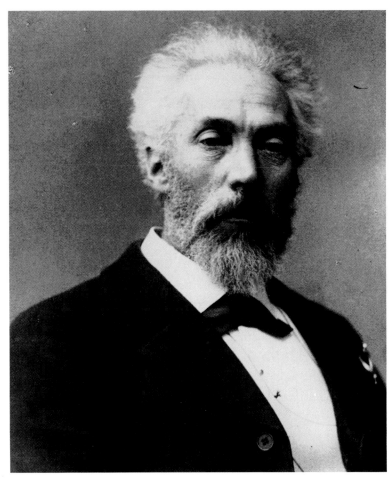

K.A. Savitsky

"we usually find that the best piece of fruit is the one at which the birds have been picking." And this painting has given rise to passionate attacks, and aroused the indignation of all the clergy and government people to such an extent that by order of the Tsar, it was withdrawn from the exhibition and forbidden to be shown. Now a certain lawyer by the name of Ilin (I do not know him personally) has decided to take the painting to America at his own risk and expense, and yesterday I received a letter to the effect that the painting has left. The reason for my letter is to draw your attention to what I feel to be a landmark painting in the history of Christian art and if it

has, as I am almost certain, the same effect on you as it has had on me, to ask you to help the American public in understanding it, in interpreting it...This painting is a milestone in the history of Christian painting because it establishes a new view of Christian themes. This is not the view of Christian themes as historical events, as has been the case so often and so fruitlessly, whereby Napoleon's abdication or Elizabeth's death were important only because of the fame of the individuals portrayed; for Christ, during his active life, was not only unimportant but unnoticed, and thus paintings from his life will never be historical paintings. A view of Christ as God has been the basis for many paintings, the most accomplished of which are now a part of the past. Genuine art cannot take this view of Christ today. Still, there are attempts nowadays to depict the moral precepts of the life and teachings of Christ. And these attempts have thus far proved futile. Yet Ge has found a moment in the life of Christ which is important to all of us today, and which is being repeated everywhere throughout the world, in the struggle for a moral, reasonable human awareness in our everyday life, with those committed to subtle and complacent, self-assured violence, suppressing this awareness. Yes, there are many such moments, and the impression made by the portrayal of these moments is very powerful and worthwhile.

Letter to George Kennan of August 8, 1890
*Russian Writers on Art*, Leningrad, 1976, pp. 183-185.

*S. Glagol (S.S. Goloushev) 1890*

The throngs of people who come to every art exhibit are presented with hundreds of paintings large and small in all types of frames, they quickly run from one painting to the next, and move from one conversation to another with the many acquaintances they meet; their attention is distracted, and they pause only in front of two or three of the most impressive pieces, and even then not for long, since they have to be in time for yet another exhibit or to shop for bargains. And before you, in this crowd of people, appears the fleeting

figure of the self-styled critic, and he, too, moves distractedly from one painting to the next, seeking out curiosities which he might be able to use for two or three clever comments and then hurrying to run through the remaining pictures he has not seen, in order to get down to writing and fulminating. Neither the public nor the reviewer has any connection with what preceded this exhibition and with how these paintings were created. They forget that each of these paintings is the fruit of long months of work, gnawing doubts and disappointments, and that each of these paintings represents an entire life expressed in the best possible manner, and if the reviewer approaches them without the love which inspired the artist himself, if he does not value art as the artist does, they will remain strangers to one another. Therefore, first of all, let us have some respect for these 98 paintings and these fifty-odd people who have dedicated themselves to the service of art. The overall verdict is that the current Wanderers exhibit is a poor one. And indeed, there is nothing in it which would draw a large crowd or be the talk of an entire city. There has always been such a lull at Wanderers exhibits after two or three years marked by major works... However, in spite of the absence of really major works, there are quite a few which cause visitors to pause and take notice.

...In conclusion, a few words remain to be said in general about the young people who are not members of the association and in ever greater numbers are being shown at the Wanderers exhibitions. Only ten years ago we saw that out of 20 members of the Association there were barely four non-members on display, whereas at this year's exhibit we see that there are already 35 works shown as against Association members. It is obvious that young people are growing increasingly fond of the Wanderers exhibits, despite the fact, for example, that the Academy of Arts is offering all kinds of advantages to exhibitors and the Academy is said to want to divert young people from the Wanderers. This is quite understandable. For each of these young artists, acceptance of his painting for a Wanderers exhibition is not merely another opportunity to show his work to the public and find a buyer as quickly as possible. Acceptance at the Traveling Art Exhibit is a kind of honor, sought after and anxiously awaited by every young artist, and this is because the selection of paintings for these exhibitions has always been extremely strict and objective. If the Wanderers exhibition wishes to retain its respected position, it will constantly have to be more demanding with regard to both its displays and its members.

Source Unknown

*V.V. Stasov 1891*

...The current Wanderers exhibition exceeds all previous ones in quantitative terms. Ever since the first Traveling Art Exhibit, which was in 1871, the number of works exhibited has grown every year. During the '70's it went from about fifty to a hundred, in the '80's from a hundred to a hundred-and-fifty, and in the '90's it has gone from a hundred-and-fifty to two hundred. This year 169 works have been presented, in addition to which an entire special hall has been set aside for a posthumous exhibit of the recently deceased "fellow" Wanderer A.D. Litovchenko... If there has been and continues to be an increase in the number of works presented, then this, of course, means that the number of new members has also grown and continues to grow. What better proof is there of the true value and significance of the original idea of the Association than its accessibility to the minds and hearts of all the recent Russian artists? Apparently, those ideas and concepts which guide the Association are cherished and needed by others as well. So all of them are flocking there, to this Association, at least all those who are among the finer, more talented and more intelligent...And it should be pointed out that there are more and more of them wishing to enter the Association, in spite of the fact that all these artists are fully aware that not everyone who so desires will be accepted into the Association, that the balloting is very strict and that quite a few artists and paintings have been rejected. This means that

there is something special, something enticing which has so strong an attraction for all our best young artists.

On the Traveling Exhibit.

V.V. Stasov, *Articles and Notes*, Moscow, 1954, pp. 25-26.

*V.V. Stasov 1892*

In all fairness, it can be said that there have been no truly significant artists who have not deemed it an honor and a real necessity to join the ranks of the Wanderers and add their strength to its collective voice...

The Association, regardless of the fact that it was founded with brush and pencil, is already unprecedented in its unity and membership, and would seem, at first glance, almost unthinkable. Here we have an association of people who are self-reliant, who do not expect nor do they ever ask for anyone's assistance, self-reliant, but never lacking in energy, daring and enthusiasm. Where and when have we ever seen anything like it here?... The Association of Traveling Art Exhibits is an unusual, incomparable exception of sorts. It alone in all of Russia has never lost its courage and energy, and has taken the same great, forceful strides ever since it began. And this for twenty years now!

The Twentieth Anniversary of the Wanderers

V.V. Stasov, *Selected Works*, Moscow-Leningrad, 1950

Vol. 1, pp. 281-282.

A.A. Kiselev

*A.A. Kiselev 1893*

...Primarily, art reviews are written here either by unsuccessful artists, or by untalented literary laymen. As a fortunate exception, we could only cite the rare articles on art by Garshin, Korolenko and Kramskoy, or, if you will, of Grigorovich, Matushinsky and others who have never been, except for the last, professional reviewers, but have written their articles sporadically, as a sideline. The majority of professional art critics, who fill the columns of newspapers and magazines with their recitations during the exhibition season, are people who are not only devoid of any artistic feeling, but also do not even like art, often even hating it...Our artists, of course, know the merits of these judges and blithely go forward, not paying any attention to this yelping. But the poor public, or better still, that small portion of it which cannot do without mentors, and needs to refer to the authoritative instructions of the press for their opinions and tastes, ends up confused and disoriented. Who should they listen to?... The extremist proponents of pure art usually believe that if the artist deals with moral or social topics in his work, and portrays the negative aspects of our public or private life, this is inevitably for practical purposes, for the sake of fashion or self-

aggrandizement and, seeing this as a trend, they regard such works as unworthy of art for art's sake. On the other hand, the utilitarians, while not denying that this trend may exist, give the artist much credit for this, believing that the pursuit of noble goals is not in contradiction with the quest for beauty but, rather, enhances it...I am told that the *The Barge Haulers* by Repin is a tendentious painting, because the artist, apparently, had a special purpose in presenting the horrifying spectacle of people forced by poverty and hunger to eternal voluntary slave labor. Such intentions, the aesthetes tell me, are surely tendentious. So then it would seem that this is not a work of art? Really? Yet everyone likes this painting so much! There is such life in it, such movement, such brightness! The barge haulers are living people; true, they have lost God's likeness and image, but this in fact is what things are really like, and I find that much more touching. I see in them people not of some other primitive race, not savages, not freaks, cheated by nature, but people the same as you and I, and only because of the circumstances of life for which we ourselves are responsible are they so cruelly separated from us! But this is, I am told, the very point of tendentiousness. Yet Repin is still a famous artist. But that should mean that there are aspects to him which are not tendentious. If I go through all his paintings in my mind, I discover to my horror that all his best works are tainted with tendentiousness...They mesmerize me with their depth, their lifelike quality and that profound truth which cannot be wrested from the soul of an artist.

Studies in Art.
*Russian Progressive Art Criticism of the Late 19th and Early 20th Centuries. A Reader*, pp. 660, 661, 667, 668.

*N. Dosekin 1894*

One's first impression is, indeed, sometimes clearer than subsequent ones, but the latter are almost always deeper and more thoughtful. The loftier and finer the artistic qualities of a work, the less value it has for us in terms of its subject. On the other hand, it has less power over us...for the painter sometimes has difficulty in determining whether some aspect he has depicted is really complete. In this regard he can be aided by a very old, well-known principle, but one somehow held in disregard: a painting should be completely understandable without its title. We have, unfortunately, seen a special fashion emerge in the quest for names: deep-sounding philosophical ones, coquettishly cute ones, dreamy-poetic ones and so on. This fashion has misled both the critics and the public. It is extremely rare that you meet a person who is capable of going up to a painting with a view to evaluating its artistic aspects as given by the artist; in the overwhelming majority of cases, the appraisal involves requirements which are prompted by reading the title of the painting along with its contents. If the idea of "nonsense" can be described as "profound," then this procedure must be one that is most profoundly nonsensical. Naturally it is applied only by aesthetically immature people, incapable of going farther than the factual aspect of what is depicted in the painting and hackneyed routine requirements, but artists themselves seem to have legitimized such approaches, providing their paintings with pretentious titles. The Wanderers exhibition of 1893 included a remarkably life-like portrait of a girl in a brown beret, a work by Repin. Unfortunately, instead of calling this painting a portrait of Miss X, the artist gave it the coquettish title of *Autumn Bouquet*. So then? This carelessly attached label, so-to-speak, has become the highest standard by which to evaluate the picture, providing some reviewers with the pretext for spouting all kinds of rubbish, while the painting skill and life-like expression, which might stand up to honest comparison with any of the portrait artists alive today, have gone unnoticed. Let us suppose that the lord of newspaper critics should be considered in a class by himself in matters of aesthetic judgment, but the example we have just given is also highly typical of the public, which is not at all accustomed to seeing in a painting the painting itself, that is, the work represented, but is still searching for the "subject" treated. Who else, if not we artists ourselves, is to teach the public to appreciate the painting in painting?

Narrative in Painting
*Artist*, 1894, No.36, pp. 105, 112-113.

*N. Dosekin 1894*

Here in Russia, it is only recently that an attempt has been made to see and appreciate a painting for itself, and not its literary element, for which the form and manner were merely a means of expression with no right to independent consideration except for their relation to content. There is now a desire to identify and express through painting those elements and combinations of external forms which in and of themselves are no less significant and valuable than the most noble and profound idea, in the fullest sense of the word. Moscow was the first to reflect this change in the understanding of painting and soon became the center for younger Russian artists...let us proceed directly to the works of two young artists whose aspirations and features are totally distinct. We have in mind Mr. Meshkov and Mr. K. Korovin. It would be difficult to find two more different artists. We are using them as a comparison in order to highlight two basic registers which lead an independent existence side by side in our art. Both of them are consummate painters. The focal point of their work is always the purely pictorial aspect of life, and not its literary or philosophical aspects. But whereas Mr. Meshkov is the representative of what we might call an epic, objective approach to life, Mr. Korovin has embarked upon the arduous path of lyricism in painting, depicting subjective moods which sometimes reflect the reality surrounding us to the point where it is unrecognizable.

The Moscow Artists Exhibit

*Artist*, 1894, No. 37, pp. 141, 143.

*A.N. Benois 1901*

...little by little Russian art, which triumphed in the 1860s over the legacy of the conventional school, has now been freeing itself from yet another yoke. Those members of the younger generation who have not joined the rear guard of their elders, who have taken a fresh look at life, with a passionate heart and with their own personal views, as truly artistic natures, have not taken to the whip and the pointer, have not wished

V.D. Polenov

to edify, instruct or correct, but simply paint what has occurred to them, what has pleased them, what they liked. This ingenuous love, this spontaneous infatuation with reality (or their own visions of it) is what distinguishes these new groups of artists from their predecessors...The Wanderers joined together "for a noble cause": they wished to reform Russian society, and to assist their older brothers, the writers. Furthermore, they had a real concern for realism, a faith in its unifying necessity, its relevance and timeliness. It seemed to them that "the childhood years" of art had passed, that the

years of light-hearted games and enjoyments were gone, and that it was time to take a sober look at life, at reality, to deal with that and draw on it alone for the content of their art...

And quite a few realists have appeared over the past 20 years. Serov, Korovin, Levitan, Maliavin – aren't these still realists? Yet these artists have painted reality not as some mental exercise and theoretical prescription, but solely as a result of their endless fascination with life and nature, without constraint, and with constant delight... The first symptom of liberation was that the sphere of painting which by its very essence most needed freedom from proselytizing and didacticism – the landscape – had suddenly, in the '70's, become increasingly important. Russian exhibitions of the '80's were primarily landscape exhibits, something which disappointed every single one of the art critics who saw in this the decline of art. It was not art that was in decline, however, but only academic routine, and its predominance. With landscape painting, and with a spontaneously simple study of nature, Russian painters became unaccustomed to the oppressive canons of Academism and the requirements of liberal aesthetics...

The most remarkable of these artists who introduced a vibrant spirit of poetry into trite realism is Levitan, who died an untimely death...The appearance of *The Silent Place* had an extraordinary, striking effect. It is as if the shutters had been removed from the windows, the windows opened wide, and gusts of fresh, light air had rushed into the stuffy exhibition hall, where the air had previously reeked of the foul odor of too many sheepskins and dirty boots. What can be simpler than this painting? A summer morning. A cool, teeming river swirls around a promontory full of trees. A fragile bridge built on piles has been thrown across it. From among the birch trees on the opposite bank we see streams of a cool, rose-shaded glow, and against a clear-blue sky we see the cupolas and bell tower of a small monastery. A sweet, refined, poetic theme but essentially a banal one. Haven't there been monasteries basking in a pinkish morning glow or evening light before? Haven't there been crystal-clear rivers, and birch groves before? Here, however, it was evident that Levitan had something new to say, had a marvelous new song to sing, and that this song about things we know so well had a new charm, in that the objects themselves seemed fresh, newly discovered. They were simply amazing for their pure, fresh poetry. And it immediately became apparent that this was not just some "nice little new study," but the painting of a master, and that henceforth, this master would be one of the foremost. Where does the secret of this modest little painting's charm lie, and how could you tell that its author was of such great significance? It would be difficult to answer this question, since great art cannot be defined in words. It remains a mystery, the sound of the bell in the Anderson tale, whose ringing reaches the nearest forest, but whose origin cannot be determined through the rational questioning of Philistines...Levitan is not a member of the Barbizon school, he is not Dutch, nor is he an Impressionist, nor any combination of the above. Levitan is a Russian painter, yet he is Russian not because he has painted Russian motifs out of some feeling or principle of patriotism, but, rather, because he has understood the hidden charm of the Russian countryside, its secret meaning, understood only this, yet like no one else. Levitan had travelled several times to Europe after 1889. He had been to Switzerland, to the south of France, and from all these places he brought back excellent, exceptionally vivid and colorful studies. Yet how cold and empty these landscapes of Levitan appear beside his favorite themes: burned-out ravines, silver streams, gray birch trees, and a bright, low sky!...He is a genuine painter. Almost alone among Russian painters, Levitan was able to take pleasure in brush and color, was able not only to paint well, but beautifully. All his paintings are intrinsically painting in its purest form. This is why it is so hard to talk about them, and yet so easy to admire them and surrender to their inexplicable charm.

New Trends

Aleksandr Benois, *History of Nineteenth-Century Painting* 1901, pp. 194, 195, 226, 227, 229, 230.

V.G. Perov

*Aleksandr Benois 1904*

Realism is usually considered to be what characterizes the history of Russian painting and what distinguishes it from all other schools. But ever since realism ceased to be "modern" and became part of the historical past, its features have become more proportionate with other phases of Russian painting and it has lost its predominance. Henceforth realism may be considered only one among several significant movements of our school...Conformist art was already on shaky ground in the mid 1840s. After the world-weariness and abstract aestheticism of the Romantics came the first appeals for a restructuring of reality. Here, Slavophiles and Westerners divided up into camps and erstwhile friends became fierce enemies; a powerful group of our greatest writers brought Russian ideas to world culture in spite of the rigid government of Tsar Nikolas I, but there was also a stifling atmosphere of conspiracy. People felt the need to shed their skin, a need for renewal and reform. Society had outgrown those forms in which it had been enveloped. Painting was also to echo this mood, but it was only natural that this echo not ring from the Imperial Academy of Arts, from that bureaucratic world with one foot in court circles...

Perov was a true son of his times. A man with keen powers of observation, inquisitive, bold, passionately devoted to his cause – he is undoubtedly among the greatest products of Russian culture, and yet his paintings are cheerless in themselves; he painted tales on canvas which would have been livelier and more understandable had they been set down in words. He dealt not with subjects of painting, but with narratives which might be expressed through painting...In spite of all his drawbacks, Perov is the greatest of all artists from the period of Alexander II. But during his time and for a few years after his death, there were a number of masters at work, almost all of whom were collected by P.M. Tretiakov for his gallery. One event brought part of this group of artists together and created a nucleus among them which would later develop into the Association of Traveling Art Exhibitions. This event is known in history as the "Protest of the 13 Contenders."[9]...The very fact that a few young, bold individuals had broken away from the Academy [after competing for the Gold Medal] was of enormous significance. The seed of protest against the imposed school formula had been sown. All the fresh and independent spirits in young Russian artistic circles now gravitated towards the *Artel*[10], and if they were not a part of it, then

---

9 *Actually, there were 14, for the 13 graduating painters were joined by a sculptor.*
10 *The Petersburg Artists' Cooperative Workshop, headed by Kramskoy.*

at any rate they were inspired by its theories, primarily by the staunch determination which was developed and maintained by the first private art community in Russia. Later on, the Association of Traveling Art Exhibits (after 1870) was founded, assuming the role of "headquarters" for avant-garde Russian art, and so it continued for more than 20 years, right up until the appearance of exhibits by the "World of Art"....

The greatest figure besides Vereshchagin among the generation of Russian artists of the 1870s was, no doubt, I.E. Repin, who had opposed the Academy of Arts as far back as the time when Bruni was rector, but who was also the most obvious pupil and successor of Kramskoy. It is a matter of interest that in his own work Kramskoy remained outside the movement he so encouraged. He was too intelligent and sensitive to devote himself entirely to a rather naive program of art. But Kramskoy realized the relative importance of this program at the time and recruited all those who might be useful to it as its representatives...Repin is a born painter. At a time of complete decline in our school of painting, when the inherently excellent but totally outdated concepts of Bruni held sway in the Academy, when in a backward artistic society, everyone followed Perov's lead in disregarding any concern for painting skill, when in high society, the mannerism and pretense of Zichi was the last word, Repin was able to create his own original and forceful method of painting and develop a fresh and genuine palette. It should be noted that he remained completely independent of Kramskoy, of his didactic pedantry and servile copying of nature. Repin took one great step aside and reminded us in his painting of the energetic Old Masters, whose only school was a scrupulous study of nature...Perov, Vereshchagin and Repin are the main pillars of our "comprehensive" realism but along with them worked quite a few artists whose works are of major interest for the history of art and especially the history of our culture. Especially typical "trends" are to be found in the grim Savitsky, the honest and dry Maksimov and Yaroshenko, the prototype of the nihilist youth in the 1870s and 1880s...Yet another

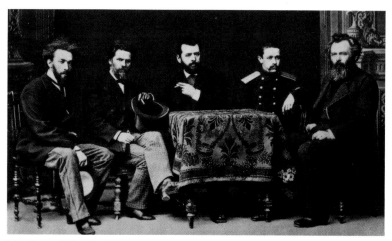

Members of The Wanderers (from left): Savitsky, Kramskoy, Briullov, Yaroshenko, Shishkin

"trend-setting" artist deserves special consideration – this is Prianishnikov...over time he tried to break away from the constraints of the conformist school...he suddenly abandoned any intention of studying, narrating, or imposing his own ideas and turned to a simple depiction of reality. This was a daring innovation at that time, but only ten years were to go by before pure realism became the slogan for all young Russian artists...We tend to forget the services rendered by the "ideological realism" by Ge and Kramskoy, and that Repin played a significant role in the victory over the art of the 1860s...Finally, it goes without saying that the change from socially-oriented art to a freer form of creativity was not without outside influences: all the political reaction of Alexander III's reign which had permeated public propaganda. But there is hardly one factor which might be deemed as significant as the paintings of Surikov. They must have had the same "astonishing" impression on our painters as the works of Dostoevsky and Tolstoy in literature. The doors were opened to let in a breath of fresh air.

Realism and Tendentiousness
Aleksandr Benois
*Russian School of Painting*, 1904, pp. 54, 57, 58, 60, 61, 65, 68.